STELARC

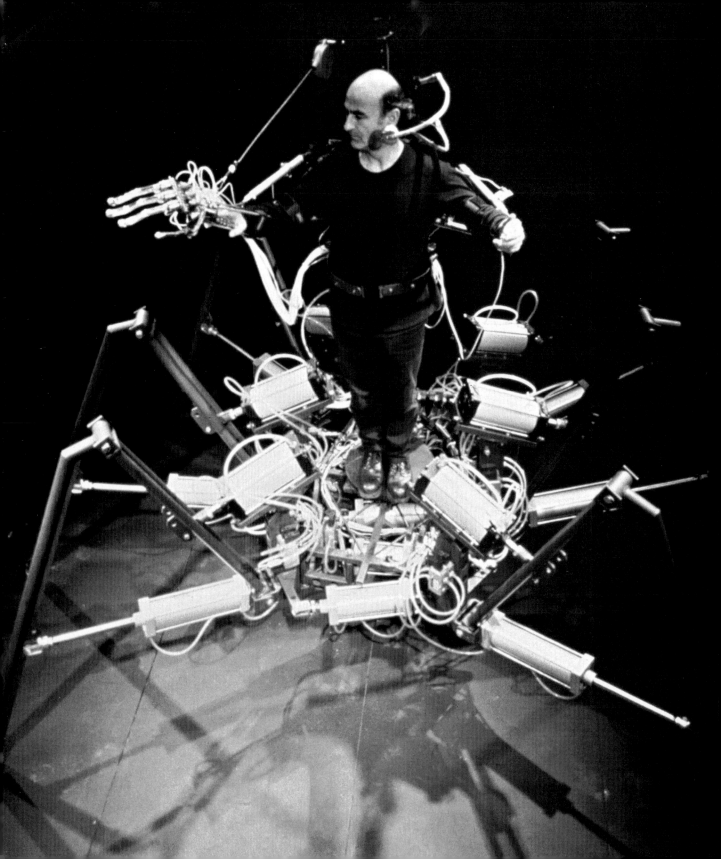

THE MIT PRESS CAMBRIDGE, MASSACHUSETTS LONDON, ENGLAND

STELARC
THE MONOGRAPH

Edited by
Marquard Smith

Foreword by
William Gibson

Texts by
Julie Clarke
Timothy Druckrey
Jane Goodall
Amelia Jones
Arthur and Marilouise Kroker
Brian Massumi
Marquard Smith
Stelarc

First MIT Press paperback edition, 2007

© 2005 Massachusetts Institute of Technology

MIT Press books may be purchased at special quantity discounts for business or sales promotional use. For information, please e-mail <special_sales@mitpress.mit.edu> or write to Special Sales Department, The MIT Press, 55 Hayward Street, Cambridge, MA 02142.

This book was set in Adobe Bembo and Clarendon by Graphic Composition, Inc. Printed and bound in the United States of America.

Library of Congress Cataloging-in-Publication Data

Stelarc : the monograph / edited by Marquard Smith ; texts by Julie Clarke . . . [et al.].
 p. cm.
 Includes bibliographical references and index.
 ISBN 978-0-262-19518-8 (hc. : alk. paper)—978-0-262-69360-8 (pb. : alk. paper)
 1. Stelarc, 1945—Criticism and interpretation. 2. Performance art. 3. Technology and the arts. I. Smith, Marquard, 1969– II. Clarke, Julie (Julie Joy), 1951–

NX590.Z9S737 2005
700'.92—dc22

2004057926

10 9 8 7 6 5 4 3 2

Illustration credits can be found on page 247.

CONTENTS

FOREWORD: "THE BODY"

William Gibson

There was a heyday of virtual-reality conferences during the late 1980s and early 1990s, and thus I found myself in Barcelona, San Francisco, Tokyo, or Linz, blinking through jet lag at various manifestations of new technology and art and attempts at interfacing the two. Very little of this stuff managed to work its way into long-term memory; most of it evaporated from the buffer almost immediately. Highly memorable, though, were the destructo displays of Survival Research Laboratories, the machine-assisted street theater of Barcelona's La Fura dels Baus, and the performances of Stelarc.

Of these three, only Stelarc has continued to hold my attention.

When eventually I was able to meet Stelarc in Melbourne, I found that he radiated a most remarkable calm and amiability, as though the extraordinary adventures he'd put "the body" through had somehow freed him from the ordinary levels of anxiety that most of us experience.

As he sat in a Melbourne restaurant—recalling the sensation of discovering that a robotic "sculpture," inserted down his throat and mechanically unfurled, was stubbornly refusing to refurl for removal and that surgical intervention might shortly be the only option for removal—he struck me as one of the calmest people I'd ever met.

He resembled a younger J.G. Ballard, it seemed to me, another utterly conventional-looking man whose deeply unconventional ideas have taken him to singular destinations. Ballard's destinations, however, have been fictional, and Stelarc's are often physical and sometimes seem to include the possibility of terminality (as with the elegant little sculpture converting "the body" to gallery space).

I had first encountered this art in the pages of the American magazine *Re-Search:* photographs of an event in which unbarbed steel hooks were inserted through various parts of "the body." Counterbalanced with rocks, on ropes, these hooks then levitated the prone body, which remained suspended for some period of time above the heads of onlookers. This immediately put Stelarc on my map.

Who was this person, and what was he up to? Whatever it was, I sensed that it had little to do with rest of the magazine's contents (which included someone who'd opted to bifurcate his own penis and the extremes of recreational corsetry).

Later, at the Art Futura festival in Barcelona, I saw video footage of more robotically oriented performances. I sat in a darkened theater during an otherwise fairly tedious multiscreen display, mesmerized by one small screen on which some sort of terror was manifesting.

I imagine now that I was watching Stelarc in performance with his robotic third arm, but what I recall experiencing was a vision of some absolute chimera at the heart of a labyrinth of breathtaking complexity. I sensed that the important thing wasn't the entity that Stelarc evoked but the labyrinth that the creature's manifestation suggested.

Extraordinary images, not least because they seemed the literal, physical realization of Marcel Duchamp's *Nude Descending a Staircase, No. 2*.

Stelarc's art has never seemed futuristic to me. If I felt it were, I doubt that I would respond to it. Rather, I experience it in a context that includes circuses, freak shows, medical museums, the passions of solitary inventors. I associate it with da Vinci's ornithopter, eccentric nineteenth-century velocipedes, and Victorian schemes for electroplating the dead—though not retrograde in any way. Instead, it seems timeless, as though each performance constitutes a moment equivalent to those collected in Humphrey Jennings's *Pandaemonium: The Coming of the Machine in the Industrial Revolution*—moments of the purest technologically induced cognitive disjunction.

I am delighted at the publication of this volume and look forward to a day when the world's museums house effectively immortal suburbs of that great work, "the body."

PREFACE

The Conception of *Stelarc: The Monograph*
Marquard Smith

Stelarc: The Monograph was conceived on 15 April 2000 at the Institute of Contemporary Art (ICA) in London. On that day, I coorganized a conference entitled "The Prosthetic: Bodies and Machines."[1] Distinguished speakers from England, mainland Europe, and the United States gathered with a sizable and lively audience to discuss, thrash out, and argue over questions circling around, embodied in, and articulated through the interplay, the interface, the hinge between bodies and machines in our contemporary visual culture. We used the figure of "the prosthetic" as a material, corporeal, historical, metaphorical, and poetic hook from which to hang these conversations.

The conference was going well. The program was on schedule, so, uncommonly, there was enough time for welcomed contributions from the audience. During one such question session, a familiar voice piped up: it was Stelarc. The voice was unmistakable, as was his laugh. It's the stuff of legend.

Later in the day, Stelarc offered kindly to make a spur-of-the-moment presentation and proceeded to update us on the progress he was making with his most recent activities, including his still unrealized efforts to develop his *Extra Ear* project, a soft prosthesis constructed from the skin and cartilage of the body that is designed to be attached to his cranium using titanium pins so that it can become a permanent facial feature.[2] (It is anticipated that the ear will be implanted with a sound chip to emit sound so that it can whisper sweet nothings to its neighbor.) He also referred to the progress being made with the *Hexapod,* a dynamic robotic locomotion machine, and cheekily invited donations.

After the conference had come to an official close, as so often happens at the ICA speakers and audience members alike retired to the bar. Stelarc joined us, and we continued to discuss the topics raised by the day's presentations and conversations. Even though hundreds of articles and chapters of books had been written using Stelarc's work—as both determining and representative of new developments in performance art, live art, body art, modern primitivism, technobodies,

interactivity, networked culture, cyberculture, virtual reality, artificial intelligence, robotics, and the posthuman—there had been no book-length study written specifically on his art practice since the 1984 edited collection *Obsolete Body / Suspensions / Stelarc.*[3] When I marveled at this, Stelarc pointed out that a number of such book projects had been initiated but failed to materialize. At that point, on 15 April 2000 in the ICA bar, I promised Stelarc I would ensure that a monograph on his work would come to pass. I'm thrilled to have been able to come good on that promise.

This was not my first encounter with Stelarc. At around 7 p.m. on Friday, 25 October 1991, I experienced my first Stelarc presentation. It was a demonstration of his *Virtual Arm* at a conference entitled "Blue Skies" curated by Mark Little and organized as part of the Edge Biennale in Newcastle-upon-Tyne in the northeast of England.[4] The conference's ambition was to scrutinize the history of art and technology and their confluence—artificial intelligence, robotics, virtual reality, interactive technology, medical and military technology, and noise machines, as well as fictional, science-fictional, and other imaginary fantasies. The conference consisted of presentations, performances, and demonstrations by Stelarc, Genesis P. Orridge, Rose English, Jeffrey Shaw, Mark Pauline, Roy Ascott, and Annette Kuhn—all of whom were intent on interrogating art's technology and technology's art, as well as the function that artists have in mediating, imagining, and imagining the future. It was accompanied by a series of other events, including open forums, an exhibition at the Laing Art Gallery, and a program of "technology" films at the Tyneside Cinema. Stelarc's demonstration at "Blue Skies" was a wondrous presentation, as was the conference as a whole—memorable for all kinds of reasons but mostly for the sight of Stelarc manipulating his *Virtual Arm* and using an electrical voltage box to stimulate involuntary motion in his own body. I was changed for good.

So nearly ten years later—having tracked closely the evolution of Stelarc's artwork and his thought and having read and digested vociferously writings on it—a chance meeting with the artist led to this project. It became my good fortune, my pleasure, my task to assemble a monograph on that body of work that was proper to it. In soliciting contributions for *Stelarc: The Monograph,* I felt it was imperative to gather a range of thinkers and writers, academics and scholars from a mixture of cultural environments and aesthetic and philosophical persuasions,

in keeping with the blend of interpretations that the work provokes. Such a mix would allow the monograph as a whole to approach Stelarc's art from a variety of perspectives and to do so with diverse critical tools in an effort to take the work apart and make sense of it in a number of ways. Thus, the arguments and lines of inquiry presented here and the distinct agendas, attitudes, and tones display the different kinds of commitment that one can have toward Stelarc's work. Together they create a network of interweaving and sometimes contradictory understandings—an overview in all its detailed specificity—of how we can think about Stelarc's oeuvre. While a celebration of an artist's work, a monograph is also a critical engagement with that work, a questioning of it, and a chance to confirm, once again, that work's conditions of possibility. This is what *Stelarc:The Monograph* tries to do.

———————

Since *Stelarc:The Monograph* was conceived five years ago, numerous people have been involved in one way or another, lending a hand or an ear, making possible and easier its realization. For their interest, advice, and thoughtful input to this project, I would like to thank Doug Armato at University of Minnesota Press, Vivian Constantinopoulos at Reaktion Books, Mark Dery, Charlie Gere, Liz Grosz, Marina Gržinić, Ray Guins, Kate Hayles, Steve Kurtz, Duncan Mc-Corquodale at Black Dog Publishing, Peggy Phelan, Thomas A. Robinson at Duke University Press, Mark C. Taylor, and Alan Thomas at the University of Chicago Press.

I'd also like to thank everyone at the MIT Press for working so hard to produce a beautifully designed book (thanks to Emily Gutheinz) whose distribution will benefit hugely from its skillful marketing and publicity. Here I'd like to offer special thanks to Deborah Cantor-Adams and Lisa Reeve at the MIT Press, who have never tired of answering, with repeated congeniality and good grace, what must have felt like an endless stream of my often banal e-mails.

The commitment of the contributors to this project—Julie Clarke, Timothy Druckrey, William Gibson, Jane Goodall, Amelia Jones, Arthur and Marilouise Kroker, and Brian Massumi—has been immense. Many thanks to you all

for making the experience exhilarating, intellectually engaging, and pleasurable from start to finish.

My most heartfelt thanks are reserved for Mark Little, Joanne Morra, and Roger Conover at the MIT Press—and of course, for Stelarc himself. Thanks go to Mark for being involved in this project in so many cerebral, sympathetic, loyal, and unmentionable ways. This book is dedicated to him. I offer public thanks and an apology to Joanne. She has had to listen to me go on about this labor of love almost daily for five years and has pretended never to be bored or exasperated. Thanks for your tolerance and encouragement—and much besides. Thanks to Roger for being positive and encouraging from the beginning and throughout and at so many times of the day and night. There were times I had to doubt your humanness. Finally, thanks go to Stelarc. This project would have been out of the question without his participation. Impossible. Pointless. From that day in April 2000 to now, he has been in contact with me—reliable, passionate, committed, spirited, obliging, instructive, and a menace in equal measure. If he didn't already exist, we would have had to invent him.

Notes

1. The conference was organized with Joanne Morra and spawned a coedited themed issue of the journal *New Formations* entitled "The Prosthetic Aesthetic," which appeared as issue 46 in summer 2002 with contributions from Fred Botting and Scott Wilson, Raiford Guins, Kate Ince, Suhail Malik, Mandy Merck, Andrew Patrizio, Aura Satz, Bernard Steigler, Joanne Morra, and myself. The presentation by Alphonso Lingis from the conference will appear in Joanne Morra and Marquard Smith, eds., *The Prosthetic Impulse: From a Posthuman Present to a Biocultural Future* (Cambridge, MA: MIT Press, 2005). Thanks to Scott McCracken and Jeremy Gilbert of *New Formations* for all their care during the realization of this issue; to Barry Curtis at the School of Fine Art, Philosophy, and Visual Culture at Middlesex University for making funds available for the event; and to Heidi Reitmaier, then head of talks at the Institute of Contemporary Art in London, for doing such a good job of handling the day so well.

2. It has since been decided that the *Extra Ear* will in fact be grafted onto Stelarc's left arm.

3. James D. Paffrath and Stelarc, eds., *Obsolete Body/Suspensions/Stelarc* (Davis, CA: JP, 1984). Recent articles and books incorporating discussions of Stelarc's work include *Alternative Interfaces: Stelarc,* catalogue for the exhibition at Monash University, Australia, 2002; David Bell and Barbara M. Kennedy, eds., *The Cybercultures Reader* (London: Routledge, 2000); Howard Caygill, "Stelarc and the Chimera: Kant's Critique of Prosthetic Judgment," *Art Journal* (College Art Association, New York) 56, no. 1 (Spring 1997): 46–51; Mark Dery, *Escape Velocity* (Grove Press: New York, 1996); Jane Goodall, "An Order of Pure Decision: Un-Natural Selection in the Work of Stelarc and Orlan," *Body and Society* (ed. Mike Featherstone), 5, no. 2–3 (June 1999): 149–170; Chris Hables Gray, ed., *The Cyborg Handbook* (New York: Routledge, 1995); Marina Gržinić, ed., *Stelarc: Political Prosthesis and Knowledge of the Body* (Ljubljana, Slovenia: Maska and MKC [International Festival of Computer Arts], 2002); Adrian Heathfield, ed., *Shattered Anatomies: Traces of the Body in Performance* (Bristol: Arnolfini Live, 1997); Amelia Jones, *Body Art/Performing the Subject* (Minneapolis: University of Minnesota Press, 1998); Mark C. Taylor, *Hiding* (Chicago: University of Chicago Press, 1997); Nicholas Zurbrugg, "Marinetti, Chopin, Stelarc and the Auratic Intensities of the Postmodern Techno-Body," *Body and Society* (ed. Mike Featherstone), 5, no. 2–3 (June 1999): 93–116; Joanna Zylinska, ed., *The Cyborg Experiments: The Extensions of the Body in the Media Age* (London: Continuum, 2002). A more complete bibliography of writings by and about Stelarc can be found on his official Web site at <http://www.stelarc.va.com.au>.

4. Paffrath and Stelarc, *Obsolete Body.* This is being remedied. While this is still the first monograph on Stelarc's work, since this project was conceived I am pleased to say that three recent publications have appeared. See the books by Marina Gržinić and by Joanna Zylinska and the Monash University exhibition catalogue cited in note 3.

STELARC

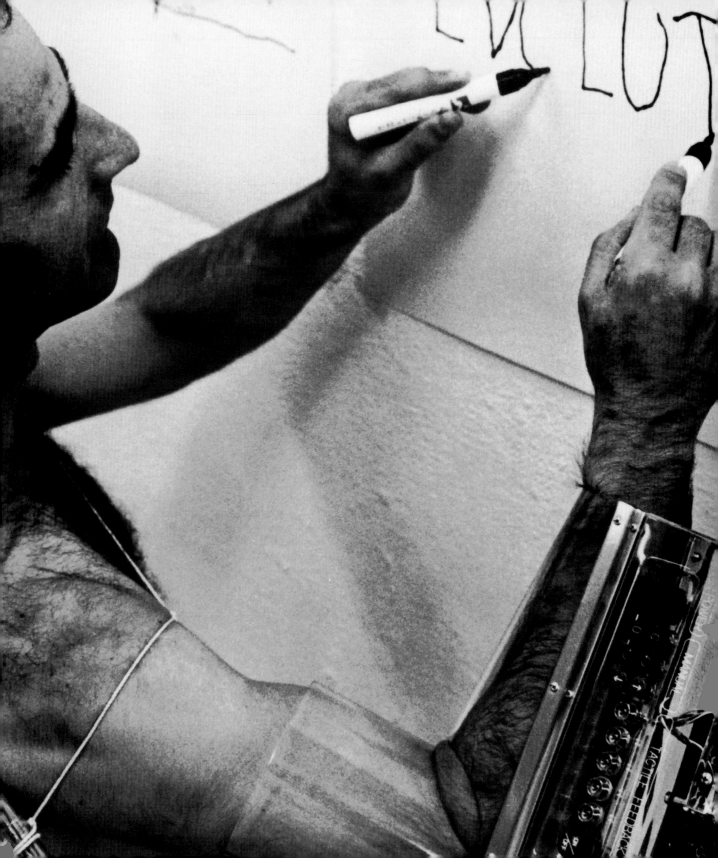

THE WILL TO EVOLVE Jane Goodall

Stelarc's work as a performance artist has run in parallel with a process of commentary in which he elaborates on the themes and purposes underlying his experiments: "I've from very early on held the view that we've always been prosthetic bodies. Ever since we evolved from hominids . . . we've constructed artifacts, amplifications of the body. It's part of what we are as a human species."[1] The word *always* runs as a leitmotif in the commentaries, the themes of which have not changed radically in the last twenty years. Stelarc's Web site maintains the archive of his texts and performances as a composite work in progress. Preoccupied as he is with the obsolescence of the human body, there is no sense that former stages of his own work ever become obsolete to him. The key concepts underlying it are all current. An interest in human evolution has remained a constant focus throughout his career, as has a view that we have brought ourselves to an evolutionary crisis point by generating a technological environment to which we cannot effectively adapt as a purely biological species.

New Scenarios

This view contrasts with conventional popular representations of the evolutionary relationship between humans and machines—for example, in Ridley Scott's film *Blade Runner* (1982, based on Philip K. Dick's 1968 novel *Do Androids Dream of Electric Sheep?*) or in the Stanley Kubrick /Steven Spielberg film *A.I.: Artificial Intelligence* (2001), based on Brian Aldiss's 1969 story "Supertoys Last All Summer

──── 1

Long"). In the prototypical science fiction narrative, technology evolves to the point where a rival species is generated, fuses human and machine qualities, threatens to become dominant, and so puts biological humanity on the road to extinction. This is a paranoid scenario, which usually plays out as a drama of persecution in which organizations of humans rush to destroy the new species before it can take over. The prototypical narrative here is Samuel Butler's novel *Erewhon* (1872), the first work of fiction to explore a rivalry between human and machine evolution as a Darwinian scenario. The novel portrays an isolated community from which all machinic artifacts have been banned. The reasons for this are revealed in a secret book, to which the narrator is eventually allowed access. This is what he reads in its opening pages:

There is no security . . . against the ultimate development of mechanical consciousness. Reflect upon the extraordinary advance which machines have made during the last few hundred years, and note how slowly the animal and vegetable kingdoms are advancing. The more highly organized machines are creatures not so much of yesterday, as of the last five minutes, so to speak, in comparison with past time. Assume for the sake of argument that conscious beings have existed for some twenty million years: see what strides machines have made in the last thousand! May not the world last twenty million years longer? If so, what will they not in the end become? Is it not safer to nip the mischief in the bud and to forbid them further progress?[2]

Fear of obsolescence—of being the losing species in the competition for progress through adaptive advantage—was already deeply embedded in the culture of the Victorian era. In the era of advanced electronics and virtual reality, the settings of the narrative have changed radically, but its underlying logic has changed little. The replicants in *Blade Runner* and the androids in *A.I.* are also seen as rival species advancing too rapidly for the good of their makers—as mischief to be nipped in the bud. Such narratives are, perhaps, a psychologically inevitable accompaniment to the Darwinian view of the natural order. But how inevitable is this paranoid tendency in our view of ourselves as a species among others, striving to retain our position of supremacy in the hierarchy of life forms?

In Stelarc's commentaries, technology is always conceptualized as environmental, never as a species in itself. The scenario is one in which the human

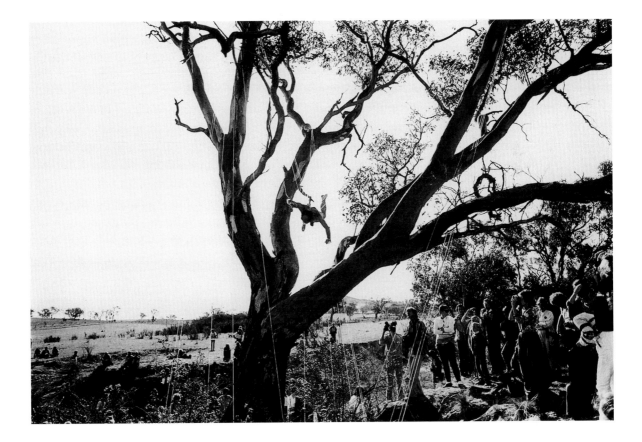

body has moved toward a condition of potentially terminal unfitness or maladaptation because of environmental changes of its own making, yet at this very crisis point it may discover a radically new evolutionary direction. Competition, the central driver of Darwinian evolution, is not involved here, since the direction is triggered through multilateral fusions. As he says in an early interview, "Technology, symbiotically attached and implanted into the body, creates a new evolutionary synthesis, creates a new hybrid human—the organic and synthetic coming together to create a sort of new evolutionary energy."[3] In the world of *Erewhon,* this kind of speculation is the inside edge of technoparanoia. "Who shall say that a man does see or hear?" asks the secret book. "He is such a swarm of parasites that it is doubtful whether his body is not more theirs than his. . . . May not man himself become a sort of parasite upon the machines?"[4]

Butler is mixing a narrative of Darwinian fitness and competitive evolution with speculations that are pushing toward another kind of paradigm. While parasitism is a relationship implying exploitation, with a winner and a loser in the struggle to profit from the environment, the view that everything is interwoven

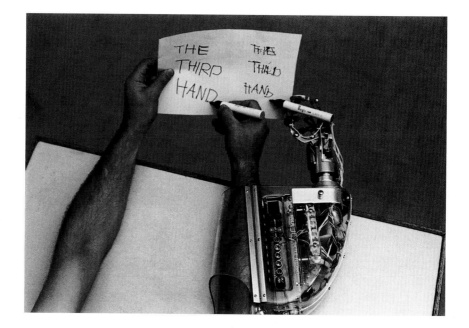

The Third Hand, Tamura Gallery, Tokyo, 8 May 1981. Photo by Jun Morioka.

facing page:
The Third Hand, Yokohama, Nagoya, Tokyo, 1981. Photo by Pamela Fernuik.

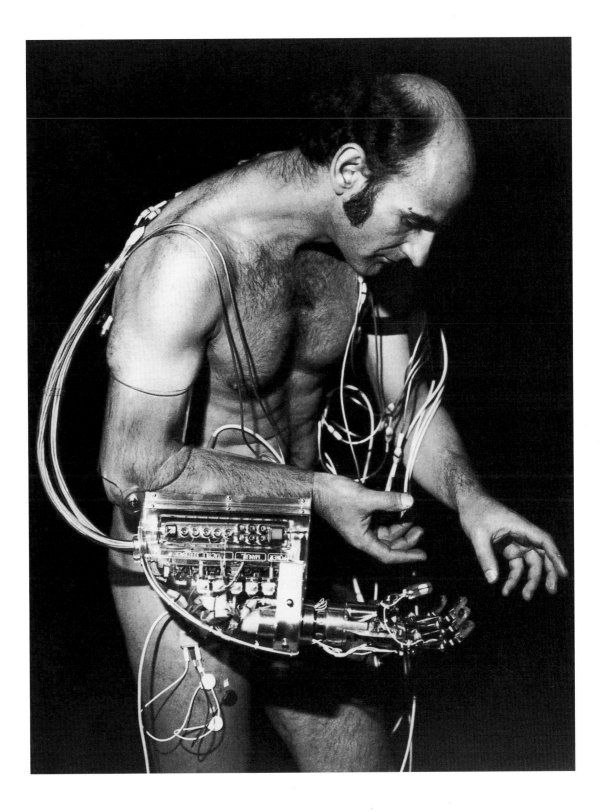

with everything else and that the parasitic relationship is intrinsically reversible comes closer to Stelarc's vision of multilateral organic and synthetic fusion. There are moments when the Erewhonian "Book of the Machines" suggests that organism and environment are fundamentally indistinguishable: "Who can draw the line? Who can draw any line? Is not everything interwoven with everything? Is not machinery linked with animal life in a variety of ways?"[5]

The inner edge of paranoia, with its images of infinitely permeable boundaries, threatens to dissolve the paradigm of competitive evolution, but Butler's narrator keeps the contradictions in place with all the determination of the incurably phobic. Butler himself claimed that "The Book of the Machines" (originally published as a separate essay entitled "Darwin among the Machines") was merely a 'specious misuse of analogy" from which "Mr. Darwin's theory could take no harm."[6]

The specious analogy between biological and technological models of evolution has become a widespread convention—and not just in science fiction. Scientists commonly explain biological evolution by means of analogies with technological processes (Richard Dawkins specializes in this). The idea of a merger between biological and technological forms of evolution, however, remains much more unorthodox. E. O. Wilson and Ernst Mayr, whose works Stelarc read in the 1970s and 1980s, were interested in widening the exploration of natural selection to consider the adaptive significance of social behavior (Wilson) and the parameters of genetic change (Mayr). "The new synthesis" to these writers was not the synthesis of the organic and the technological that intrigued Stelarc but the synthesis of Darwinism and genetics. Wilson was bullish about the importance of the integrated paradigm, anticipating that the social sciences were about to "shrink to specialized branches of biology," but Mayr insisted on a restrictive view of evolutionary change: "Darwin never said 'Selection can do anything'; neither do we. On the contrary, there are powerful constraints on selection. And selection is, for various reasons, appallingly often unable to prevent extinction."[7]

The prevention of extinction was precisely what captured Stelarc's imagination, and the restrictions that Mayr was emphasizing were a spur to engage in experiments outside the parameters of natural selection. Perhaps, too, a techno-biological synthesis would escape the deterministic restrictions of Wilson's so-

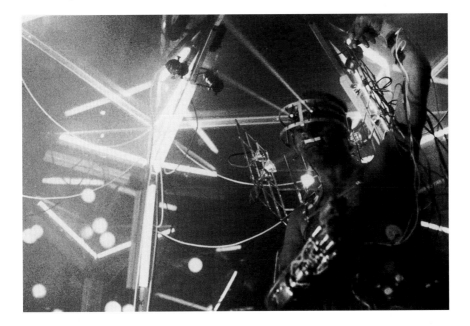

Remote: Event for Amplified Body/Involuntary Arm, Melbourne International Festival, 13–19 September, 1990. Photo by Anthony Figallo.

ciobiology. "Information is the prosthesis that props up the obsolete body," Stelarc declared, and "information gathering satisfies the body's outmoded Pleistocene program."[8]

Outmoded Programs

Stelarc's insistence that the body is obsolete can be seen as a curiously perverse intervention from someone with genuine interests in biological evolution. In Darwinian terms, obsolescence—interpreted as incapacity to adapt to environmental change—would mean simply extinction, and Stelarc was defying that assumption while embarking on a line of speculation belonging to science fiction rather than science. He was accused of denying the body, propagating technophilic fantasies, and indulging in macho narcissism.[9]

Yet the performance experiments that accompanied the speculation were, quite literally, exercises in restraint. They emphasized the fleshiness of the body and surrounded it with natural materials of rock and wood. The only ingredient

from the world of information technology was his *Third Hand*—the robotic arm he designed in collaboration with engineers at Wasada University and the Tokyo Institute of Technology. In the first of the *Obsolete Body* events in Melbourne in 1980, the *Third Hand* (making one of its first public appearances) took the lead in a subtle way. Its movements were triggered by electromyography (EMG) signals from the abdominal muscles of the body, which lay on a bed of forked branches, surrounded by suspended rocks that swung in varying patterns: "For 20 minutes the real hand attempted to mimic the motions of the artificial third hand" but "appeared clumsy and jerky" and "could not cope with the 270 degree wrist rotation of the artificial hand."[10] In subsequent *Obsolete Body* performances, the body was suspended from hooks through the flesh so that its limbs were immobilized, while it became a moving object in space and the activity of its interior organs was monitored by electrodes that transmitted the EMG signals as an ambient soundscape. One of the commentaries states that technology "literally brings the body back to its senses (sensors)."[11]

What we see in these experiments are attempts to harmonize organic and technological components in diverse and nuanced ways. There is no dramatic confrontation between the body and a machinic other (though such images are occasionally evoked, half humorously, in subsequent performances). In the early 1980s, Stelarc was anticipating some of the most significant developmental trends in electronics. He was interested in nanotechnology, virtuality, interiority, and information as milieu. Marshall McLuhan's influence is evident:

MCLUHAN: *The stepping up of speed from the mechanical to the instant electric form reverses the explosion into implosion. In our present electric age the imploding or contracting energies of our world now clash with the old expansionist and traditional patterns of organization.*[12]

STELARC: *With the desire to measure time more and more accurately and minutely, the necessity to process vast amounts of information and the impulse to catapult creatures off this planet, technology becomes more complex and compact. This increasing miniaturization creates an implosive force that hurtles technology back to the body, where it is attached and even implanted.*[13]

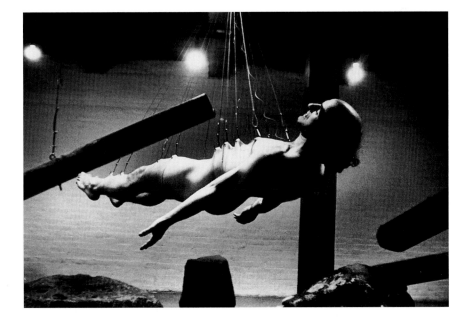

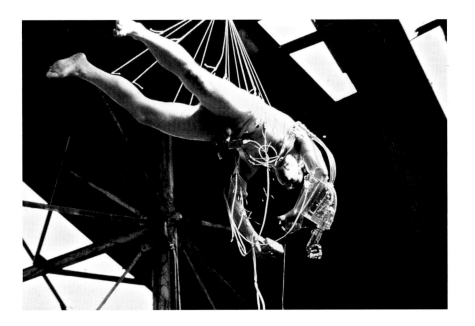

Internal/External:
Suspension for Obsolete Body,
80 Langston Street Gallery,
San Francisco, 31 July 1983.
Photo by Dan Ake.

Stretched Skin/Third Hand,
Monorail Station, Ofuna, Japan,
1988. Photo by Simon Hunter.

McLuhan's focus on the electronic leads to an interest in technologies as media rather than as machinic entities. System, circuitry, and information are environmental elements, and the specific forms through which they pass have no determining status in the world. He thinks in evolutionary terms about technological progress but sees human agency as playing a role that enables development in saltations rather than through gradual accretion.[14] "These media, being extensions of ourselves, also depend upon us for their interplay and their evolution. The fact that they do interact and spawn new progeny has been a source of wonder over the ages."[15] But humans are also acted on by their technologies, so that the relationship is one of dynamic symbiosis.

Here, McLuhan's reasoning takes a line that is directly contrary to the tenets of evolutionary biology. Mayr stresses that natural selection "by its nature is a thoroughly selfish process, measured only in terms of the reproductive advantage it gives to an individual. The great question, then, is how can true altruism evolve?"[16] Essentially, all forms of altruism must in Darwinian terms be constructed as diversified strategies of self-interest.[17]

But in McLuhan's world, symbiosis has become so comprehensive that there is no such thing as an individual. Consciousness itself is "collectively and corporately extended to the whole of society."[18] Like Wilson, McLuhan regards human evolution as being necessarily bound up with "the whole psychic and social complex," but where Wilson sees competitive self-advancement as the central driver of social behavior, McLuhan sees agency itself as becoming collective: "In the electric age, when our central nervous system is technologically extended to involve us in the whole of mankind and to incorporate the whole of mankind in us, we necessarily participate, in depth, in the consequences of our every action."[19]

Projections and Orientations

An interest in distributed and displaced agency becomes increasingly evident in Stelarc's work through the 1980s and 1990s and grows out of his experiments with feedback loops between body and machine. The *Third Hand* features in most of these experiments and evidently plays a catalytic role in extending the field of activity normally available to the central nervous system.

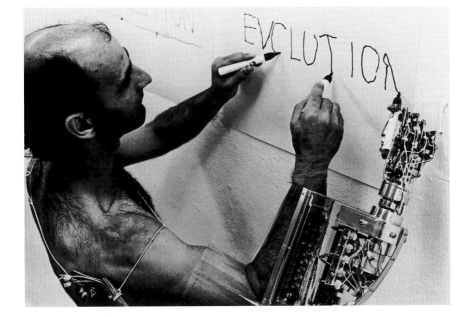

Handswriting "Evolution,"
**Maki Gallery, Tokyo, 22 May
1982. Photo by Akiro Okada.**

When Stelarc used all three hands at once to write the word EVOLUTION on a glass panel at the Maki Galleries in Tokyo in 1982, he made a defining gesture in more ways than one. Prosthetic extension must involve harmonization and synchrony if it is to lead to a new evolutionary—or postevolutionary—phase. A tactile feedback system provided the *Third Hand* with "a sense of touch" and thus the beginnings of an ontology. Its movements were triggered by abdominal and leg muscle signals, so that it was mediating between areas within the body that were not used to being "in touch" with each other. McLuhan talked of "new ratios" created between the senses through media extensions, but Stelarc was practicing a more deeply interventionist approach to mediation than even McLuhan had envisaged.[20] The interior sounds and movements of the body were projected outward through speakers and onto screens, while in a characteristically theatrical embellishment, mirrors projected laser beams from just above his eyes.[21]

Stelarc as cyborg appeared as the antithesis of Stelarc in suspension. The silent and frighteningly vulnerable body of flesh was transformed into a techno-alien figure—the generative center of a noisy and visually spectacular force field.

As an artist, he clearly enjoyed evoking some of the more sinister resonances of the cyborg persona, though he has never indulged in anything that might be described as "acting" in any of his performances. The face remains a neutral screen across which the muscular configurations of pain, exertion, or concentration may come and go; it never wears expressions of the kind associated with dramatic involvement. Stelarc explicitly disclaims Faust and Frankenstein as role models or as relevant associations for his experiments. Yet there is some tongue-in-cheek melodrama in the visual design of the performances.

A monstrous double figures in the *Psycho/Cyber* series of the mid-1990s and takes various forms. The *Third Hand* itself projects a double in the form of a massive *Virtual Arm* whose movements are generated from data gloves worn on Stelarc's own hands. It responds to signals in a gestural command language that controls its appearance as well as its movements. Whatever the *Third Hand* can do, the *Virtual Arm* can enlarge and multiply: it rotates through 360 degrees, sprouts new sets of digits from each finger tip, changes mode from blue ectoplasm to metallic opacity to graphic diagram. "Amputees often experience a phantom limb," runs the commentary. "It is now possible to have a phantom sensation of an additional limb—a virtual arm—albeit visual rather than visceral."[22] A Freudian reading of this might be tempting, but also would do little to illuminate what is actually a physiological and cognitive exploration of unprecedented complexity.

In some performances, the double is solidly present—a robotic giant that both choreographs and is choreographed by the movements of the human body. An IRB 2000 industrial robot manipulator with a camera inserted into the end of its arm circles and scans the body, projecting its image onto a screen behind. Multiperspective imaging is an important feature of the performance, since the image begins to take on an autonomy that gives it, too, the status of a rival presence: "Images are imbued with intelligence—they can act and react. Images are cyber-skins that displace the physical into the virtual, that transduce the physical body into the phantom entity."[23] The abandonment of any organizing point of view is an important part of the *Psycho/Cyber* experience but should not be mistaken for a postmodern gesture. Stelarc distances himself from postmodernism and from many other readily classifiable cultural approaches: "My concern about postmodernism is that it ultimately becomes so self-referential that it falls into an incestuous discourse and spirals back into itself."[24] He is interested in feedback

loops but not contained circuits. However, he is clearly doing something that also distances him from any of the established oppositions to postmodernism—for example, that of Frederic Jameson. Like Stelarc, Jameson believes that the electronically saturated environment is too much for us to cope with. But where Stelarc embraces the saturation and turns disorientation into a new aesthetic, Jameson wants to embark on a redressive exercise in "global and cognitive mapping" that will enable us to "grasp our positioning as individual and collective subjects and regain a capacity to act and struggle."[25]

The coupling of act and struggle in Jameson's formulation is essentially Darwinian. In Stelarc's coupling of human and robot, struggle is eliminated (since it would only disrupt the complex and highly sensitive process of stimulus and response), and action is indistinguishable from manipulation. He sometimes refers to the robot as "the manipulator," but it is itself manipulated, its movements being determined by signals transmitted through sensors attached the body or the *Third Hand*. Which is the puppet, and which the manipulator? Who is the master, and who the slave? Audiences culturally programmed to speculate in these terms are taken into an entirely unfamiliar zone of experience. With the robot as coperformer, Stelarc confuses the traditional master/slave terminologies that are attached to the human/machine relationship by increasing the feedback loops to a point where the body and the robot are effectively one operational system. Rather than residing in one or the other, intelligence and agency are extruded into the system itself: "Plugged into and arrayed in circuitry, the body becomes remote from its psycho-chemistry and hollow, with its internal processes emptied into the electronics."[26]

Stelarc may be deliberately and humorously evoking the zombie and other demons of the cultural imaginary, but he shows no great interest in the cultural implications of what he is doing. As he has at various times declared in response to the inevitable suggestions by interviewers, his work is not about paranoia, the uncanny, sadomasochism, or any other form of psychodrama. Yet he takes up their signifiers and even their vocabulary, with such titles as *Parasite: Event for Invaded and Involuntary Body* (1997) or *Extreme Absence and the Experience of the Alien*.[27] Parasitism, involuntarism, and aliens are the core business of paranoid fiction, so what is he doing with these allusions when he claims to be refusing the psychological baggage that usually accompanies them? By transposing them from the

Parasite: Event for Invaded and Involuntary Body, Virtual World Orchestra, Glasgow, 4–6 April 1997. Diagram by Stelarc and Merlin.

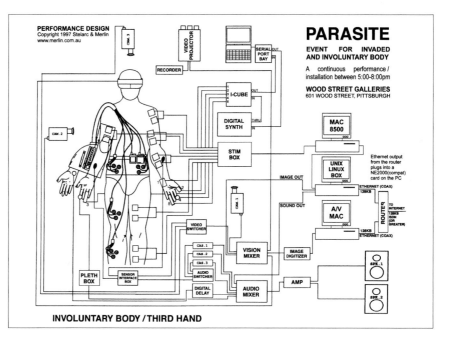

realms of the psychological to demonstrate an entirely physical, material version of possession, he effectively defuses them: "Glove Anaesthesia and Alien Hand are pathological conditions in which the patient experiences parts of their body as not there, as not their own, as not under their own control." Thus, the problem "would no longer be possessing a split personality, but rather a split physicality."[28]

The Nonpathological Split

The concept of split physicality began to take precedence in Stelarc's performances from the mid-1990s as a development of the opportunities provided by the image as "avatar." The use of this overtly metaphysical term is another provocative gesture: an avatar is an emissary from a transcendent world—a deity incarnate or a spiritual emanation. Mythologically, it can take the guise of an uncanny double and belongs to a dualistic cosmology in which the physical world has an intangible other. In late twentieth-century science fiction, most notably the nov-

els of William Gibson, a new kind of metaphysical dualism was inspired by the development of virtual-reality imaging. When avatars broke through into the physical world from the virtual, they brought with them all the apparatus of a metaphysical dramaturgy, as is evident in the plot structures of such films as *The Lawnmower Man* (1992), *Johnny Mnemonic* (1995) (based on Gibson's 1986 story), and *The Matrix* (1999), where it is associated with hysterical attempts to defend the borders of the self. In Stelarc's relationship with the avatar, there is no struggle and no hysteria: "What's of importance is the realization that interactive images become operational agents—the body performs best as its image. Electronic images displace and even erase the body."[29]

Ping Body/Proto-parasite (1995), an event designed for Telepolis at the Pompidou Centre in Paris, displaced the body quite literally by keeping it at a distance from the spectators, who could determine its movements by choosing contact points on a screen image. Stelarc was in Luxembourg, wired up to a six-channel

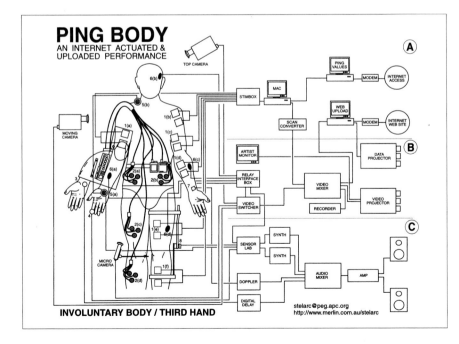

Illustration, *Ping Body: An Internet Actuated Performance*, Digital Aesthetics, Artspace, Sydney, 10 April 1996. Diagram by Stelarc and Merlin.

muscle stimulator that controlled the left side of the body so that the nervous system itself was split. The signals that entered via the touch screen produced more than a knee-jerk reaction. They were picked up by an arrangement of sensors, electrodes, and transducers that effectively "made the body a video switcher and mixer," transmitting sounds and images back to the studio in Paris.[30] This strategy was developed in subsequent performances, where the body was choreographed through random Internet activity.

The practice of split physicality in such experiments also creates a dissociation between body and self. Stelarc has consistently maintained that the body reconceived for evolution in an electronic environment is no longer the container for a self or psyche, but when he actually demonstrates this, he is doing something that E. O. Wilson declares to be a logical impossibility. Wilson regards the self as a construct or illusion, a dramatic character in the various mental scenarios we process, yet he also sees it as a physiological necessity:

It must exist, and play on center stage, because the senses are located in the body and the body creates the mind to represent the governance of all conscious actions. The self and body are therefore inseparably fused. The self, despite the illusion of its independence created in the scenarios, cannot exist apart from the body, and the body cannot survive for long without the self.[31]

Darwinian psychology may portray the individual organism as a mere channel for the DNA stream, a puppet in the service of a determining genetic program, but an illusion of individuality drives the behaviors that are essential to survival and reproduction in the drama of natural selection.

This awkward paradox has been much discussed among Darwin's followers. According to Thomas Huxley, all states of consciousness must be caused by molecular changes in the brain, and so "to take an extreme illustration, the feeling we call volition is not the cause of a voluntary act, but the symbol of that state of the brain which is the immediate cause of that act. We are conscious automata."[32] Yet we are conscious automata programmed to be furiously protective of our autonomy. Agency is precious to us, so much so that we are haunted by fears of its loss or usurpation. Spirits that possess our minds, alien influences that cause our limbs to move at the will of another, parasites that take over our bod-

ies, surroundings that confuse and overwhelm us: these are the nightmares of Western modernity. The struggle for survival has an individual, psychological dimension as well as a genetic one.

Stelarc turns the paradox around. We must exercise our agency by consciously, deliberately taking steps in a new evolutionary direction that will move us beyond the obsolete body, but in doing this we will also move toward a condition in which agency, consciousness, and deliberation will never be the same again. Specifically, they will never again belong to "us" as individual subjects. They will be systemic and circulatory. Is this just a provocative suggestion, or is it a hypothesis beginning to acquire proof through the public demonstrations that Stelarc has initiated? The hypothesis itself is derived from McLuhan, who envisaged "an age of co-presence . . . an implosion in which everybody is involved with everybody."[33] McLuhan was roundly attacked for what many perceived to be undisciplined speculations that amounted to little more than a neovitalist daydream of an electronic future that was blind to the political and social realities of the world around him. Much the same charge has been leveled against Stelarc. "But who writes the code that creates the 'high fidelity illusion of tele-existence?'" challenges Mark Dery. "Who controls the remote controllers? What is needed here is a politics of posthumanism."[34] Dery sees Stelarc as a McLuhan disciple who has been seduced by the same "rhetoric of transcendental lift-off," is in denial of power politics, and finds himself beset by the same kinds of reality problems.[35] It's an easy accusation to make, and Dery presents it with rhetorical force and flair, but he fails to take account of what is actually happening in the performances. In Stelarc's case, it is important to approach the rhetoric through the performances, and not vice versa.[36]

Stelarc may trade in "McLuhanesque epigrams," but he also designs experiences that put them to the test and in doing so engages with questions that underlie the kinds of political concerns that Dery insists must be addressed. It is one thing to talk in poetic aphorisms about the split body and another to go through the process of having some areas of your body move in response to external triggers while other areas are still under the control of the brain and central nervous system. When Stelarc talks of displacing and erasing the body, he is concerned with an experience that bears no resemblance to "the bodiless exaltation of cyberspace."[37] The gestation of the postevolutionary, image-driven, networked

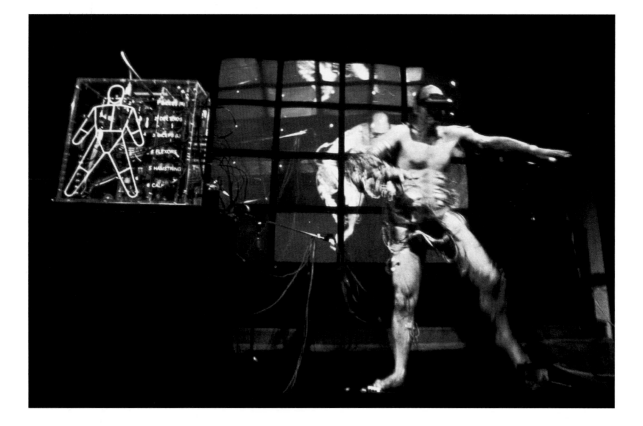

body is as painful and immediate a process as any other kind of birth, and if not managed well, it would be life threatening.

Pain is manifested in most of Stelarc's performances. If you stand close enough to the action, you can see the pain pass in waves through the musculature of the face and the effort of pain management register as the next cycle of movement is anticipated. This is not meant to be the visual focus of the event, though. Visual aesthetics are important in the design of the performances, which demonstrate an almost classical attention to scale, balance, linear dynamics, and sensory texture. *Extended Arm,* a work I saw at the College of Fine Arts in Sydney in August 2000, features a pneumatic arm extension that bends at elbow and wrist with an almost sinuous movement, the weight being taken by a supporting wire. This is the successor to the original *Third Hand* and, compared with it, conveys an impression of transparency and elegance. It seems almost to float on its air supply. The evidence of pain and effort crossing the human face is curiously at odds with this image—a necessary counterpoint that reminds spectators of how much is going on with the two human arms involved in the performance. One is thrust

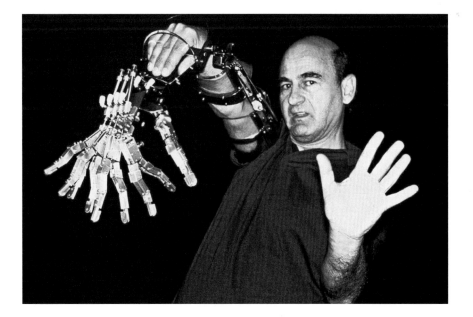

Extended Arm,
Melbourne/Hamburg, 2000.
Photo by Anthony Figallo.

facing page:
Split Body: Voltage In/Voltage Out, Galeria Kapelica, Ljubljana, Slovenia, 12 June 1996. Photo by Igor Andjelic.

into the sleeve of the extended arm, controlling the movements of its long aluminum fingers from a key panel. The other is itself controlled by muscle stimulators, which force it through an incessant and sometimes quite vigorous choreographic pattern.

Demonstrations of the split body may cause pain, but they cannot accommodate fear, however deliberately they play on the generic ingredients of cultural phobia. In Darwin's account, fear and terror have—of all our instinctual reactions—the strongest, least controllable physiological manifestations. Indeed, being out of physical control is one of the defining elements of terror in physiological terms. The heart beats quickly and violently, the vasomotor center causes contraction of the small arteries under the skin, the superficial muscles shiver, and a general trembling of the muscles is produced, the tensions in which may build to a point where there is spasm or rigidity. The hands twitch, the mouth is dry, and the skin sweats.[38]

Any of these symptoms would be perilous in the extreme to a body that is suspended from hooks through the skin, in the process of trying to swallow a large object, or coordinating its movements with those of a large robot. Yet these events provoke fear and terror because they violate the sense of self that E. O. Wilson regards as a fundamental component of the survival apparatus, which is consistently selected for in the evolution of the human species. Curiously, the physical effects of terror mimic the psychical narratives associated with it: the body is ripped from the controls of consciousness and intentionality and delivered over to instinctual command. Darwin discusses how particular scalp and facial muscles are caused to contract under the influence of fear, so that the body becomes a puppet of its own primordial programming and needs no muscle stimulators to set it moving in ways that override the inhibitory power of the will. Narratives of terror often describe the experience of struggling to regain control of one part of the body—to stop the hands from trembling, for example, or to unlock the jaw muscles so that it becomes possible to speak. Terror may itself be a split-body experience.

The Psychical By-Pass

"Can a body cope with experiences of extreme absence and alien action without becoming overcome by outmoded metaphysical fears and obsessions of individuality and free agency?"[39] Stelarc's question—posed in a 1999 text—is indicative of a growing acknowledgment in the commentaries that fear is an issue, but here there is an important distinction to make between the fears that reside in the cultural imaginary (which Stelarc refers to as "metaphysical") and the physical symptoms of fear that are an instinctual reaction to perceived danger. Stelarc's question is whether "a body" can cope with experiences that commonly generate fear. Another kind of split is implied here. If the body *can* cope, this means that the physical symptomatology of fear has been kept out of the situation—and therefore that the fears have been effectively resisted at a psychological level (through an act of will) or, more radically, that the body in the performance is, as Stelarc has repeatedly claimed, "not a site for a psyche." Significantly, his question is not whether the body can succeed in overcoming the fears but rather whether it can escape being overcome by them. Does this imply some kind of psychical by-pass surgery? If there is a radical dissociation between body and mind in these experiences, what has happened to the mind with all its stock in trade of determinations, interpretations, and protection apparatus?

This question intrudes with increasing insistency into Stelarc's more recent works. An introductory statement on his Web site implies that the psyche has been conjured away as if it were only an illusion—a temporary cultural construct to be rendered obsolete along with the body without prostheses: "We fear the involuntary and we are becoming increasingly automated and extended. But we fear what we have always been and want we have already become—Zombies and Cyborgs."[40] There are compensations for the loss of the psyche. The prostheses are not merely therapeutic replacements. They are augmentations that create new possibilities for the species, and if they involve alien invasions of the body's central nervous system, their takeover results in an amplification of its range and influence. *Movatar* (2000) is a pneumatic harness—an exoskeletal structure—that is worn on the upper body and that controls the movements of the arms and of the spine from the waist upward. The vertical split body of *Ping Body/ Proto-parasite* (the Telopolis experiment at the Pompidou Center) is now a horizontally split body, and the jerky effect of voltage feeding into the muscles is

replaced by a more fluid, integrated system of motion control. A "genetic algorithm" in the *Movatar* enables behavior to evolve in performance. Thus the body becomes a host for the agency of an artificial intelligence—a prosthesis enabling the behavior of a virtual entity.

In an interview, Stelarc speaks about the implications with cackling relish:

I wanted the effect of Alien Agency, possessing and performing with your body. I'm reconciled to the fact that in a complex technological terrain where there's multiplicity of feedback loops, it's no longer meaningful to ask who's in control.[41]

Motion prosthesis for
Movatar, Melbourne, 2000.
Image by Steve Middleton.

facing page:
Movatar, Cybercultures,
Casula Powerhouse,
Casula 2000. Photo by
Heidrun Löhr.

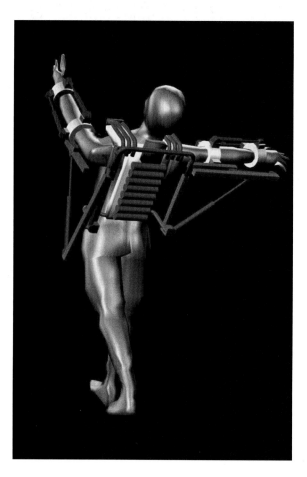

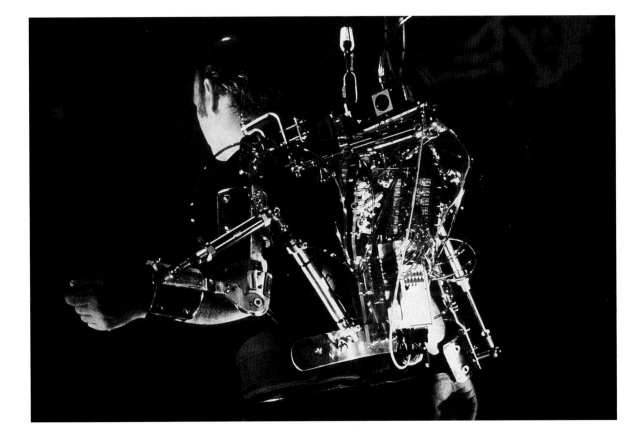

When Mark Dery insists on asking who controls the remote controllers, he misses the essential challenge of the experiment, which throws into question the very concept of control. This has political implications, though not of the kind Dery is looking for. The prospect that we might move beyond a Darwinian politics—of dominance and subordination, winning and losing, and survival and extinction—is far more significant (however remote) than any conventional political analysis. This is not to say that there is anything overtly political about the *Movatar* performances, but as demonstrations of action without intention, they show us, in the most literal sense, a human who is not an actor and a body that is not a contained entity.

The dispersed nervous system and distributed agency of this body constitute a radical threat to the sense of self on which, according to the Australian critic Ghassan Hage, the sense of nation is modeled. Hage sees the current "border-protection" policy in Australia as symptomatic of pathological national anxieties about self-definition and containment. "Borders are used to define the self," he says. They are "a compressive mechanism. They stop what they contain from disintegrating." He refers to Jacques Lacan's 1949 theory of the mirror stage for the image of an infant body learning its boundaries and thus beginning also to learn a fear of disintegration. There is "a constant striving to pull back the extensions of the self, to reintegrate them," and "pulling yourself together" becomes a key imperative for secure identity in the world.[42] Current political policies in Australia give an urgent relevance to Hage's analysis, and it may be that an anxious obsession with selves is especially acute in Australian culture, with its recent history of invasion and migration. Edward Scheer, another Australian critic, devotes particular attention to the impact of Stelarc's work in displacing the sense of a humanistic self "that remains in charge of its intentions and agency and located within its own affective field." Audiences also are upset by Stelarc's pronouncements about this, Scheer observes: "I have seen it time and again in public situations."[43]

When Stelarc claims that his work unsettles notions of identity, agency, and intelligence, he is not entering a metaphysical debate but referring to the implications of a highly controlled set of experiments in physiological extension and dispersal. If we are in search of control here, we need to examine the terms in which the experiments themselves are controlled, since control and experiment

are integrally related in scientific discipline. Human agency has been denied before, at a philosophical level, by materialists and mechanists, but it is one thing to make general philosophical statements and another to present a technical demonstration of agency-free activity.

In an essay on "The Feeling of Effort" written in 1880, William James poses the question, "What is the volitional effort proper?" He relates this to the terms "exertion, striving, straining" and to "feelings of active energy,"[44] all of which are eliminated from human-movement sequences in Stelarc's performances. However, the performances as whole works fit James's overarching criteria for voluntary action:

1, a preliminary idea of the end we wish to attain;
2, a fiat;
3, an appropriate muscular contraction;
4, the end felt as actually accomplished.[45]

A work like *Movatar* involves the development of a preliminary idea within the framework of a wish to accomplish a particular range of effects. The *fiat* is, in James's definition, a determination that translates into action in the world or an act of will leading to "the stable victory of an idea."[46] Stelarc may insist on talking of a planned work in terms of what "the body" is going to experience rather than in terms of what "an I" is going to do, but planning is going on, and the body is both its instrument and its instigator. The development of the work proceeds in the face of complex difficulties and demonstrates the stable victory of an idea over a range technological, physiological, and sociocultural factors that present themselves as impediments to its realization.

With this kind of analysis, we are at risk of reverting to a traditional model of the mind-body split, but the challenge needs to be faced. James is too sophisticated a thinker and too much of a physiologist to be content with a simple mind-over-body explanation, but he tackles the question of mental determination with special clarity. In the case of a decision to make a muscular movement, he suggests, the real test of volition is not the movement itself but the determination to make it regardless of any resistances that may encountered. The body may be tired, for example, or the movement may be strenuous.[47] Conversely, the

operations of the will are also starkly in evidence where there is resistance to instinctual or impulsive movement. A person's determination not to move when it may give away his or her presence in a dangerous situation calls for intense mental and physical effort precisely because it involves overriding biochemical signals automatically sent to the nerves and muscles.

Is a performance of *Movatar* just an example of this phenomenon at one remove? In support of such a view, it could be argued that there is a mental determination to put the body in a situation that will be intensely difficult for it, a willful abdication of its habitual control mechanisms, and a sustained process of execution in which physiological impulses are constantly fielded in an agile game of cognitive sorting. This kind of argument could put the metaphysicians back in business. The very compliance of the body in the overall design of the event could be seen to substantiate their case. In James's words, "this acquiescence, connivance, partiality, call it what you will, which seems the inward gift of our selfhood. . . . This psychic effort pure and simple, is the fact which a priori psychologists really have in mind when they indignantly deny that the whole intellect is derived from sense."[48] James has some arguments of his own to confine the claims of a priori inspiration, but Stelarc's work complicates the picture in a way that James could not have envisaged. While Stelarc's bid to transcend natural selection through willed technological intervention can be said to be really a manifestation of the "gift of selfhood" that he purports to deny, this selfhood must also be acknowledged to be no longer "inward." It has become a slippery phenomenon, difficult to locate.

Encounters and Exchanges

Stelarc's newest project is a concept for a talking head or "embodied conversational agent." This would be introduced to the public as a gallery installation, and the planning focuses on the moment when visitors walk in off the street to experience a first encounter with the avatar. The head will turn, perhaps making a remark based on visual information that it has picked up from the person's behavior or appearance. Visitors approach a keyboard to begin dialogue with it, but a sensor cues a comment before they actually touch the keys. The head gets the first word and appears "seductively intelligent." The conversation has begun. Its de-

velopment will depend on two things. One is the artificial intelligence program built into the head, which will be designed on evolutionary principles so that it learns from interaction—selecting, picking up, and imitating patterns of dialogue that are effective in generating responses. The other is the assumptions and inferences programmed into the human participant, who will automatically read intelligence into certain kinds of facial expressions or comments. Thus a minimal set of programmed actions may generate a continually diversifying range of interactive possibilities.[49]

Postcolonial theorists have taken an interest in the phenomenon of the first encounter as a degree zero of intercultural understanding, during which there is a rush on both sides to fill the void with assumptions and inferences. Charles Darwin's description of a first encounter in 1832 between the Fuegians and the crew of the *Beagle* is a favorite example for analysis. Darwin's companions find their gestures and English sentences being mimicked. Darwin offers an interpretation of the mimicry, suggesting that it expresses a condition of precivilization characterized by involuntary, automatic response mechanisms. This condition, he

Prosthetic Head, Smile, Prosthetic Head, Surprise, Prosthetic Head, Devious, San Francisco, January 2003. 3D models by Barrett Fox.

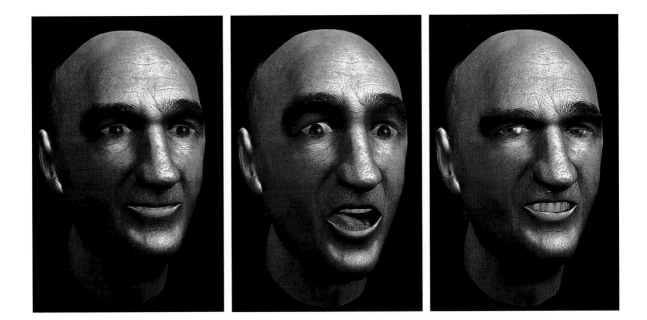

assumes, is the polar opposite of his own and that of his companions. Yet the Fuegians are seductively acting out a condition of sameness. Michael Taussig is particularly astute in his commentary on the ways in which this creates the effect of a feedback loop, as the *Beagle* crew members start to join in the game of mimicry: "Could it be that this is the consequence of an unstoppable circulation of mimetic and alteric impulses along a sympathetic chain in which each moment of arrest stimulates further impulsion?" A certain blindness to what is going on, Taussig suggests, is a necessary defense mechanism for a culture to which individual selves and their highly evolved agendas are precious. Thus "we seem to be doing something quite strange, going round and round and unable to see that we are doing so, simulating and dissimulating at one and the same time for the sake of our epistemic health and the robust good cheer of realness."[50]

If the scenario of competition between cultures, like the competition between all life forms, is really just a matter of simulating and dissimulating to conceal a reality of symbiotic interdependence, then we have the basis for a very different interpretation of evolution and what drives it. We have something that illustrates the biologist Lynn Margulis's concept of "individuality by incorporation."[51] Margulis's hypothesis is that symbiosis occurs at the level of the cell and is the basis for macroevolutionary change. Thus natural selection would have only a partial and subsidiary role in the explanation of how organisms evolve, and what Wilson calls the "key dramatic character" of the self may itself be a symbiotic coalition. When Stelarc writes about parasite visions, he is clearly using the word *parasite* for provocative effect, since much of his rhetoric is aimed at the prototypical forms of cultural paranoia. The body in these visions may be "invaded" and rendered "involuntary," but it is also a body linked to an extended life-support system. Its invaders are voluntarily admitted (indeed, their insertion calls for determination and consciously designed technique), and their incorporation offers reciprocal advantages to their host.

This is symbiosis, not parasitism, and even *host* may be the wrong word for the body's role. According to the *Oxford English Dictionary,* the word *parasite* derives from the Greek term παρασιτοσ, which means literally "one who eats at the table of another." There is surely a critical difference between one who eats at the table of another and one who is inserted into a feedback loop. Certainly parasitism occurs in the natural world. In the OED's definition, the term applies

to animals or plants that live as tenants of others, those that grow on others, and those that derive nutriment from others. A relationship of symbiosis may begin a parasitic connection, but once the interactive process of development is established, coevolutionary possibilities are opened up that may lead to radically new adaptive capabilities, just as Stelarc envisages. I am a skeptic about the potential for biotechnological coevolution. I am more interested in the cultural implications of Stelarc's provocations than in any bid to change the destiny of the species, which itself may be symptomatic of a commitment to the soon to be outmoded Darwinian paradigm. Margulis offers some provocations of her own in this regard: "Despite or perhaps because of Darwin, as a culture we still don't really understand the science of evolution. . . . My claim is that, like all other apes, humans are not the work of God but of thousands of millions of years of interaction amongst highly responsive microbes."[52] If this is the case, our technologies still have much more to learn from our "obsolete" bodies, and Stelarc may be one of those best qualified to assist this process.

Notes

1. Stelarc, interview with Jane Goodall, Sydney, 23 August 2000.

2. Samuel Butler, *Erewhon* (London: Penguin, 1985), 199. (Original work published in 1872)

3. Stelarc, 1983 interview reprinted in James D. Paffrath and Stelarc, eds., *Obsolete Body/Suspensions/Stelarc* (Davis, CA: JP, 1984), 17.

4. Butler, *Erewhon*, 205–206.

5. Butler, *Erewhon*, 199.

6. Butler, preface to the second edition of *Erewhon*, 30.

7. E.O. Wilson, *Sociobiology: The New Synthesis* (Cambridge, MA: Harvard University Press, 1975), 547; Ernst Mayr, *One Long Argument: Charles Darwin and the Genesis of Modern Evolutionary Thought* (London: Penguin, 1992), 164.

8. Stelarc, "The Myth of Information," in Paffrath and Stelarc, *Obsolete Body*, 24.

9. Anne Marsh, *Body and Self* (Melbourne: Oxford University Press, 1993), chap. 2.

10. "Event for Obsolete Body," in Paffrath and Stelarc, *Obsolete Body*, 61–62.

11. Stelarc, "Triggering an Evolutionary Dialectic," in Paffrath and Stelarc, *Obsolete Body*, 52.

12. Marshall McLuhan, *Understanding Media* (London: Routledge, 1964), 38.

13. Stelarc, "Triggering an Evolutionary Dialectic," 52.

14. The theory of saltations, or sudden leaps in evolutionary development, was first put forward in the 1930s and was given renewed currency by Stephen Jay Gould and Niles Eldredge in "Punctuated Equilibria: The Tempo and Mode of Evolution Reconsidered," *Paleobiology* 3: 115–151.

15. McLuhan, *Understanding Media,* 54.

16. Mayr, *One Long Argument,* 155.

17. Altruism has become a major topic of enquiry for evolutionary psychologists. Matt Ridley, *The Origins of Virtue: Human Instincts and the Evolution of Co-operation* (New York: Penguin, 1998).

18. McLuhan, *Understanding Media,* 3.

19. McLuhan, *Understanding Media,* 5.

20. McLuhan, *Understanding Media,* 58.

21. Stelarc, *Remote: Amplified Body, Laser Eyes and Third Hand,* La Mama, Melbourne, March 1990.

22. Stelarc, notes for *Graft/Replicate: Event for Virtual Arm and Third Hand,* The Great Australian Science Show, Melbourne, 15 July 1992.

23. Stelarc, notes on the *Psycho/Cyber: Event for Muscle and Machine Motion* performances, *Cantrill's Filmnotes* October 1993, 67.

24. Stelarc, notes on the *Psycho/Cyber* performances, 67.

25. Frederic Jameson, *Postmodernism, or The Cultural Logic of Late Capitalism* (London: Verso, 1991), 54.

26. Stelarc, notes on the *Psycho/Cyber* performances, 68.

27. Stelarc, "Parasite Visions," in Mike Featherstone, ed., *Body Modification* (London: Sage, 2000), 121, 123.

28. Stelarc, "Parasite Visions," 121.

29. Stelarc, program note for *Images Have No Organs: Absent Body/Involuntary Actions,* performance at La Mama, Melbourne, 4–5 August 1994.

30. Stelarc, "Parasite Visions," 122.

31. Edward O. Wilson, *Consilience: The Unity of Knowledge* (London: Abacus, 1998), 131.

32. Thomas Henry Huxley, quoted in William James, "The Automaton Theory," *Selected Writings* (London: Dent, 1995), 132.

33. Marshall McLuhan, *Counterblast* (London: Rapp and Whiting, 1970), 35.

34. Mark Dery, *Escape Velocity: Cyberculture at the End of the Century* (London: Hodder and Stoughton, 1996), 165.

35. Dery, *Escape Velocity,* 47.

36. Jane Goodall, "An Order of Pure Decision," *Body and Society* 5, nos. 2–3 (1999): 167.

37. William Gibson, *Neuromancer* (New York: Ace, 1984), 123.

38. Charles Darwin, *The Expression of the Emotions in Man and Animals,* ed. Paul Ekman (London: Harper Collins, 1998), 290–293.

39. Stelarc, "Parasite Visions," 122.

40. Accessed at <http://www.stelarc.va.com.au/index2.html>.

41. Stelarc, interview with Jane Goodall, August 2000.

42. Ghassan Hage, presentation to the *Borderpanic* symposium, Museum of Contemporary Art, Sydney, 22 September 2002. The argument is more fully developed in Hage's latest book, *Against Paranoid Nationalism* (Melbourne: Pluto, 2002).

43. Edward Scheer, "Stelarc's E-motions," in Joanna Zylinska, ed., *The Cyborg Experiments* (London: Continuum, 2002), 87.

44. William James, "The Feeling of Effort," *Essays in Psychology* (Cambridge, MA: Harvard University Press, 1983), 101, 83.

45. James, "The Feeling of Effort," 86.

46. James, "The Feeling of Effort," 111.

47. James, "The Feeling of Effort," 114–115.

48. James, "The Feeling of Effort," 116.

49. Descriptions based on conversations with Stelarc at the Macarthur Auditory Research Centre, University of Western Sydney, 16 September 2002.

50. Michael Taussig, *Mimesis and Alterity* (London: Routledge, 1993), 76–77.

51. Lynn Margulis, *The Symbiotic Planet* (London: Weidenfeld and Nicolson, 1998), chap. 3.

52. Margulis, The Symbiotic Planet, 4.

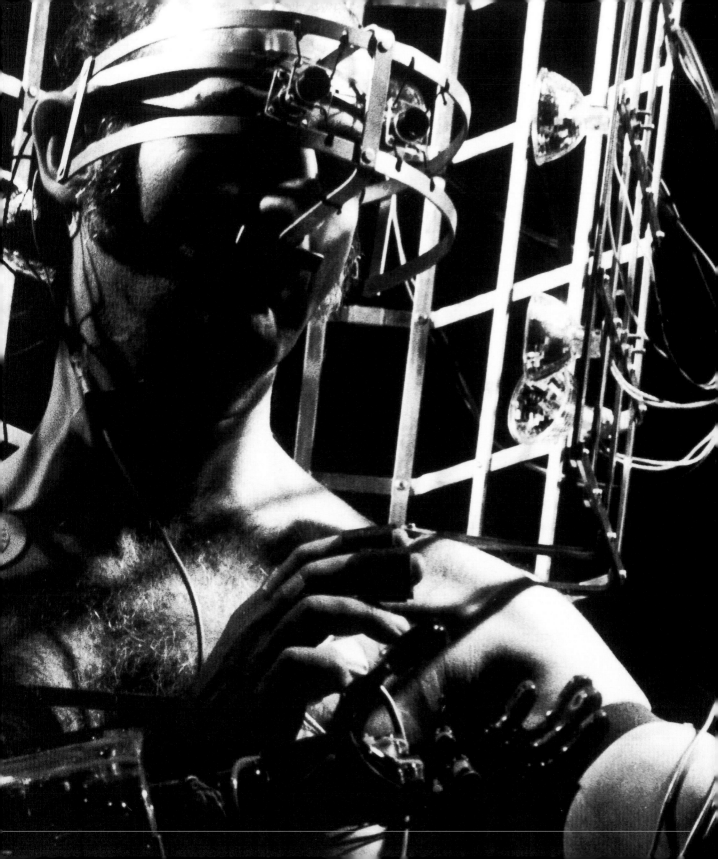

AN ITINERARY AND FIVE EXCURSIONS Timothy Druckrey

Yesterday's machine, today's and tomorrow's, are not related in their structural determinations: only by a process of historical analysis, by reference to a signifying chain extrinsic to the machine, by what we might call historical structuralism, can we gain any overall grasp of the effects of continuity, retro-action, and interlinking that it is capable of representing.
— *Felix Guattari*[1]

The recurring reciprocity between machines and life has its roots in any number of discourses and has led to assessments of artificialization, substitution, extension, replacement, virtualization, and integration. It is related, on the one hand, to mechanization (and its effects) and, on the other, to evolving ideologies (and aesthetics) and attempts to disintegrate the borders—break the line—between human agency and the systems in which it is inevitably embedded. It is with little irony that the proceedings of a recent media art festival—the 2003 Dutch Electronic Art Festival (DEAF 03)—in Rotterdam have been published in a book called *Information Is Alive: Art and Theory on Archiving and Retrieving Data,* whose title echoes the cry of the cinematic incarnation of Dr. Frankenstein: "It's alive!" The shift from the brute creation of life to the enlivening of information as surrogate "life" comes amid stunning debates concerning codes (genetic and otherwise), algorithms, networks, and representations that blur the once comfortable notion

that difference was presumed and that systems and humans were distinct forms. This state of alterity is increasingly obscured in the circuits of electronic culture.

This technologized "world as a picture" (as Martin Heidegger put it)[2] was a line of demarcation that threatened subjectivity with forms of mediated externalization that would sunder the essentialized authenticities of premodernity. Revolving around Heidegger's defensive retreat were sciences, media, and politics that mobilized technologies in ways that shattered representation (in science and art), sparked the culture industries, and revolutionized the public sphere. The reverberations of this convergence have led an extensive media sphere to continue to grapple with the "achievements" of a technomodernity that has found its shaky metaphors in biology and computation.

In this contested zone, Stelarc's work provokes stubborn questions about the adaptability—and autonomy—of the body within systems that often outperform human functions in precisions that expose both the vulnerabilities and promises of prosthetics (material and immaterial) to hot-wire alterity. In Stelarc's broad project, this short circuit will not switch effortlessly. Rather, it prompts reevaluations of many episodes in which the rubrics of so-called new media are emptied of their oversimplifications and the archeologies of media establish precedents and conflicts that are irreducible to linear development and that are episodic, botched, or lapsed.

More closely assessed in other chapters in this book, Stelarc's itinerary is not reducible as a mere consequence of electronic media but is one with many "lines of descent" and many implications:

In the history of mechanical contrivances, it is difficult to know how many of the automata of antiquity were constructed only in legend or by actual scientific artifice. Icarus's wings melt in the light of historical inquiry, as they were reputed to do in the myth; but was the flying automaton, attributed to a Chinese scientist of c. 380 BC actually in the air for three days, as related? (The same story is told of Archytas of Tarentum.) The mix of fact and fiction is a subject of critical importance for the history of science and technology; for our purposes, the aspirations of semi-mythical inventors can be as revealing as their actual embodiment.[3]

1

Mediating between "nature" and "culture," the machine's presence in the imagi-
nation has long led to speculations about its autonomy and sentience. By the time
of the Enlightenment, machines began to *acknowledge* rationality (for better or
worse) in performing feats (real and illusory) of reason (chess playing, flute play-
ing, writing) that seemed stunning in their effects. Joining technologies of me-
chanics with those of electricity or magnetism, these machines were enlivened
in forms that linked life to circuits driven by an understanding of the mutability
of energy.

Eighteenth-century research was accomplished in demonstrating that
electricity moved through circuits and, in a spectacular display, though bodies.
In 1746, Jean-Antoine Nollet linked some two hundred monks with lengths of
wire (reportedly over nearly a mile) to build a human circuit into which he dis-
charged a battery. The shocked network of charged bodies no doubt winced in
their currency. He later replicated this experiment with the shock of modernity
with 180 people for Louis XV. Soon, the work Benjamin Franklin, Luigi Galvini,
Allesandro Volta, Marie Ampere, and Hans Oersted demonstrated principles of
circuits, force, conduction, storage, and current. It is also no coincidence that
Julien Offray de la Mettrie's book *Man a Machine* (1748) or Jacques Vaucanson's
automata (most famously *The Flutist* and *The Duck* of 1738) emerged in a culture
in which, in the words of Siegfried Giedion, "the miraculous and the utilitarian
co-existed."[4]

Electrification was to become as much a driving force as it was to signify a
critical stage in the discovery of an animating principle that would revolutionize
medicine, physics, economics, and communication. Under a rubric of circuits,
vitalism could demonstrate (through Galvini's work) what Bruce Mazlish called
"the galvanic twitch" (the contraction of the muscles of frogs' legs turned into
electrical circuits), while Mary Shelley's *Frankenstein, or The Modern Prometheus*
(1818) "propagated the idea of the incontrovertibility of forces, linking the ani-
mate and the inanimate through galvinism, magnetism and electricity."[5] Under
the rubric of circuits, the development of the electric telegraph in the 1830s
would eventually hard-wire the links between communication and economics as
it systematized the eccentric (and already widespread) optical codes of torches,

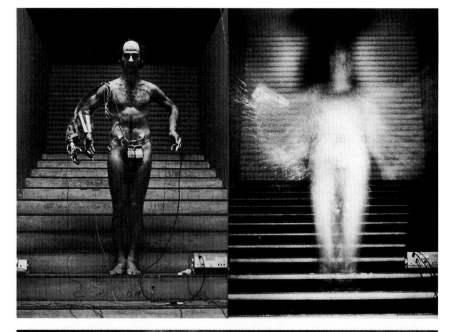

Event for Amplified Hands, Hosei University, 18–19 September 1982. Photo by Minoru Watanabe.

Curves: Event for Three Hands, Tamura Gallery, Tokyo, 28 December 1981. Photo by Shigeo Anzai.

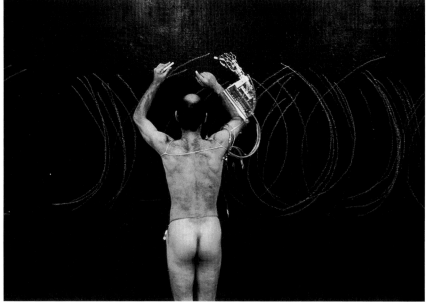

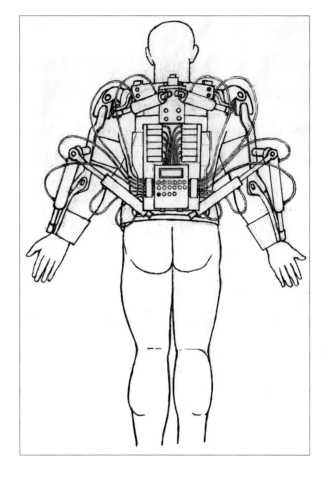

Motion Prosthesis, Melbourne, Hamburg, 2000. Drawing by Stelarc.

semaphore, and light into Samuel F. B. Morse's code and create "the Victorian Internet."[6] Under the rubric of circuits, internationalized train routes (and standards) would join "route and vehicle" (and link them with the telegraph networks for both efficiency and stable contact) in what Wolfgang Schivelbush calls the "future shock" of the nineteenth century. In this paradoxical mobility, as John Ruskin puts it, "These are human parcels who dispatch themselves to their destination by means of a railroad, arriving as they left, untouched by the space traversed."[7]

It is no surprise that Schivelbush's *Railway Journey* contains a parenthetic section (an "excursion") called "The History of Shock." And though the excursion is focused on the traumatic history of the concussions of militarism, its shock also, like that of the electrical jolt, propelled the transformation of space and time into an industrial modernity that was now to be electrified. This integrated system displaced hierarchies, "democratized" information, incorporated communication, regularized labor, destabilized locality, externalized imagination, and, in the end, potentialized experience in a way that radically altered memory, identity, and presence by temporalizations that were both fragmentary and urgent. Iwan Rhys Morus identifies the "cultures of electrical experiment" that multiplied throughout nineteenth-century England and that conceptualized electricity as both economically discursive and culturally disciplining.[8] As Friedrich Kittler writes, "The media revolution of 1880, however, laid the groundwork for theories and practices that no longer mistake information for spirit." In this, "so-called Man is split up into physiology and information technology."[9] Small wonder, then, that the subjects of *Gramophone, Film, Typewriter* (the title of Kittler's pivotal study) metaphorized a culture riveted by the recording and playback apparatuses of sound, sight, and writing. The machine, the code, the "annihilation" of distance, and unimagined mobility joined with the calculating machine, the animation of images, the networks of light, and the network of the telephone to create a vast network that could seemingly create life (and take it, as well) with the same energy source that triggered light, communicated across oceans, or encoded representation as signal.

This *electrical modernity*—soon to be a quantum modernity—shattered continuities and laid the foundation for a twentieth century whose relentless crises oscillated between technology and power, matter and quantification, representation and shock (the trope for the avant-garde), artificiality and materiality, the "imaginary" and the "real," the apparatus and the system.

2

Though quickly rooting itself in the creative practices of twentieth-century art, the mediaization of creativity has only slowly—if not grudgingly—begun to be assessed in a critical perspective. This "media archeology," though, is less an at-

tempt to resurrect "dead" technology than a reconsideration of the systemic reciprocity between the media (in the broadest sense of the term) and their effects. Rather than excavation, media archeology aims at reintegration. It looks at failed trajectories and disregarded (willfully or not) possibilities as it traces histories largely ignored by the Westernized narrative of dominant (or victorious) media industries that leads to the linear and progressive simplifications that one medium follows logically as the offspring of another.

Several exhibitions have attempted to assess and examine the development (and less the archeology) of the mechanizing effect: *The Luminous Image* (Stedelijk Museum, Amsterdam, 1984), Jean-François Lyotard's *Les Immatériaux* (Centre Georges Pompidou, Paris, 1985), *Video Skulptur* (Kunstverein, Cologne, 1989), and *Passage de l'image* (Centre Georges Pompidou, Paris, 1990). Two exhibitions, however, bear directly on the history of the relationship between apparatus and electricity.

Pontus Hultén's *The Machine, as Seen at the End of the Mechanical Age* (1968) is one of the first surveys that attempted to locate the transition points between technologies and art. It is at once a history and a requiem. The elegant metal-covered catalogue announces: "This exhibition is dedicated to the mechanical machine, the great creator and destroyer, at a difficult moment in its life when, for the first time, its reign is threatened by other tools."[10] It traces a history back to Leonardo da Vinci's sixteenth-century *Flying Apparatus,* Jacques Vaucanson's *Duck* (1738), Leon Harmon and Kenneth Knowlton's *Studies in Perception* 1 (1966), and Richard Frankel and Jeffrey Raskin's *Picture Frame* (1968). Hultén looks at the machine as a reverberating influence on art and draws a line from the Greeks through futurism, dadaism, kineticism, and constructivism to the introduction of the "other tool," the computer. The sober text sometimes evokes Charlie Chaplin's "speech" to the audience in *The Great Dictator* (1940) and ends with these remarks:

Perhaps what is most frightening is the notion that modern technology has an evolution of its own, which is uncontrollable and independent of human will. Many economists and technicians speak as though they were merely explaining inevitable processes— deterministic laws analogous to natural laws, which govern the development of technology. In their fatalistic view, products and consequences of technology and mass production simply do not grow by themselves, like a landscape. . . . To paraphrase what Tristan

Tzara once said about Dada: "No one can escape from the machine. Only the machine can enable you to escape from destiny."[11]

More specifically related to the bridging of historical and contemporary practices was the 1983 exhibition *Electra: Electricity and Electronics in the Art of the Twentieth Century* sponsored by Electricité de France to mark the centennial of the Society of Electrical and Electronic Engineers. The curator of this expansive—if problematic—investigation, Frank Popper, outlines an enormous project,

starting from iconographic allusions to electricity over the last hundred years . . . via the use of electricity for producing light and other effects accessible to the human senses and finally to computer-generated images.

However, this exhibition remained also a pretext and a privileged example to illustrate a more general problem: the relationship between art, science, and technology at the present time, which, coupled with the sociological questions it raises, is one of the main currents of contemporary art in opposition with, or rather complementary to, other topical tendencies in art, such as the widespread revival of painting.[12]

The exhibition was a collaborative effort between specialists (including Popper, Marie-Odile Briot, Edmond Couchot, Jean-Louis Bossier, Itsuho Sakane, and many others) and representatives of institutions (including the Institut de Recherche et Coordination Acoustique/Musique, the Center for Advanced Visual Studies, and Parc de la Villette). According to Popper, it attempted to take into account "different factors without imposing a definitive order, but rather suggesting a variety of itineraries."[13] Three aspects "of the artistic use of electricity" were outlined: its "iconographic use in painting, drawing, sculpture," its "'energetic' use as an independent artistic medium creating certain physical manifestations or effects, such as electrically produced artificial light or sound," and "finally, its incorporation in machines or other apparatuses serving as support for artistic communication, diffusion, modulation, and manipulation of information, such as photocopying machines, video electronic appliances, and digital computers."[14]

The exhibition appraised the three territories and included an astonishing range of works—Jean Tinguely, Wolf Vostell, Jean Dupuy, Bernhard Leitner, Alice

Aycock, Orlan, Sonia Sheridan, Roy Ascott, and many others. The essays in the catalogue reflect broadly on the history and possibilities. Marie-Odile Briot, in *Electra-Memories: Electricity at Large in Modernity,* writes "Into the word *modernity* we blithely place the myths of progress, of the avant-garde and their attendant deluded ideologies—revolution, the march of history."[15] Edmond Couchot remarks that "the image, and perhaps the whole of art, is no longer characterized by metaphor, but by metamorphosis."[16]

Emerging at the highpoint of the clash of modernisms in the 1980s, such sweeping surveys would inevitably be conflict zones. Popper's position is clear that "the exhibition attempted to go beyond this theme by trying to demonstrate that a scientifically based technology can help liberate an artist's creative powers as well as the public's faculties of appreciation and interactive involvement."[17] In "*Electra* Myths: Video, Modernism, Postmodernism," Katherine Dieckmann writes that "*Electra* charts a model of rational development"—a "serial presentation of 'just facts' . . . *Electra*'s bluntly utopian presentation is a disturbing document of our time—art historical and otherwise. . . . Its artworks are exempted from investigation into the nature of their mediums by the protective cloak of a scientific (rational, linear) perspective; with this isolation, *Electra* propagates a modernist progress without consequence."[18]

Yet for all its problems, the 1983 exhibition *Electra* acknowledged the reverberations that haunt the history of art in the twentieth century[19] and was a harbinger of the split between mainstream media and the experimental scene that was developing around it (Ars Electronica, for example, was formed in 1979).

In 1990, the Pompidou organized *Passages de l'image* (coordinated by Raymond Bellour, Catherine David, and Christine van Asche), an exhibition that traveled to Barcelona, Ohio, San Francisco. Broad and well conceptualized, the exhibition was proposed as "an attempt to delimit and reveal passages that occur today between photograph, cinema, video, and new images" in a form that revealed a "double tension" between "immobility and movement" and "between the analogical representation and what suspends, destroys, corrupts it."[20] With an extensive video program and a series of installations, the exhibition included Dennis Adams, Genevieve Cadieux, Gary Hill, Thierry Kuntzel, Chris Marker, Marcel Odenbach, Michael Snow, Bill Viola, Jeff Wall, Grahame Weinbren/ Roberta Friedman, and many others. Surely a reflection of a generational shift,

following pages:
The Third Hand, Tokyo, Nagoya, Yokohama, 1980. Photos by Simon Hunter.

The Third Hand, Tokyo, Nagoya, Yokohama, 1984. Photo by Toshifumi Ike.

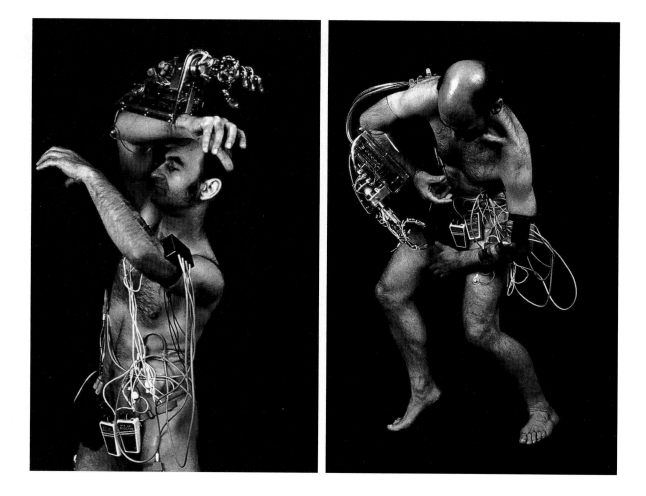

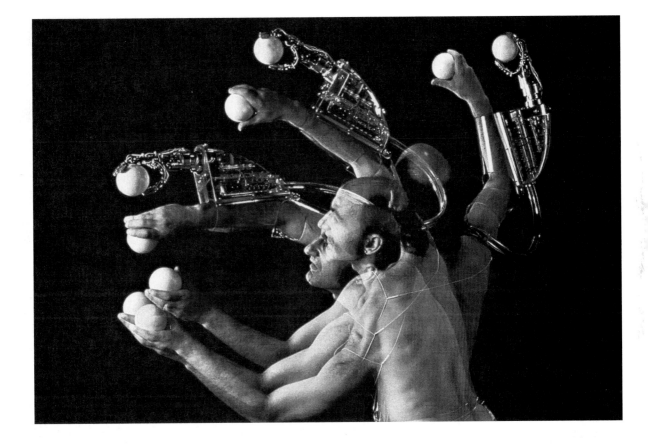

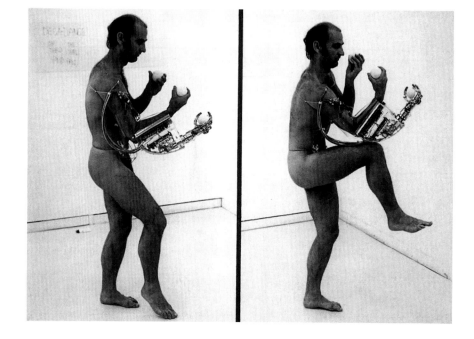

Passages de l'image drew on the work of artists in what the curators call "the point of no return in a crisis of the image."[21]

As significant as it was, however, the "crisis of the image" was not the only stage on which the media were to be conceptualized. Intelligence (artificial and otherwise), consciousness, computation, robots, automatons, cyborgs, androids, aliens, and replicants filled the popular imagination of science fiction in both written and cinematic genres. Frankenstein, the Golem, and Maria (in Fritz Lang's 1927 film *Metropolis*) now sat astride Karel Capek's R.U.R. (*Rossum's Universal Robots*) (1921), Isaac Asimov's *I, Robot* (1950), HAL (in Stanley Kubrick's 1968 film *2001*), the replicants of Ridley Scott's 1982 film *Blade Runner* (based on Philip K. Dick's 1968 novel *Do Androids Dream of Electric Sheep?*), Robocops, Terminators, and the dozens of variants that morphed the boundaries between humans and their hybrids. The puppet, robot, and automaton also fill a long history in the mainstream arts from Claude Cahun and Hans Bellmer, through dada and

surrealism, to Valie Export and Cindy Sherman,[22] a history being written within the feminist reconceptualization of the representation of women in the pages of *Afterimage, Discourse,* and particularly *Camera Obscura.*

This sketch is the background, therefore, to a conceptualization shift from electrified modernity to electronic postmodernity in which the simple circuit is supplanted by the integrated circuit.

3

This "solid state"—in which the electronic disciplines of robotics, neobiology, neurocognition, artificial life and intelligence, cyberdemocracy, nonlocated power, electronic economics, profiled authenticity, or pervasive surveillance predominate—cannot be sustained by the reinvention of simple dialectics or by the traditional discourses of sociology, psychoanalysis, or critical theory. Instead, the seemingly provisional and fast-changing sources of technoauthority—masked behind the metaphors of open systems, specialized protocols, and mystifications of cyberdemocracy and by a glaring lack of historical theorization—have developed a kind of nomadic expertise paradoxically legitimated by its very lack of centrality and by its intransigent allegiance to the principle of technical reason. Yet the less capitalized disciplines of cultural studies, psychoanalysis, and sociology have found stable positions in the now retrenched institutions of academia, marginalized journals, and Web logs and seem unprepared to confront social, cultural, and individual transformations that have exploded the borders between reflection and experience, identity and singularity, the body and its mechanization, and the public sphere and the pseudo-spheres of electronic collectivity.

Supplanted by notions of constant immediacy, mutable or schizoid selfhood, and the noospheric illusions or increasingly regressive "publics" of the cybersphere, the challenge to the social sciences is to confront extant and emerging changes. It also is challenged to abandon inert, rhetorical, and often essentialist observer-based models (whose effectiveness seems less and less relevant) and to seek adaptable systems in which the shifting terrains of politics (as they are circumscribed by technology industries), subjectivities (as they are extended by communications and neurological and cognitive technologies), embodiments (as they

are prostheticized), and "publics" (as the crumbling spheres of localized correspondence are despatialized into zones of contentious nationalism) emerge as signifiers of transformation in which instability itself is contingent and situational.

If issues of the shift from "nature" to a culture mediated and controlled by technology represent one facet of the response to "computer-produced progress," the issues of identity, embodiment, autonomy, and agency represent yet another. One significant aspect of the "simulation industry" examines these two issues in stark terms. Recently, the implantation of a nearly portable artificial heart, advanced research into carbon-silicon transmitters, and the implantation of computer-controlled pacemakers run parallel with a revived discourse of robotics. An inevitable systems mentality also emerged when the "completion" of the sequencing of the human genome led to presumptions about control mechanisms. In this system, mechanical prosthetics mutate into nano- or bioprosthetics that refunction many issues of a human-machine discourse whose history is embedded deeply in the social imaginary.

In a culture that Frederic Jameson once described as "triumphantly artificial," the contrast could not seem more contradictory. The assimilation of so-called artificial technologies into the body is more than a signifier of a triumph of informatics. It is a stage in the slow erosion of the border between the self and the systems put in place to regulate its operation. Already enveloped in a surveillance economy that interposes itself in a pervasive panoptical and logistical presence, the fragile economy of identity teeters between autonomy and integration. But the "mechanization of the world picture" (specifically as a form of representation distinctly related to human subjectivity) is transformed by the autonomization or detachment of systems (vision systems, genetic systems, cognitive systems, motor systems) as embodied agents and disembodied functions. Thus emerge forms of identification joined less with presence and more with markers (such as genetic "fingerprints" and retinal scanning) that establish authenticity as an aspect of the desubjectification of the self and the objectification of the body as code.

This strange circumstance is reflected in the escalating array of electronic appendages linking us to a paradoxically wireless "umbilical" interdependence with an omnipresent infosphere. In this sense, the absence of information itself seems suspicious, and the social staging of identity is bound to forms of legitimation linked less and less with embodied presence and more and more with

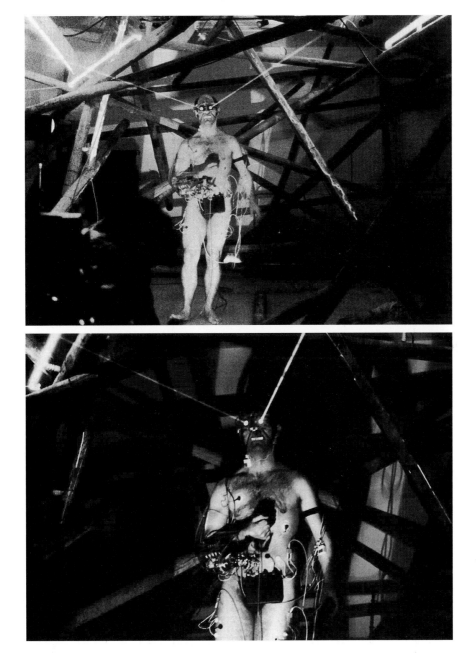

disembodied verification (and one in which the current criminal rage for "identity theft" emerges as a signifier of the status of incorporeal individuality). The image, the passport, the license, and even the fingerprint, long understood as legal forms of identification, have become obsolete and are being replaced with biometrics—technologies that pose identity as encoded in systems of measurement, in technologized forms of infoprofiling, in reductive and elaborate systems that demolish identity as anything more than the accumulation of data. As Donna Haraway writes, "Late twentieth-century machines have made thoroughly ambiguous the difference between natural and artificial, mind and body, self-developing and externally designed. . . . Our machines are disturbingly lively, and we ourselves frighteningly inert."[23]

N. Katherine Hayles's *How We Became Posthuman: Virtual Bodies in Cybernetics, Literature, and Informatics* opens with the following: "This book began with a roboticist's dream that struck me as a nightmare."[24] The dreamer, Hans P. Moravec, evangelized for sentient machines with stubborn zeal. Although Hayles focuses on Moravec's *Mind Children: The Future of Robot and Human Intelligence*

Elapsed Horizon/Enhanced Assumption: Event for Laser Cone, Light Structure, Image '90, Melbourne, 15 June, 1990. Photo by Anthony Figallo.

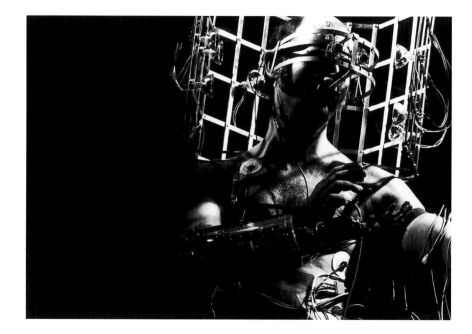

(1988), his final book, *Robot: Mere Machine to Transcendent Mind* (1988), leapt into the speculative pseudotheologies of machines with the kind of loopy logic that characterizes many of the dreamers of "collective intelligence," "technoetic aesthetics," or other artificial paradises. With extraordinary pertinence, Hayles's situates her argument:

Moravec proposed that human identity is essentially an informational pattern rather than an embodied enaction. The proposition can be stated, he suggested, by downloading human consciousness into a computer, and he imagined a scenario designed to show that this was in principle possible. The Moravec test, if I may call it that, is the logical successor to the Turing test. Whereas the Turing test was designed to show that machines can perform the thinking previously considered to be an exclusive capacity of the human mind, the Moravec test was designed to show that machines can become the repository of human consciousness—that machines can, for all practical purposes, become human beings. You are the cyborg, and the cyborg is you.[25]

Hayles's book, too long to fully summarize here, investigates informatics as an essential component of the reciprocity between technoscience and creativity and suggests that the narratives of science are not far from the fantasies of fiction as they speculate on future life, intelligence, virtuality, or the body. In the end, the illusions of artificial intelligence (AI) join the illusions of artificial life (AL): "By positioning AL as a second instance of life, researchers affect the definition of biological life as well, for now it is the juxtaposition that determines what counts as fundamental, not carbon-based forms themselves."[26] Crossing this line, however, does not imply that the "posthuman condition" is characterized by the inevitable loss of selfhood. Hayles continues:

When Moravec imagines "you" choosing to download yourself into a computer, thereby obtaining through technological mastery the ultimate privilege of immortality, he is not abandoning the autonomous liberal subject but expanding its prerogatives into the realm of the posthuman. Yet the posthuman need not be recuperated back into liberal humanism, nor need it be constructed as antihuman. Located within the dialectic of pattern / randomness and grounded in embodied actuality rather than disembodied information,

following pages:
Structure/Substance: Event for Laser Eyes and Third Arm, Ballarat Fine Art Gallery, Ballarat, Australia, 21 October 1990. Photos by Polixeni Papapetrou.

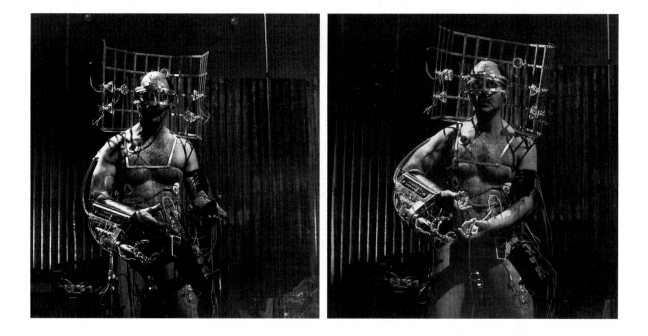

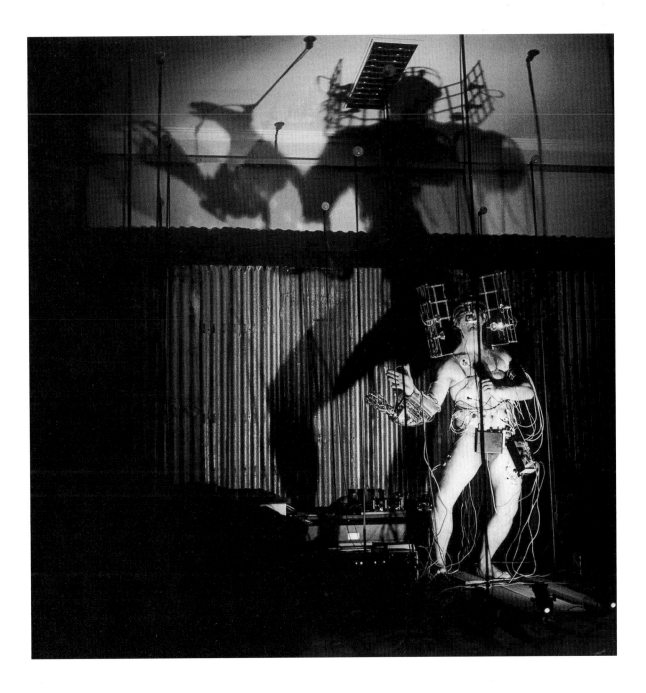

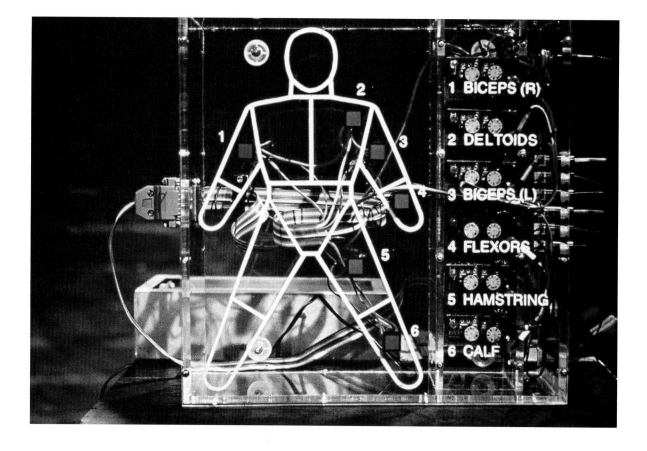

the posthuman offers resources for rethinking the articulation of humans with intelligent machines.[27]

If, as Donna Haraway, Sandra Harding, Evelyn Fox Keller, Carolyn Merchant, and other feminist critics of science have argued, there is a relation among the desire for mastery, an objectivist account of science, and the imperialist project of subduing nature, then the posthuman offers resources for the construction of another kind of account. In this account, emergence replaces teleology, reflexive epistemology replaces objectivism, distributed cognition replaces autonomous will, embodiment replaces a body seen as a support system for the mind, and a dynamic partnership between humans and intelligent machines replaces the liberal humanist subject's manifest destiny to dominate and control nature. . . . Just as the posthuman need not be antihuman, so it also need not be apocalyptic.[28]

4

So the automaton appears as a submachine which, depending on our fantasies and the logical way our reason works, connects up with the supermachine, often taking on its attributes, as if myth and technological utopia were conspiring in some osmosis of the "progressive image" and the "screen image. . . ." Sharing in the trickery of the automaton is merely another way to define ourselves as human, as both being and nothingness, presence and absence: the automaton is, in a way, our mirror . . . or our evil eye.[29]

A convenient reading of the "posthuman" as the substitution of the body by technology would miss the complexity of a phenomenon that breaches many disciplines and touches on identity not merely as a reflection but in intricate forms. Bruno Bettelheim's case history in childhood autism, "Joey," is a case in point. "If he did anything at all," Bettelheim writes, "he seemed to function by remote control—a 'mechanical man' run by machines that were both created by him and beyond his control."[30] He built a "breathing machine," a "car-machine," and a "breathing apparatus." He had a "carburetor," "transistors," "exhaust pipes," and electricity, since "he had to plug himself in."[31]

Muscle Stimulation System, Empire Ridge, Melbourne, 1995. Photo by Anthony Figallo.

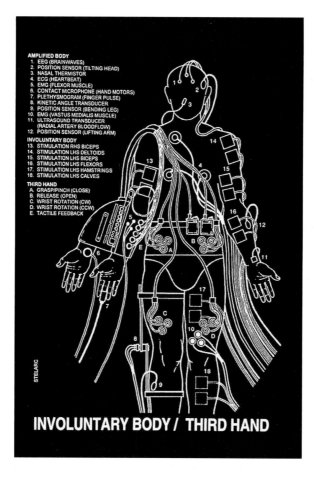

In the essay "Delusional Circuitry," Hilary Strang reflects on this in ways that evoke Hayles's reading of "liberal humanism" and the posthuman condition:

Joey the mechanical boy is legible as a site in which a particular rational humanist project of representation is temporarily broken down, and construction of the productive body is momentarily frustrated. Bettelheim describes Joey's story as "a cautionary tale" (Bettelheim, 234), explicitly setting this narrative apart from the "case history." A "complete catalogue of [Joey's] symptoms," the relied on format for documenting therapy,

"would fall short of the true picture," and Bettelheim notes that his ability to represent this case fell apart in other ways as well: "Maybe a measure of our awe, and our rejection of the uncanny, shows up in our failure to take pictures of the most elaborate devices Joey created for running his body and mind. Only after this phase was in decline did we have sense enough to photograph them. Unfortunately they show the machinery that ran him at night in the very reduced form it had taken after a year and a half at the School" (Bettelheim, 236). The confusion between human and machine that seems to block representation also threatens the ability of capitalism to construct subjects as productive bodies, a process which Deleule says relies on a maintained hierarchy of functioning, on "the juridical separation between the body/machine" (Deleule, 207).

At the same time it is possible to read Joey the mechanical boy as a matter of (a particular) course, as "exactly what you would expect" from late industrial capitalism. Not only because, as Canguilhem and Deleule argue, the machinic and the human are historically inseparable because "machines can be considered as organs of the human species" (Canguilhem, 55), but because "what else" could a flow of signs that includes Taylorism, Popular Mechanics, *Turing machines, the space program, World War Two, the atom bomb, stream-lined kitchens, produce but a boy who is a machine?*

As Canguilhem argues, "the theory of the animal-machine is inseparable from 'I think, therefore I am'" (Canguilhem, 52), inseparable from the project of Enlightenment rationality. As Bettelheim argues, "the typical modern delusion is of being run by an influencing machine. . . . Just as the angels and saints of a deeply religious age help us to fathom what were man's greatest hopes at that time and the devils what he trembled at most, so man's delusions in a machine world seem to be tokens of both our hopes and our fears of what machines may do for us, or to us" (Bettelheim, 234). The animal-machine, human-machine is "uncanny" and poses a threat to "cataloguing," to the rational project. Why do the logic of heart as pump and the threat of legs as extensors exist simultaneously? Note that this is not a matter of examining some brave new world, but (as both Canguilhem and Bettelheim point out) a question thoroughly imbricated in European-American modernity.[32]

To think merely of the pathological effect the machine, however, cannot unravel either its intricate relationship with modern life or expose its historical meaning. An example is Keith Piper's installation *The Automaton's Bloodline* (2001). The work "dissects" the robot, the android, and the cyborg without resorting to the

tropes of mechanization that trace the mere evolution of the technologies that substitute increasingly sophisticated surrogates into the service economy. It reminds us that the evolution of our machines themselves embodies discourses of class, race, history, oppression, and identities not so easily hidden in their insidious resemblance to their makers.

Not surprisingly, Piper's interests have turned toward the cyborg, which he describes as "a hybrid figure, physically an amalgamation of the mechanical 'other' with organic human 'norm,' but often also imaged as torn between the conflicting agenda's embodied with the norm/other dichotomy."[33] The cyborg, indeed, has played a significant role in the popular imagination of mass culture and in a kind of confrontation with embodiment that mobilizes technology. This is outlined in Donna Haraway's prescient "Cyborg Manifesto," where "the cyborg is a condensed image of both imagination and material reality. . . . The cyborg has no origin story in the Western sense—a 'final' irony since the cyborg is also the awful apocalyptic telos of the 'West's' escalating dominations of abstract individuation," emerges as "the illegitimate offspring of militarism and patriarchical capitalism," and "is not subject to Foucault's biopolitics." Instead, "the cyborg simulates politics, a much more potent field of operations."[34]

But Piper's investigation of the robot, the automaton, and the cyborg also involves historical readings that problematize the Deleuze and Guattari suggestions about "machinic agency." It looks beyond the androids of *Metropolis* or *Alien,* the robots of *Forbidden Planet* or *Star Wars,* and the replicants of *Blade Runner* at another aspect missed in often ironic social assessments of pop culture—race. The cogent example in *The Automaton's Bloodline* is the National Aeronautics and Space Administration's decision to name the Mars robotic rover vehicle *Sojourner Truth.* Here Piper parallels "the Robot as a unit of labor, visually distinct and 'other,' consigned to labor, in the case of the Mars rover, mining a harsh alien landscape in response to remote commands until its power cells are exhausted, to the body of an enslaved African. . . . [The robot] becomes not only a cipher for an exploited economic class, but also a class who are fundamentally distinct from the dominant group."[35]

More feeble versions of artificial sentience have emerged in mainstream cinema. Just think of Steven Spielberg's abysmal, oedipal version of the Turing test in the Hollywood film of whatever Stanley Kubrick had in mind for *A.I.:*

Artificial Intelligence (2001). Little David, the affably inane (that's "A.I.") cross between ET and HAL, ends up in the automaton emergency room after ingesting some decisively "imprecise" spinach while learning that humans suffer from "cybling" rivalries. Cyborgs, after all, can be programmed to express artificial love but can't eat. Nevertheless, the proponents of AI and cyborg sentience celebrate little David's endearing persistence to bond with a theme-park Madonna sunken, for just a few short frozen millennia, in what was once Coney Island. We haven't gotten very far if the best that this little circuit-board kid can do is pine for a virtual version of mommy. David's problem is that he cannot age, that he has always been frozen in time and unable to do more than fulfill the maudlin fantasies of his creators with aimless repetition. As Norbert Bolz writes:

The important thing for artificial intelligence is to risk moving from the chessboard to the football pitch—that is, from semiosis to the interplay of perception and understanding. The simulation of coordination which does not require communication of freely

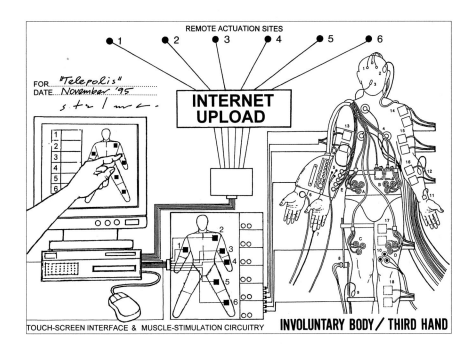

Fractal Flesh, An Internet Body Upload Performance, Telepolis, Luxembourg, 10, 11 November, 1995. Diagram by Stelarc.

movable bodies is an infinitely more complicated task than computing possible positions on a chess board. For this reason people often speak nowadays of postalgorithmic computers, even of "organic computing." Whatever might be meant by this specifically, it is intended to mark the connectionist transition from the artificial intelligence of the Turing machine to artificial life.[36]

5

Research done over the past two centuries resolutely establishes that the links between flesh and machines no longer function merely as utilitarian prosthetic devices but form integral communication systems through which messages can be exchanged. The history of this "interface" has slowly fixed itself as a central issue in the way that the body and the systems ideology (that increasingly envelops it) have been steered into presumptions of a smooth incorporation into electronic culture amid fantasies of ascendancy and tropes of transcendence.

At the turn of the millennium, *Wired* magazine featured Bill Joy's "Why the Future Doesn't Need Us"[37]—a lament for the speculative assumptions of zealous and vague futurists such as Raymond Kurzweil and Hans Moravec and a realization that technologies emerge with very real consequences (as if this were in any way a new insight). The text provoked much debate concerning the establishment of a nearly autonomous technical sphere engaged in a kind of Faustian bargain—what Lewis Mumford calls the "magnificent bribe"—with the triumph of technology "out of control" (a term found in the titles of Kevin Kelly's *Out of Control: The Rise of Neo-Biological Civilization* and Langdon Winner's invaluable *Autonomous Technology: Technics-out-of-Control as a Theme in Political Thought*).[38] One of Joy's many resolutions: "The only realistic alternative I see is relinquishment: to limit development of the technologies that are too dangerous, by limiting our pursuit of certain kinds of knowledge."[39] "Relinquishment" is a form of refusal even while the trajectory of the technosciences is accelerating toward autonomy, superalgorithms, and systems that act outside the frail and subjective valuations of human agency.

In this system, the implications of Stelarc's radically materialist interventions into the boundaries of the body emerge as decisive confrontations. Rather than conceptualize the body as an effect of computer modeling (as in the works

of the last decade), Stelarc renders the human-machine interface as a site of con-trolled conflict, trauma, shock—in short, a kind of circuit in which the "galvinic twitch" loses its metaphysical aura and instead is materialized as a control mech-anism rather than the "spark of life." In Stelarc's work, the interface is a kind of negative "diaelectric" (*realized* through electrodes, transducers, muscle stimula-tors, amplifiers, forced-feedback systems, and extra limbs) that probe the ten-sion—perhaps resistance—between the human and machine. We must distinguish it from the nearly homoerotic weaponry in the Survival Research Laboratories' performances, from the faux embodiment of machine vision in Steve Mann's work, from the pathetic prosthetic surgeries of Orlan, from the rit-ualized actions of David Therrien.

Instead of "relinquishment," Stelarc prods the "dangerous knowledge" that information is somehow neutral by empowering systems (and participants) to wield power and regulate actions in which command, control, and communica-tion lose innocence and implicate agency in actions that are neither painless nor devoid of real-world consequences. A provocateur of the circuit, Stelarc gener-ates a "future shock" that is implicit in every action in electronic culture. As Regis Debray writes, "no more than there is any innocent medium can there be any painless transmission."[40]

Notes

1. Felix Guattari, *Molecular Revolution: Psychiatry and Politics,* trans. Rosemary Sheed (New York: Penguin, 1984), 112.

2. Martin Heidegger, *The Question regarding Technology and Other Essays,* trans. William Lovett (New York: Harper and Row, 1977), 134.

3. Bruce Mazlish, "Constructions of the Mind: The Man-Machine and Arti-ficial Intelligence," *Stanford Electronic Humanities Review* 4, no. 2 (1995): unpaginated.

4. Siegfried Giedion, *Mechanization Takes Command* (New York: Norton, 1948), 34.

5. Bruce Mazlish, *The Fourth Discontinuity: The Co-Evolution of Humans and Machines* (New Haven: Yale University Press, 1993), 40.

6. Tom Standage, *The Victorian Internet* (New York: Walker, 1998).

7. Wolfgang Schivelbush, *The Railway Journey* (New York: Urizen Books, 1977), 45.

8. Iwan Rhys Morus, *Frankenstein's Children: Electricity, Exhibition, and Experiment in Early Nineteenth-Century London* (Princeton: Princeton University Press, 1998), 13. Also see the book's coda, "The Disciplining of Experimental Life."

9. Friedrich Kittler, *Gramophone, Film, Typewriter* (Stanford: Stanford University Press, 1999), 16.

10. Pontus Hultén, *The Machine, as Seen at the End of the Mechanical Age* (New York: Museum of Modern Art, 1968), 6.

11. Hultén, *The Machine,* 13.

12. Frank Popper, *Electra: Electricity and Electronics in the Art of the Twentieth Century* (Paris: Musée d'Art Moderne de la Ville de Paris, 1983), 24.

13. Popper, *Electra,* 24.

14. Popper, *Electra,* 25.

15. Marie-Odile Briot, *Electra-Memories: Electricity at Large in Modernity,* in Popper, *Electra,* 259.

16. In Popper, *Electra,* 243.

17. Frank Popper, editorial in Twentieth Anniversary Issue: Art of the Future—The Future of Art, *Leonardo* 20, no. 4 (1987): 301.

18. Katherine Dieckmann, "Electra Myths: Video, Modernism, Postmodernism," *Art Journal* (special issue on Video: The Reflexive Medium, ed. Sara Hornbacher), 45 (Fall 1985): 196, 202.

19. A fuller treatment of the history of media exhibitions appears in my "Points of Origin," published as the introduction to *Produced@zkm* (forthcoming).

20. Raymond Bellour, Catherine David, and Christine van Asche, eds., *Passages de l'image* (Paris: Centre Pompidou, 1990), 14.

21. Bellour, David, and van Asche, *Passages de l'image,* 12.

22. See Pia Müeller-Tamm and Katharina Sykora, *Puppen, Körper, Automaten: Phantasmen der Moderne* (Düsseldorf: Oktagon, Kunstsammlung Nordrhein-Westfalen, 1999); Silvis Eiblmayr, Dirk Snauwaert, Ulrich Wilmes, and Matthias Winzen, eds., *Die verletzte Diva: Hysterie, Körper, Technik in der Kunst des 20. Jahrhunderts* (Munich: Oktagon, 2000); Gill Kirkup, Linda Janes, Kathryn Woodward, and Fiona Hovenden, eds., *The Gendered Cyborg: A Reader* (New York: Routledge, 2000).

23. Donna Haraway, *Simians, Cyborgs, and Women* (New York, Routledge, 1991), 152.

24. N. Katherine Hayles, *How We Become Posthuman: Virtual Bodies in Cybernetics, Literature, and Informatics* (Chicago: University of Chicago Press, 1999), 1.

25. Hayles, *How We Became Posthuman,* xii.

26. Hayles, *How We Became Posthuman,* 235.

27. Hayles, *How We Became Posthuman,* 287.

28. Hayles, *How We Became Posthuman,* 288.

29. Jean Claude Beaune: "The Classical Age of the Automata," in Michel Feher, ed., *Fragments for a History of the Human Body* (pt. 1) (New York: Zone, 1989), 434, 437.

30. Bruno Bettelheim, "Joey," *The Empty Fortress: Infantile Autism and the Birth of the Self* (New York: Free Press, 1967), 234.

31. Bettelheim, "Joey," 236.

32. Hilary Strang, "Delusional Circuitry," at <http://eserver.org/cultronix/Hilary/default.html>. The references to Bettelheim's "Joey" are left here. The other references are to Didier Deleule, "The Living Machine: Psychology as Organology," and Georges Canguilhem, "Machine and Organism," in Jonathan Crary and Sanford Kwinter, eds., *Incorporations (Zone 6)* (Cambridge, MA: MIT Press, 1992).

33. Keith Piper, lecture (November 12, 2002) in conjunction with the exhibition "Bits and Pieces: Shifting Boundaries and Different Readings." Curated by Timothy Druckrey, Josesott Gallery, Hartford, Connecticut.

34. Donna Haraway, *Simians, Cyborgs, and Women* (New York: Routledge, 1991), 150–152.

35. Keith Piper, lecture (November 12, 2002).

36. Norbert Bolz, "Brother Robot," in Susanne Anna, Jorge Pardo, and Pae White, eds., *Ex Machina: Eine Geschichte des Robotens von 1950 bis heute (Ex Machina: A History of Robots from 1950 to the Present Day)* (Cologne: Hatje Cantz and Museum für Angewandte Kunst, 2002), 76.

37. Bill Joy, "Why the Future Doesn't Need Us," *Wired,* April 2000, at <http://www.wired.com/wired/archive/8.04/joy.html> unpaginated.

38. Kevin Kelly, *Out of Control: The Rise of Neo-Biological Civilization* (London: Perseus, 1994); Langdon Winner, *Autonomous Technology: Technics-out-of-Control as a Theme in Political Thought* (Cambridge, MA: MIT Press, 1977).

39. Joy, "Why the Future Doesn't Need Us."

40. Regis Debray, *Media Manifestos* (New York: Verso, 1996), 46.

WE ARE ALL STELARCS NOW

Arthur and
Marilouise Kroker

We are all Stelarcs now.

We are laser eyes
and chip brains
cell ears
and third-hand communicators
wireless ghosts
and data-dump philosophers

In a dramatic instance of art as a precession of reality, we are living in a world whose main scientific and technological features have been accurately forecast and artistically performed by Stelarc.

Stelarc futures our body.

In a case of acute body lag, our cultural consciousness of the significance of the twin spearheads of technology—digitality and biogenetics—lags far behind the actual and future modifications of the body in the culture of biotechnology. Like it or not, we have collectively already climbed out of the mechanical images of the body of the modern era into the genetically modified bodies of the present and future. Stelarc's performance of the genetically modified body is like a talisman guiding us to the consciousness of the body as a gene machine. We already reside within the architecture of Stelarc's artistic vision.

He erases and Enhances
Implants and Repositions
Designs and Activates our Future

Think of his key concepts:

Information is radiation
The body is obsolete
The accelerating speed of technology
Slams into the inertia of flesh.
Cyber-systems spawn
alternate, hybrid and surrogate bodies.
The cortex that cannot cope resorts to specialization.
Physical bodies have organs.
Phantom bodies are hollow.
The Body now performs best as its image.

Stelarc pierces our minds
And triggers our bodies
To think against time,
Against space,
Against our species–being

He performs the postbiological body in advance. Think of his key multimedia performances. An Australian performance artist, in his own terms Stelarc "has used medical instruments, prosthetics, robotics, Virtual Reality systems, and the Internet to explore alternate, intimate, and involuntary interfaces with the body. He has performed with a *Third Hand,* a *Virtual Arm,* a *Virtual Body,* and a *Stomach Sculpture.*"[1]

Fractal Flesh and *Stimbod* and *Parasite* and *Ping Body* and *Extra Ear* and *Exoskeleton:* Stelarc is the artist par excellence of cyborgs, zombies, and parasite flesh—an artist of the emerging reign of postbiologics.

Liquid body
Circuit body

Transformed body
The body as image
The body as memory
The body as disappearance
The body as perfection
The Postbiological Body

Performing Technology

When the history of the twenty-first century is written, the name Stelarc will light the intellectual horizon as one of the few artists whose aesthetic creations were imprinted under the sign of postbiologics. Present at the historical juncture in which the body, responding to the stress of technological change, suddenly doubled itself in the form of a split physiology (one part the local physiology of an earth-bound body and the other part the networked physiology of an electronically mediated body), Stelarc will be spoken of as a courageous prober of the future and a relentless debunker of past illusions. With Stelarc, the framework understanding the body suddenly undergoes an Einsteinian shift. The future cartography of the contemporary century is Stelarc's body, the postbiological body—streamed by data flows, probed by digital telemetry harvested by anonymous databases, shaped into an object of "extruded awareness" that flares outward into galaxies of information, made a subject of technological "displacement" that is both dominated and emancipated by its disappearance into images. With Stelarc, relativity theory becomes flesh because in *thinking* Stelarc we suspect that the future of technology that he performs is more than an experimental artistic rendering of the cultural impact of information technology: it also is a brilliantly obsessive modeling of the future that is cut to the aesthetic specifications of his own autobiography. Curiously, Stelarc may be the first artist whose aesthetic "performances" of technology actually trigger a radical metamorphosis of the digital stars. In that future history, the first new galaxy sighted—dimly at first but then ever more clearly as it separates from the light-bound debris of the twentieth century—might well bear the name Stelarc. He is an electronic artist whose technological imagination became the model of reality that he thought he was only simulating.

Liquid Stelarc

Muscle Machine, **Digital Research Lab/Engineering Department, The Nottingham Trent University. CAD drawings by John Grimes.**

What is the future of Stelarc? At what point in the contemporary condition of technological stress will the discourse of the body shatter into a debris field of discarded code, finally abandoned by postbiologics as the last illusion of the unhappy (digital) consciousness? Because we live at the gateway between fading conceptions of the modernist body and the wired reality of processed flesh, we are necessarily inhabited by split consciousness. Like Stelarc himself, we use the body to react against the body: the left side of the postbiologic brain is completely alert to invading electronic aliens; the right side of the brain operates on full-repression sequencer. Living in cloner culture with future transgenics on our (cinematic) minds, we think the future body in terms of "muscle stimulators," "third ears," and Pentium-chip nerve implants. Everything finally returns to the body as a screen—a site of radical experimentation, a trompe l'oeil for obscuring from intellectual consciousness the fading away of the body itself in the biogenetic vortex. Perhaps we should ask the next question: "Why do we need a body at all?"

Not so with Stelarc. Because he is a performance artist whose understanding of technology is always presented with an attentive (laser) eye to the gathering electronic crowd, Stelarc's art is often displaced into the safety of futurist rhetoric. But what is most futurist about Stelarc is that his artistic imagination is a relentless, critical dissection of present regimes of bodily understanding. In the literal sense, we are living within the architecture of Stelarc's "outered" mind: the "absent bodies" of networked communication, the "phantom bodies" of the image simulacrum, the "hollowed out" bodies of global capitalism. Ours is the age of liquid Stelarc.

So in a future that is electronically mediated and in which we live with a split physiology, why do we need the comforting mask of bodily referents? Why the continuing alibi of the misplaced body? Why a technological economy of gigantic mechanical technologies, muscle stimulators, and third ears? Does Stelarc's preoccupation with the body represent survivalist nostalgia for the past—a better design for eugenically perfected living for the future—or something entirely different?

Does Stelarc's hesitancy between bodies immersed in mechanical giganticism and bodies wired and increasingly invisible represent perhaps the first sighting of the liquid body? Do Stelarc's preferences for the wired over the

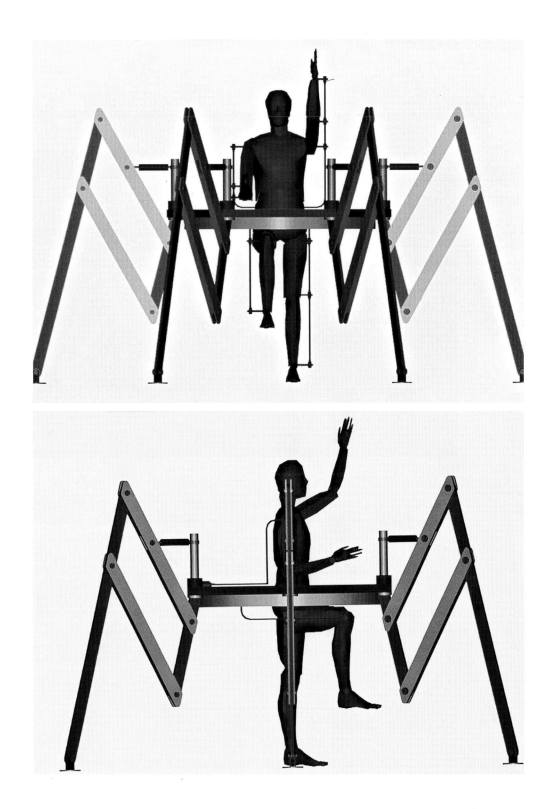

Hexapod, Nottingham Trent University/Sussex University, 2002. Image by Steve Middleton.

facing page:
Muscle Machine, Digital Research Unit/Engineering Department, The Nottingham Trent University. Images by Steve Middleton.

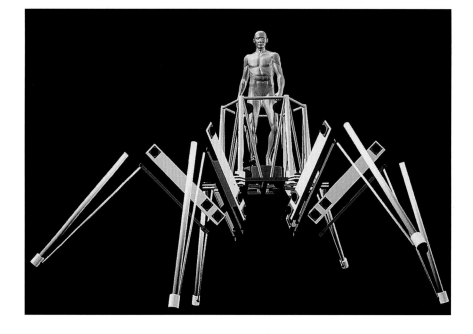

biotechnological, for giganticism over invisibility, for "extruded awareness" over imploded consciousness represent the necessary repression to deliver us to the future of the liquid body? And if this is so, then in finally overcoming Stelarc—in wearing the mask of Stelarc's performance body as a ritualistic gesture—are we also undertaking a final transition to the coming reality of the liquid body?

The liquid body? Cohabited by electronic space. A multiplicity of selves. Always online, never really shutting down. A game culture for a mind and a dual-track chip for a heartbeat. Its history is a database. Its future is an image. The liquid body is a creator and a predator.

Floating Bodies, Folded Skin, and the *Prosthetic Head*

The Prosthetic Head *will be both a Web avatar and a gallery installation. Imagine entering a room with a three- to four-meter-high head that will be blinking, moving its head, and making different expressions. When interrogated, the head will respond. The*

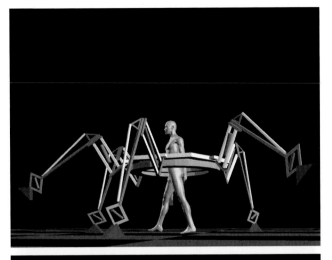

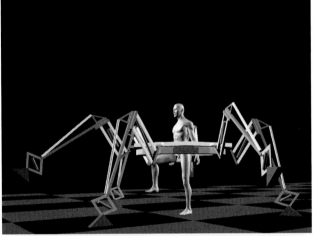

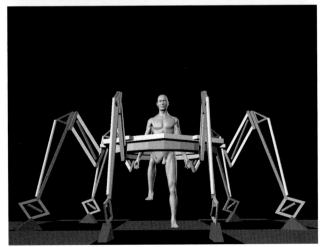

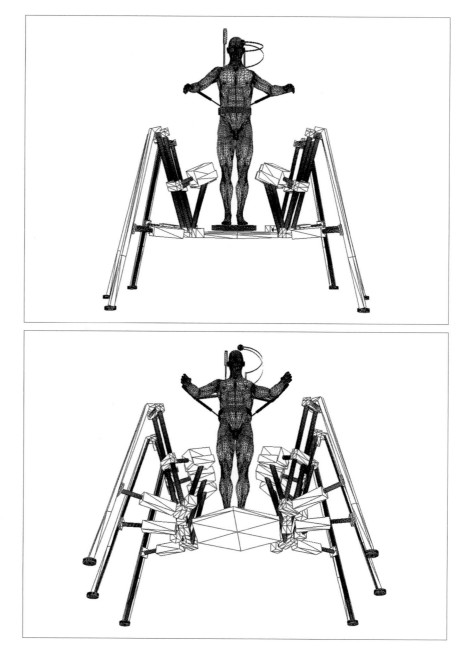

Exoskeleton, Hamburg,
1998. Wireframe models
by Steve Middleton.

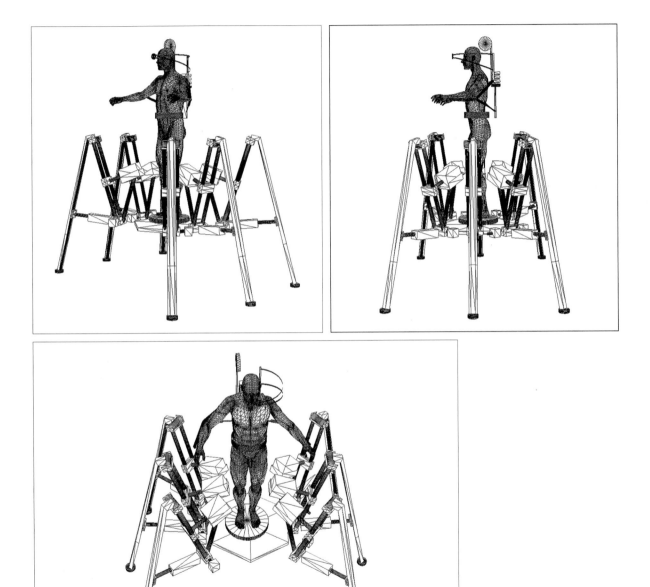

next layer of architecture would be to give the head a vision system that would detect both a user's presence in the room and perhaps also the color of their clothing. The Prosthetic Head *would then initiate a conversation acknowledging the user and the color of their clothing. There are also vision systems now that are capable of analyzing facial expressions. The* Prosthetic Head *could then make an appropriate comment like "Don't be too perplexed; ask me a question" or "Are you sure you want to be here?" or even perhaps "Take that smirk off your face."*

I see this project exposing the inadequacies of commonsense notions of awareness, identity, and embodiment. For an embodied conversational agent like the Prosthetic Head, *these are performative constructs rather than internalized essences.*[2]

The *Prosthetic Head* (2003), Stelarc's most recent art project, is the first electronic sighting of the liquid body. Beyond cyborgs and aliens, automatons and artificial-intelligence constructs, the *Prosthetic Head* prototypes conversations of the future between humans and computers. It's hypercryogenics for posthuman culture.

Everything of the gravity-bound Stelarc is there:

> The signature laugh
> Full facial features
> A conversational repertoire of precoded responses
> Software support for emergent learning
> An audience participation platform of stimulus-response
> Eyeball, teeth, and tongue objects
> Head mesh with a variable polygonal resolution
> Seamless unwrapped skin for the head

The result is a *Prosthetic Head* that is "cloned, stretched, and painted," skin-textured, and texture-mapped—for clear-eyed thought and fluid conversations in a disjointed alien world.

But what happens when the liquid body disappears into the prosthetic head? Is future talk only about eye blinks, facial recognition, vision systems, rendered skin, and texture-mapping? What is the *Prosthetic Head?*

If Stelarc can now focus so brilliantly on the design of the *Prosthetic Head,* it is because he is the artist par excellence of prosthetic culture. For Stelarc, the

body has always been prosthetic—a site of radical experimentalism that in his art has been objectified, excavated, penetrated, virtualized, roboticized, emptied out, alienated, and suspended with such ferocity that the purely prosthetic quality of the body has been forced to surface.

The metaphysician of fully accomplished technology, Stelarc creates art that has an enigmatic quality of seduction. In his artistic vision, we witness the gamble of technology prophesied by Martin Heidegger. A functionalist who is determined to flush out nostalgia from the modernist rhetoric of "embodied" identity, consciousness, and the self, Stelarc is also seduced by the postmodern dream of breaking boundaries, disrupted surfaces, and floating consciousness. He can brilliantly conceptualize the *Prosthetic Head* because he has always lived in relationship to his own flesh as a prosthetic body. Here the body is a deliberately alienated object of experimentalism that is framed by an artificial rhetoric of perfect functionality. Here there is no mystery of life, no intimacy with the facticity of death, no vicissitudes of the flesh: the body floats as a perfect object of technology with the *Prosthetic Head* as its blinking satellite and folded skin as its fast-burn shield.

Or is it the opposite? Is the *Prosthetic Head* not the technological remainder of the evacuated body but the beginning of embodied technology? As an artificial creation of fractal dreams—yearning to be liberated from its operational codes, dreaming of wrinkled skin, soothed by the eternal cycle of life and death, rebellious against error-ridden behavior, recalcitrant rather than communicative, bored not functional, always alert to the fractured lines of broken conversations— the *Prosthetic Head* may initiate the fatal humanization of our three-dimensional modeled future. In this case, quite against the intentions of its gravity-bound interlocutors, the *Prosthetic Head* represents perhaps the return of identity, consciousness, and the self as the "internalized essence" of technology. The fleshly needs of the body, then, are imbued in the *Prosthetic Head*. An end and a beginning, the *Prosthetic Head* is also seduced by the mystery of the body that it thought it had long left behind.

And why not? Technology is always double-edged, and Stelarc is the leading exponent of prosthetic consciousness in the twenty-first century. This is why the *Prosthetic Head* can be so enigmatic and seductive—enigmatic because it prototypes the communicative order of a prosthetic future in which humans will

CGIs for *Prosthetic Head*,
January 2003, by Barrett Fox.

CGIs for *Prosthetic Head,*
January 2003, by Barrett Fox.

CGIs for *Prosthetic Head*,
January 2003, by Barrett Fox.

begin to shed received notions of identity, consciousness, and the self as "internalized essences" and seductive because the *Prosthetic Head* (like prosthetic culture before it) fascinates and charms with the hint of disappearance that its ghostly presence evokes and that its blinks, nods, facial recognition, skin texturing, and design mapping work feverishly to repress. A future of "seamless unwrapped skin for the head" is the true seduction of the *Prosthetic Head*. Bringing into presence the doubled fate of technology as both creation and objectification is the true seduction of the prosthetic art of Stelarc.

Stelarc Scans

Scanning Stelarc?

What if Stelarc's artistic performance practice were reversed? No longer is Stelarc the artistic probe of technology's impact on the body, but technology (in the form of the following three stories—"Tattooed Sound," "Image Flesh," "Matrix Machine") performs Stelarc. In this case, Stelarc's imaginary bodies ("Redesigning the Body," "Phantom Body," "High-Fidelity Illusion") would be torqued by the technological imagination itself—not technology under the sign of art but wired culture as it is sequenced by sampler musicians, reverse engineered by British scientists, or run at the speed of the digital nerve.

"Stelarc Scans" is Stelarc operating under the sign of the technological imagination. Stelarc is a blip, a jump, a data conduit. But what happens if Stelarc disappears? Flesh ends in the triumph of the chilled vortex. In the following stories, we write the scan that is Stelarc.

1. Tattooed Sound

It is no longer meaningful to see the body as a site for the psyche or the social, but rather as a structure to be monitored and modified—the body not as a subject but as an object—NOT AN OBJECT OF DESIRE BUT AN OBJECT FOR REDESIGNING.[3]

It's a full moon, mid-October evening, and I'm working my way down No Go Avenue to a gig at Club Gamma Ray. My electronic sensors are splayed wide

open, and my ears are on full alert. David Kristian, a technomutate composer, e-mailed to say that he was doing a gig with Zilon, sort of a recombinant tattoo showdown in which human flesh meets data sound. He warns me to wear earplugs because what I'll hear is going to hit like a laser pulse wave. Or as David would say, "If the vortex machine is working just right, it should ripple the flesh on people's faces and pancake the eyes like a hard wind blowin' across the water." Cheap electronic thrills with a little body mutation thrown in for good data measure. I like that. In fact, I *need* that because my soul is riding on high-octane empty—no disturbances, just this zombie land with the cynical joker in command.

Down the street from Gamma Ray, a large, sort of disco square-dance crowd spills out of Club Metro. David Bowie is in town for a show, and I guess I should be into Ziggy Stardust Recombinant time, but I quick-check my culture-alert patches, see that the red lights are still flickering on the low energy cycle, and push right on through. Out of the corner of my electronic eye, I see three guys up the street, bagged out in night-walking, triple-striped Adidas running suits, giving a couple of working women a real tough time. Seems they haven't got the money or the inclination to do the honorable thing and pay the bill for the body rent time, so they've decided to take their street-time pleasure in low-level, mouth-squealing, mean-spirited harassment. Trapped hookers and a posse of snickering guys. Don't much like it, but I let that one file back to the memory banks, take a sharp left at the gargoyles and android cockroaches and road-warrior swirling dervishes blasted onto the Gamma Ray antiarchitecture, and immediately fall forward on my virtual face into the labyrinth of the future.

The show at Gamma Ray was advertised as an art-imitates-Photoshop sim-scene. Zilon, a local performance artist who "performs" mostly by tagging buildings with his trademark signature, was to be filmed live being tattooed by an electronic needle carving weirdly beautiful Egyptian hieroglyphs on his back and face and arms, the sounds of which were to be spliced, mixed, and recombined by the composer, David Kristian.

It all started innocently enough. A flesh/metal dark Gothic scene with Zilon, stripped to the waist, his back to the spectators, and a tattoo artist bearing down close with an electronic needle working his flesh, and all of this fed live to a hovering vid for large-scale screenal display. But what made the scene really interesting wasn't the body tattoo but the *sound tattoo*. Over in the corner, Kristian

weaved and shuffled like some alchemical artist mixing up a medieval sound brew from the Vortex machine, mixing live samples of the sharp reverbs of the tattoo needle with files from deep in the android sound memory of hizzes and pop and shrieks and statics and hammerhead noise blows to our listening skulls.

Sound surgery. Tattooed sound spliced and recombined with such intensity and speed that natural body rhythms just choked up and shut down, and your nervous system *became* the rhythm of the sound. Might like just to have sat there a bit alienated maybe, watching, mind-drifting, but it wasn't possible because the sound surgery forced your body to be an active mediation between the (flesh) tattooing and the sound (tattooing). I was part of the performance. Resynched, no longer really in control of my body, riding sound vector waves, low and high, of Kristian's music. Abuse music for abuse flesh.

Even Zilon spewed to the max-magnitude of the Vortex machine. His body was sound-pulsed by the remixed tattoo needle—the Zilon body trapped in a double Kafka tattoo machine: electronic needles for the flesh, electronic sound for the organs internal. Precision-aimed with laser intensity at different bodily organs—vortexing the kidneys, rewiring the bowels, fibrillating the heart, sound purging the spleen, splicing broken synapses in the nerve-net—the sound tattoo of David Kristian tingled the nipples, Viagraed the cock, jump-started the ears. Sometimes hardly audible, it grabbed your stomach with a deep-drone silent sound. Zero-sound, so low that the room fell silent except that the concrete began to shake. Or sounds so high that it split your nerves, interrupted again and again with a jar-jar roar, as the sound barrier of the auditory universe is broken. Kristian kills the barrier of sound with his Vortex machine.

A perfect evening for liquid sound that flesh-shifts the face as it needles the internal organs of the body wetware. Digital fingers across the chalkboard of the nerves pulse the body so that flesh dies, organs mutate, eyeballs bulge up and then flatten down supine smooth. You feel the nausea waves hit and the sounds of chairs emptying as people panic and rush the exits. But somehow in the chaos, my mind pops out feeling tranquil and serene in the blue sky of vortex music. I'm sitting there suddenly all by myself in an abandoned room with raw sounds of electronic needle-tattooing and blood dripping and big-screen black and red images of it all, and I know that I've come home to the technomutate future where I always longed to be and where my android body belongs.

2. Image Flesh

Technologies are becoming better life-support systems for our images than for our bodies. IMAGES ARE IMMORTAL, BODIES ARE EPHEMERAL. *The body finds it increasingly difficult to match the expectations of its images. In the realm of multiplying and morphing images, the physical body's impotence is apparent.* THE BODY PERFORMS BEST AS ITS IMAGE.[4]

The body as image? That's riding the digital nerve. Living within the externalized eye. The eye severs its biological relationship to the optic nerve, splits wide open the cavity of the skull, listens for the sound of the digital matrix, and suddenly, without warning, reverses field. The (digital) world becomes an exteriorized eyeball. It floats in the sky of the mind, networks heretofore privatized consciousness, becomes an artificial intelligence and a telematic nerve ending. Quickly it loses its nostalgia for the nesting place of decaying human flesh and gains confidence, beginning to spread its optical nerves across the skull of the digital mind. The world becomes a perspectival simulacrum.

An information matrix running on a platform of shadow light. The global mind moves at the speed of light. The digital eye blinks open. It is a light-through array of flickering data. But it's not really data. *It is us.* Image Flesh. *Eye-through beings* living on the energy of their exteriorized orifices. Swimming in the codes of always overexposed algorithms. The laws of normal physics cease to be meaningful. String theory is our skin, n-dimensional space the digital air we breathe, the elliptical curve of the sky is beneath our pixel feet, and the eye, always the eye, turns upward into the white orb of the darkened cranium of the multicolored horizon. Flash the flesh, shock-wave the nerves, stream the waiting sensorium, fire code perspective, and the digital body floats in a visual world of its own creation.

The image simulacrum is the new philosophy. The matrix is our true flesh. It is the void that we will illuminate with our imagination. Riders of the digital nerve, we gladly accept the ancient challenge of the gods—to be digital gods ourselves or to be taunted through the history of mythology as victims of the curse of hubris. We may remain silent in the face of the silence of the gods. We may remain forgetful even of ourselves when confronted by the forgetfulness of the

gods. We know that we have been abandoned. We stand empty. We accept the mythic fact that we are held out into the void. But that just might mean that we are prepared. The challenge of the gods is unforgiving, but we are children of the data streets. And we have an ace up our sleeve. Unknown to the gods, we are prepared to abandon the now obsolescent carrier of the body. We are disloyal to our origins. We are no respecters of genealogy. *We are biotech.* We depend on genetic engineering and the Human Genome Projects of the future and the present to solve the riddle of dying flesh. We are ready for the migration of the spirit. We have always been ready.

Astral projection is the deepest roots of our common religions. The death of the body has always been equivalent with the birth of our spirit life. Virtuality is another name for spirit longing, for a reunion with something much more proximate to our deepest being. Long before digitality, we have sought the specter of virtuality in the torture machines of the Inquisition and the pleasures of sexuality. From such a delirious past can come only a delirious future. And that is why the beginning sounds of genetic engineering, telepresencing, and the externalized orb of the electronic eye are no strangers to the reptilian recesses of our minds. They are also a circling back to something long forgotten, to something whose absence has effected a fundamental strife in subjectivity—the night spirits of aboriginal faith, the process philosophy of the pre-Socratics, the great fusion religions of Eastern mysticism. But that oneness—that metaphysics of loss of identity, that return to the discourse of the ancient gods—is also the underlying spirit of technicity. That is why "technicity crushes." It knows that we are ultimately faithless. We will quickly move beyond the technology of image flesh to the essence of what technology exists for and for which it must work to deny its own promise.

3. Matrix Machine

The experience of Telepresence (Minsky) becomes the high-fidelity illusion of Teleexistence (Tachi). ELECTRONIC SPACE BECOMES A MEDIUM OF ACTION RATHER THAN INFORMATION. *It meshes the body with its machines in ever-increasing complexity and interactiveness. The body's form is enhanced and its functions are extended.*

ITS PERFORMANCE PARAMETERS ARE LIMITED NEITHER BY ITS PHYSIOLOGY
NOR BY THE LOCAL SPACES IT OCCUPIES.

Electronic space restructures the body's architecture and multiplies its operational parameters. The body performs by coupling the kinesthetic action of muscles and machines with the kinematic pure motion of the images it generates.[5]

A mind-machine code named the "Soul Catcher 2025" is being developed by British Telecom.[6] In the future, the soul catcher will be able to be implanted into the brain to complement human computational skills. The soul catcher would enable the human brain to gather extrasensory data that are transmitted directly by wireless networks.

Scientists predict that once in place, the soul catcher will have two functions—acting as a superconductive medium that links the human brain with neural networks of data and also acting as an internal surveillance device that sends signals about the human central nervous system to chip manufacturers from its privileged position within the human brain.

So you become the machine.
The machine becomes you.
The brain of the Soul Catcher
As a neural network skull
Fast Processing
Fast Data
Waiting finally to see with its biotech eye.

The matrix machine. The mirror moon becoming trash. A slow eye in a fast zone—a data catcher. The eye of forgetting—the sun-shattered eye—slips through the code and captures light.

Stelarc as Radical Deconstructionist

The above three stories reveal the hidden destiny of technology in the language of tattooed sound, image matrices, and resequenced bodies. The predictions that are suggested by Stelarc's artistic body experiments actually begin to colonize the nerve fibers of the digital universe as his body's wired skin. These three scans re-

veal the prosthetic heads, prosthetic mouths, and prosthetic flesh of his techno-
logical imagination.

If much of Stelarc's artistic practice focuses on destabilizing traditional
conceptions of identity, embodiment, awareness, and consciousness, perhaps this
is because Stelarc is a radical deconstructionist. Emphatically breaking with hu-
manist conceptions of the body as a self-enclosed container of consciousness and
refusing the romanticism of what he considers shamanistic practices, Stelarc's art
traces that broken line of flight wherein the posthuman body alternates between
past and future.

Blocked from regressing into the theater of modernist representation by
the laws of technological acceleration but as yet unwilling to explore the disap-
pearance of the body into postbiologics, Stelarc's art negotiates the space of the
in-between. Always recuperating sufficient traces of the modernist body to dem-
onstrate its weakness in the age of the image matrix, Stelarc demonstrates the true
extent of the contemporary predicament of the body as an unresolved reaction-
formation. We may all be Stelarcs now, but Stelarc's art also contains the promises
and perils of a technology whose destiny is an art of radical deconstruction—a re-
lentless spirit of deconstruction that holds us in the sway of a global reaction-
formation that now assumes the character of an unchecked civilizational crisis.

Are we all caught up in the optimism of a dead futurism?

Notes

An earlier, different version of this text appeared as "We Are All Stelarcs Now" in
Marina Gržinić, ed., *Stelarc: Political Prosthesis and Knowledge of the Body* (Ljubljana,
Slovenia: Maska, 2002), 71–80.

1. Stelarc, "Biographical Notes," *Stelarc,* at <http://www.stelarc.va.com.au/
biog.html>, accessed 6 April 2004.

2. Correspondence with Stelarc, 2 December 2002.

3. Stelarc, "Redesigning the Body," *Stelarc,* accessed 6 April 2004.

4. Stelarc, "Phantom Body," *Stelarc,* accessed 6 April 2004.

5. Stelarc, "High-Fidelity Illusion," *Stelarc,* accessed 6 April 2004.

6. Margie Wylie, "A New Memory Chip—for the Brain," *c/net,* 18 July
1996, <http://news.com.com/2100-1001-218102.html?legacy=cnet>, accessed
9 April 2004.

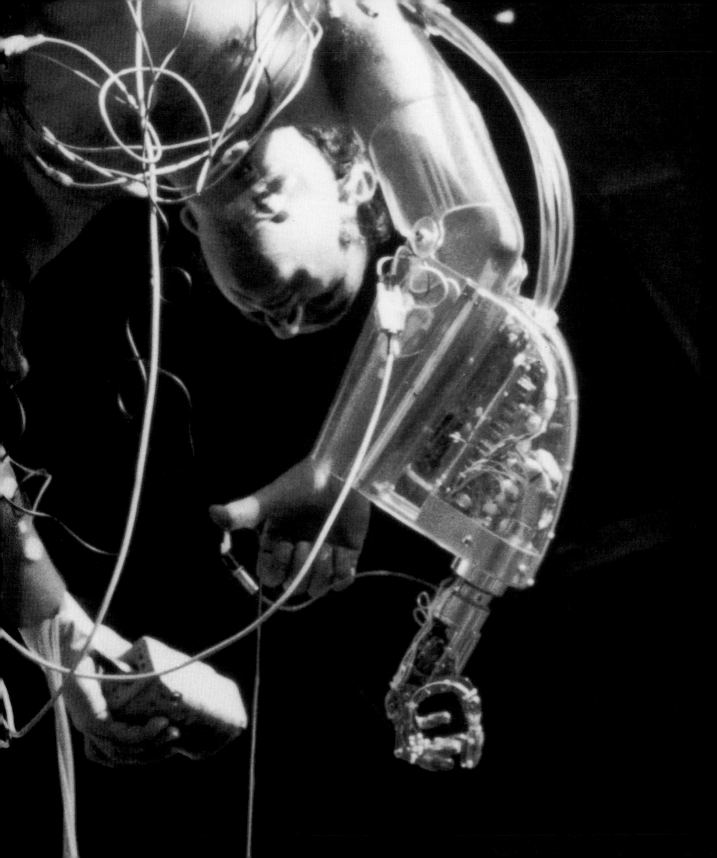

STELARC'S TECHNOLOGICAL "TRANSCENDENCE"/STELARC'S WET BODY

Amelia Jones

The Insistent Return of the Flesh

In the fall of 2000, I experienced my first live Stelarc performance—in this case, a demonstration of the *Extended Arm*.[1] Contrary to Stelarc's vociferous claims about his work extending the "obsolete" body of the global capitalist era (even the opening spread of his official Web site grandly unrolls the word "OBSOLETE" at the end of the phrase "the body is"), I found myself responding in a deeply empathetic way to the drone of the *Virtual Arm*'s technology and to this small, compact, masculine body partly sheathed in metal and speaking to the audience passionately about his work. Tears came into my eyes in the most emotional fashion, as I imagined (even empathetically experienced) my own body trapped, controlled, directed by this technological apparatus. Far from experiencing Stelarc's (or my own) body as "obsolete" or otherwise irrelevant or transcended, I felt *more* aware of my bodily attachment to his artistic practice—*more* and not less cathected to his technologized form. My response was immediate and identified deeply with him through an interwoven process of sensation, perception, cognition, and feeling.

As one reviewer has pointed out, the irony of Stelarc's reiterated idea that the body is obsolete is that "it is nevertheless his body that is the subject, the focus, and the controlling [and, I would add *controlled*] device of his performances."[2] Why then does he continue to claim the obsolescence of the body—despite its obdurate refusal to disappear, its brute centrality in his performance practice, and its affective materiality?

To try to answer this question, I want to evoke a kind of willed essential-ism to call attention to the body's materiality in exploring the tension between Stelarc's statements and the complex and productive effects (as I experience and explore them) of his practice.[3] I want to play Stelarc against himself, as it were, to argue that although his verbal rhetoric is problematically rationalizing, Cartesian, and by extension phallocentric (in his words, explicitly *hard* and *dry*), his practice allows for a fluid, even *wet,* circuit of exchange with his spectators that opens to an identification with and a deeper understanding of the inexorable emotional, psychic, and material effects of technology on contemporary subjectivity.

Ultimately, then, I read Stelarc against the grain of his own statements, interpreting his bodily enactments of, through, and with technology through a feminist lens. In my reading, his melancholic if resigned evocations of the trau-matizing of the contemporary body (which I interpret *as* a subject) by the ram-pant technologization of everyday life and of the refusal of the wet, fully fleshed, mortal body to disappear except, indeed, in death itself enact a networking that is simultaneously technologized and embodied, conceptual and corporeal—proving, in fact, that these forces are inextricably intertwined in contemporary experience.

Stelarc's "Hard" Body/Stelarc's Rationalism

Stelarc's rhetoric is over the top and often seems to contradict the productive am-biguities that his practice puts into play. For example, his statements about the supposedly "hollow body" are contradictory in that they usually refer to his works in which a camera and microphone have been inserted into his stomach. But these works demonstrate the *presence* of material folds of flesh and digesting food rather than the "hollow" emptiness of the body's interior. Stelarc proclaims, in aggressive capital letters,

HOLLOW BODY: OFF THE EARTH, THE BODY'S COMPLEXITY, SOFTNESS AND WETNESS WOULD BE DIFFICULT TO SUSTAIN. THE STRATEGY SHOULD BE TO *HOLLOW, HARDEN,* AND *DEHYDRATE* THE BODY IN DEVELOPING A PLANETARY PHYSIOLOGY. . . . THE BODY PLUGGED INTO A MACHINE NET-

WORK NEEDS TO BE IMMOBILIZED. IN FACT, TO TRULY ACHIEVE A HYBRID SYMBIOSIS, THE BODY WILL BE INCREASINGLY ANAESTHECIZED.[4]

Stelarc here makes explicit his call for a strategy to "hollow, harden, and dehydrate" the body, noting in another version of this text that the corollary goal is to make the body "more durable and less vulnerable, . . . a better host for technological components."[5]

The association of the "hard" body with masculinity is obvious. Cultural historian Klaus Theweleit has eloquently explored the link between the hard, armored body and masculinity—particularly of the fascist variety—in his two-volume study *Male Fantasies.*[6] Theweleit points out the extent to which masculine armor is a defense against the perceived unmanageability of "feminine" hoards (comprised in the German fascist imaginary primarily of Jews but also of women, homosexuals, and Communists) and, in general, of the flow of blood, pus, and other bodily fluids that expose the vulnerability of mortal, human existence. The hardening of the male body (whether figuratively or literally, whether psychically or physically) is driven by the felt need to reaffirm the virility (the phallic prowess) of the male body in the face of the threat posed to his fantasized impermeability by flow, femininity, and the homoerotic.

I am not accusing Stelarc of being a closet fascist. His work, at any rate—with its willfully self-mutilated, punctured, and prosthetically enhanced (or compromised) flesh—would completely belie any such connection, as would his willingness to mark (even obsession with marking) the failure of the (male) body to keep pace with technological change. However, I do want to force the issue of the implications of his rhetoric. The implications go beyond this aggressive masculinism, with its troubling ideological implications. Elsewhere, Stelarc makes his Cartesianism even more explicit, calling directly for the transcendence of the human body: "My events are involved with transcending normal human parameters, including pain."[7]

Feminist theorists from Simone de Beauvoir to the present have argued extensively and persuasively that such a yearning for transcendence reinforces—if not comprises, on the most basic level—the patriarchal logic of Western thought. In Beauvoir's epochal 1949 feminist study *The Second Sex,* she points to the way in which transcendence in patriarchy is aligned with masculinity, while

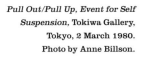

Pull Out/Pull Up, Event for Self Suspension, Tokiwa Gallery, Tokyo, 2 March 1980. Photo by Anne Billson.

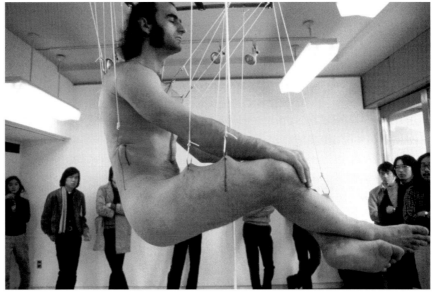

immanence (being *in* the flesh) is projected onto femininity—and female subjects.[8] The consequences of this psychic dynamic—including the political oppression of women and their relegation to a state of passive immanence (think Victorian matron or Afghan woman under the Taliban regime)—are clear.

Recently, referring to Stelarc's own rhetoric (while not directly citing him), technotheorist and artist Simon Penny has noted that the notion of the body as "obsolete," which he argues has become fashionable in cybercultural circles, is hardly a new idea but has its roots in a "long tradition from Christian Neo-Platonism to Descartes and beyond." It is, Penny concludes, "perhaps the most consistent and continuous idea in Western philosophy."[9] Penny explores how this Cartesian belief system dovetails ideologically with the propensity of computer technologies to create a dangerous illusion that human intelligence is discrete from embodiment.

Such a seemingly literal disconnect of mind from body—which has its epitome in the discourse and scientific logic surrounding research in artificial intelligence (AI)—exacerbates the effects of Cartesianism by seeming to prove them

true. The increasingly dominant belief that human intelligence has nothing to do with human embodiment has led to an increasingly instrumentalized view of intelligence, thought, and human existence in general. Penny cites Noah Kennedy's 1989 book *The Industrialization of Intelligence: Mind and Machine in the Modern Age* on this important point:

In a sense, the mechanical intelligence provided by computers is the quintessential phenomenon of capitalism. To replace human judgment with mechanical judgment—to record and codify the logic by which the rational, profit-maximizing decisions are made— manifests the process that distinguishes capitalism: the rationalization and mechanization of productive processes in the pursuit of profit. . . . The modern world has reached a point where industrialization is being pointed squarely at the human intellect.[10]

Such contemporary fantasies of transcending the body through pure thought show the era of high technology to be as rationalizing in its way as was the era of high industrialism. While industrialism directly rationalized human *labor* via Taylorism and Fordism, arrogating reason to the elite classes (who ideologically projected their immanence onto their women and workers), the computer era rationalizes human intelligence itself through a reinscribed logic of Cartesianism. As Kennedy begins to suggest, this reinscribed logic parallels the machinations of late (or global) capitalism, which encourages the flow of money and ideas (as "capital") but contains this flow into usable (commodifiable) forms that allow human intelligence to be separated off as a kind of product.

But a growing number of researchers coming out of philosophy, neuroscience, and AI studies have begun to contest this highly rationalizing set of beliefs. Hubert Dreyfus, in his book *What Computers Still Can't Do: A Critique of Artificial Reason* (first published in 1972), was one of the earliest to intervene into AI discourse. Dreyfus points out the various mechanisms through which AI researchers have occluded the role of the body and emotions in their supposedly objective, scientific modeling of human intelligence. Dreyfus presents simple examples to demonstrate how "feelings and bodily coping skills" are necessary to understand language and complex spatial and social interactions. The body is central to aspects of imagination and perception, to understanding analogy and social behavior.[11]

In their book *Embodied Mind: Cognitive Science and Human Experience,* scientist Francisco Varela, philosopher Evan Thompson, and psychologist Eleanor Rosch draw on cognitive science and phenomenological philosophy to argue for an "enactive" approach to cognitive science that asserts that "cognition has no ultimate foundation or ground beyond its history of embodiment."[12] And in *Descartes' Error: Emotion, Reason, and the Human Brain,* Antonio R. Damasio provides an elaborate descriptive model of how the body informs cognition and what role emotion plays in bodily as well as intellectual processes. The body, he argues, "as represented in the brain," constitutes "the indispensable frame of reference for the neural processes that we experience as the mind."[13]

As Varela, Thompson, and Rosch's book suggests, attending to what philosopher Maurice Merleau-Ponty would call the chiasmic intertwining of flesh and the world—the coextensivity of mind and body, emotions and reason, and their interconnectedness with the "fleshed" world in which the subject is suspended—profoundly shifts our understanding of Stelarc's work.[14] Far from being "obsolete," the body (insistently performed, enacted, and propelled into the world as Stelarc's body is, far more aggressively than most) persists—full of hooks, penetrated by a camera, dwarfed by metallic prostheses. The body—wet, unpredictable, emotively disorderly, itself a technological marvel—is at stake in (and also inevitably escapes the control of) Stelarc's cerebral rationalizations.

Stelarc's Wet Body/Stelarc's Inadvertent Irrationalism

I have already alluded to the paradoxical nature of Stelarc's claims for the obsolete or hard body. Expanding on some of the contradictions put into play by his rhetorical excesses, it is relatively easy to see that the utopian (if also masculinist) implication in Stelarc's claims for bodily transcendence is belied by the logic of his work. Following on his observation that the body can no longer handle the violent stresses of information-age living, Stelarc claims that the body is a pure object to be redesigned through his practice, with the goal of confirming and even exacerbating its obsolescence: "OBSOLETE BODY: THERE ARE BOTH TECHNOLOGICAL PRESSURES AND EXTRATERRESTRIAL REASONS FOR *REDESIGNING* THE BODY BOTH IN FORM AND FUNCTION. . . . What is important is the body as an object, not a subject."[15]

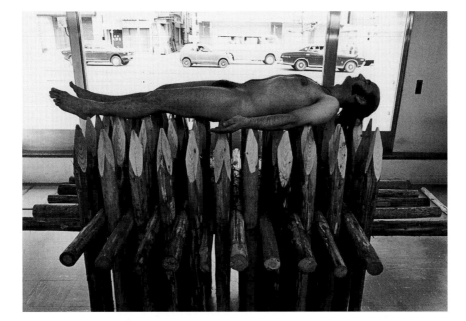

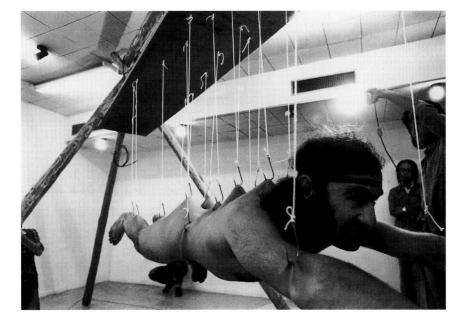

Event for Propped Body,
Tokiwa Gallery, Tokyo, 14 May
1978. Photo by Shigeo Anzai.

Event for Stretched Skin, Maki
Gallery, Tokyo, 16 May 1976.
Photo by Shigeo Anzai.

He proclaims that the body is an "object" to be "redesigned" with the implication that the redesign will shift conceptual (mental) terrain. The implicit, ultimate goal of Stelarc's multifarious project is to refigure our *understanding* or *comprehension* of the technologized world around us by manipulating the body—by embracing the extensions and violations perpetrated on human subjects by technology rather than resisting them.[16] The central, obsessively deployed vehicle for this refiguring, then, is the body itself, which, correlatively, is implicitly of interest *because of its coextensivity with the mind*. If the body were truly obsolete, what would be the point of suspending it and prodding, invading, extending, and manipulating it with technology? If it were a dull object—irrelevant to consciousness, thought, cognition—then manipulating it would have no effect whatsoever on understanding.

The "redesign" of the body thus has significance only within the context of assuming this body to be a "self"—one that thinks, feels, and experiences the world (one that thus is unpredictable and impossible to control). By extension, this body/self must be understood as having the potential to propel itself into the world in a purposeful way to affect it. The body actualizes thought, putting it in motion as what Brian Massumi has called an "interrupter" of the technologized network. The thinking body, the activator of human agency, is always already technologized, and yet in its inexplicable materiality (its inexorable mortality), it confuses the regularized logic of technological networks. Massumi notes: "human agency enters the network as a local input of free variation: in other words, a variation not subordinated to the programming of the self-network."[17]

Stelarc activates this body/mind complex far more extensively and dramatically than most visual artists. The tendency in the more traditional graphic and sculptural arts, after all, is to *veil* the artist's body, to obscure its role in production—precisely to imply a "pure" and disincarnated (if aesthetic) impulse behind artistic creation.[18] After all, this artist who rhetorically insists that the body is obsolete chooses performance as his medium. The medium of performance most insistently begs the question of bodily "presence," materiality, unpredictability, sweat, and stench. Performance is, by definition, polluted by irrationality—the threats of potential disaster and erotic seduction hover over every "live" event.

Perhaps—as with the "soldier males" who are examined so incisively by Theweleit and who, he argues, claim invincibility to mask their profound lack

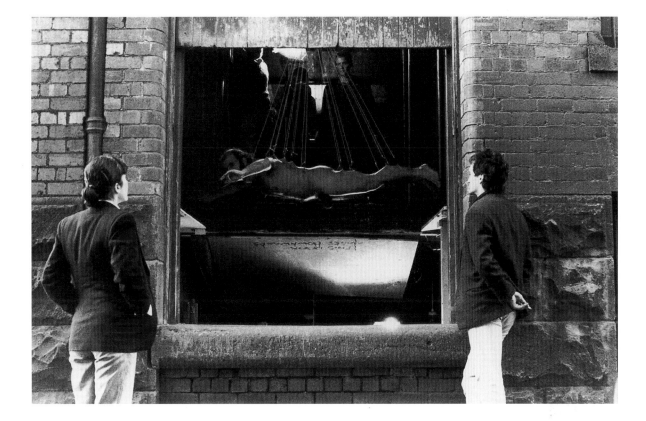

Street Suspension, Mo David
Gallery, 604 East 11th Street,
New York, 21 July 1984.
Photo by Nina Kuo.

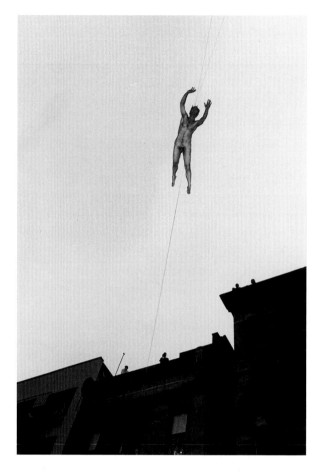

and hysteria—Stelarc is the lady who doth protest too much. Perhaps his "hard body" is itself a prosthetic device masking a roiling mass of insecurities, a fleshy sack filled with pain (not "hollow"). One scholar of Stelarc's work (only one, to my knowledge) has dared to glimpse this potentially explosive aspect of Stelarc's highly controlled practice. Timothy Murray has noted that the trauma of the body in regimes of high technology is at the basis of Stelarc's practice and cites the artist's Web site text "The Anaesthecized Body": "DISTRAUGHT AND DISCON-NECTED, THE BODY CAN ONLY RESORT TO INTERFACE AND SYMBIOSIS." Murray

follows this citation with this question: "How is [it] that the surface of the re-designed body itself carries the energetics of the distraught affect of trauma?"[19]

But even Murray fails to ask what the point would be of simply reinscrib-ing—or even exacerbating—the effects of technological trauma on the body in a performative artistic practice as Stelarc's work so insistently does. I think there is a point to such a reinscription (and Brian Massumi spends almost forty-five pages of tortuous but brilliant prose arguing as much in his recent essay on Ste-larc, cited above). But I refuse to accept Stelarc's claims of the body's obsolescence or his related claims that his work transcends pain.

The latter claim, at any rate, is directly contradicted by this kind of state-ment: "A woman goes through tremendous pain to give birth and it's worth it. I identify with that. The pain is inevitable."[20] Stelarc's conflation of his self-inflicted, artificially induced pain with that of childbirth is troubling, but as I have begun to suggest, the visceral effects of his work contradict the appropriative logic and self-certainty of such aggressive rhetoric. As theorists such as Jurij Krpan and Massumi have argued, Stelarc's performance practice is powerful because it labors to concretize and deabstract the effects of new technologies by enacting them in and through the body—the point being the *enaction* rather than the claims of tran-scendence, which Massumi, for one, chooses to ignore.[21]

In her important antiracist theorization of the cyborg subject, Jennifer Gonzalez asks crucial questions that bring the technologically enhanced subject of Stelarc's exploration back to earth, refusing the kind of abstracting logic of Stelarc's ultimately metaphysical claims of transcendence:

What are the consequences of a montage of organic bodies and machines? Where do the unused parts go? What are the relations of power? Is power conserved? Is the loss of power in one physical domain the necessary gain of power for another? Who writes the laws for a cyborg bill of rights? Does everyone have the "right" to become any kind of cyborg body? Or are these "rights" economically determined?[22]

Gonzalez's point, which brings us back to politics and the intelligent, thinking bodies struggling to get by in this particular moment of global capitalism, makes it doubly clear that Stelarc's strategy of self-inflicting technological trauma (or, more accurately, his strategy of *exacerbating* the trauma of this high-tech age) on

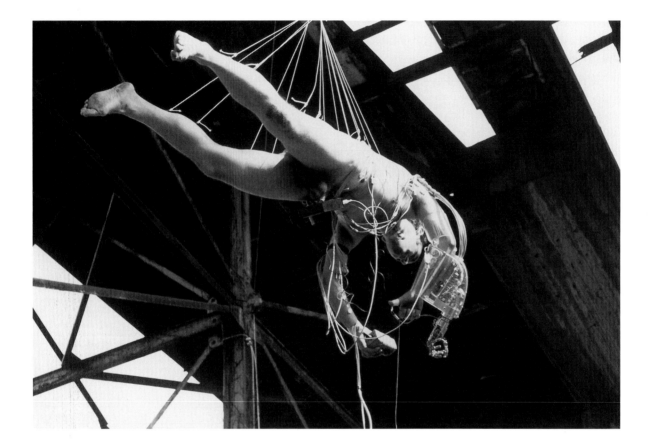

what he calls "the body" is a gesture that makes particular sense for a heterosexual white male subject at this moment in time.[23] Even in the context of the United States, imagining a white middle-class feminist or a working-class black lesbian who would perpetrate such violence on her body is difficult. Bodily technological invasions would be experienced and understood differently by such subjects—who may, for example, have experienced the childbirth pain that Stelarc seems to want to emulate (and yet simultaneously to disavow). At the very least, most women would not have easy access to the fantasy of transcendence that Stelarc promotes. A subject whose options have been circumscribed by the apparent identifications of her cognate body would find it far more difficult to claim its "obsolescence" than would an apparently enfranchised, apparently heterosexual, white male such as Stelarc.[24]

Having put my identity-politics cards on the table, for the remainder of this chapter I want to compare some of Stelarc's projects with those of other body artists to counter the troubling ideological implications of his rhetoric. The idea here is to look in both directions in relation to Stelarc's work: to cast light on the richness and also the limitations of other body artworks that deal with technology

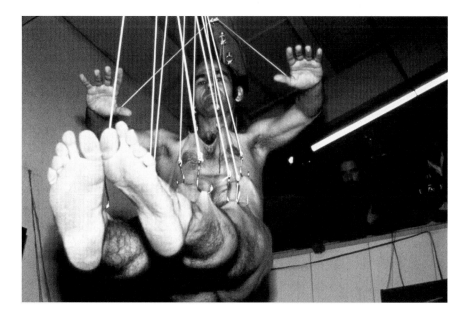

Spin Suspension, Artspace, Nishinomiya, 1987. Photo by Helmut Steinhauser.

facing page:
Event for Stretched Skin/Third Hand (The Last Suspension), Yokohama Art Gallery, Ofuna Monorail Station, Japan, 29 May 1988. Photo by Simon Hunter.

by viewing them in relation to Stelarc's rigorous theorizations of the technologized body; but also to highlight the way in which Stelarc's practice can be thought through other body-art practices that more overtly (or less defensively) raise questions of corporeality, masochism, trauma, excess, and ultimately death. In so doing, I want to insist on the "wetness" of Stelarc's body: its uncontainable messiness (down to the cellular level), its unpredictability, its irrationality, its fear, its panic in the face of the trauma of everyday life in the late twentieth and early twenty-first centuries, and most of all, its electrified—but *inexorable*—coextensivity with his dripping, sodden brain and the often perversely contradictory thoughts that filter through it. By definition, it will be a feminist project to embrace irrationalism rather than the rationalized instrumentalism of Cartesianism, to refuse claims of transcendence in favor of exposing the interconnectedness of brain-flesh and the other fleshed aspects of the body, to *derationalize* the body.

Penetrated, Wet Body: Stelarc's Practice

Suspensions

Large metal hooks with barbed tips gouge into the skin and rip it from the muscle as Stelarc's body dangles from cords. In *Event for Support Structure* (performed at Tamura Gallery in Tokyo in 1979), as Stelarc notes, "The body was positioned between two planks and suspended from a quadrapod pole structure in a space littered with rocks. The eyes and mouth were sewn shut."[25] The body between two planks, only *partially* sewn up (after all, other holes allow ingress to and egress from the body), becomes, Massumi argues, a "stranded abject object."[26] It is an object but is motivated, positioned, violated by a subjectifying intelligence: that of this very body itself. Perhaps in this sense, Stelarc's mind-body continuum has its most striking specificity in a political sense. After all, plenty of bodies have—against their will—been subjected to equivalent and worse pain. We interpret him as having chosen this pain freely, as an "artistic" act, which informs our understanding of its meaning. Watching a woman in childbirth wouldn't convey the same social or political significance.

Stelarc claims he is not a masochist and not interested in masochism: "This talk or emphasis on masochism in the context of what I'm doing is utterly, totally wrong."[27] But what do we have here but willfully (masochistically) self-inflicted

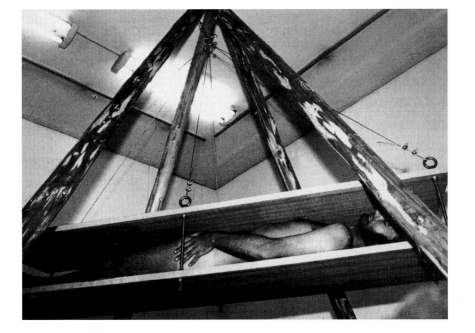

Event for Support Structure,
Tamura Gallery, Tokyo,
9–15 July 1979. Photo by
Yuichi Konno.

discomfort? While the discomfort may not be the goal of Stelarc's practice (then again, it may be, if we take his quote about childbirth seriously), it is nonetheless an operative aspect of it. Again, it is the *perception* of Stelarc's pain that moves the spectator and that provides the work with its cultural power by provoking a visceral, personal, affective response. If no pain was implicit in the work—if, say, Stelarc were lying on the floor of the gallery fully clothed for one hour—then the work would not provoke new ways of thinking about embodiment and subjectivity, as Massumi rightly claims it has the potential to do.

A comparison of Stelarc's partially sutured body (did he forget he has an anus? ears?) with the deliberately violated bodies of other more overtly masochistic male body artists is instructive. Ron Athey and Bob Flanagan both perpetrate penetratory violence on their bodies at least in part to exorcise or at least exaggeratedly exteriorize immense internal physical pain and the emotional disorder that accompanies it. Athey, an ongoing survivor of HIV, slices his body and penetrates his anus with various objects (such as high heels from the women's

shoes he sports) or marks its vulnerable inside-outsideness by extracting a string of pearls from its puckered orifice.[28] Flanagan, who died of cystic fibrosis in 1996, worked with dominatrix Sheree Rose to violate his body in a myriad of ways—having her suspend him by his feet from the ceiling for long periods of time; burning his penis with melted wax or nailing it to a board; sewing his flesh; safety-pinning plastic babies to his skin while raving in the voice of antichoice activist Randall Terry.[29]

The bodies of Athey and Flanagan are suffering bodies and bodies that are not afraid to say so. They are also enacted as overtly sexual and motivated by intelligence—an intelligence inextricably bound into emotion, pain, and bodily sensation. Athey and Flanagan narrate their sexualized bodies with thick personal content that has broad social implications. One of the public scandals surrounding Athey's work in the mid-1990s turned on his scary exposure of what people perceived to be AIDS-infected blood.

These overtly pain-filled bodies, which project themselves insistently into the social realm, contrast dramatically with the body in Stelarc's work, which he

Moving/Modifying: Suspension for Obsolete Body, Espace DBD, Los Angeles, 1982. Photo by Daniel J. Martinez.

facing page:
Event for Lateral Suspension, Tamura Gallery, Tokyo, 12 March 1978. Photo by Anthony Figallo.

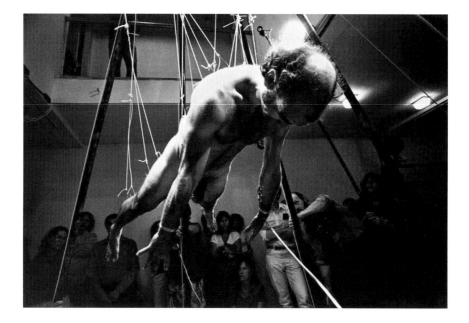

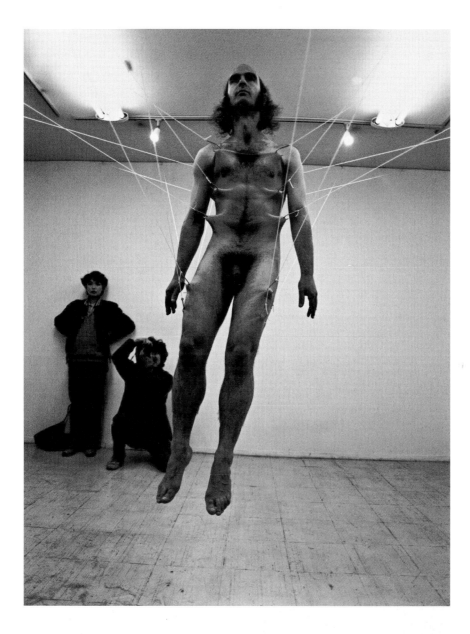

rhetorically contextualizes as "empty"—without memory, emotion, or ideology. Stelarc explicitly rejects the emotive level of experience and equates emotion with failed transcendence, with the embeddedness of the body in the "social . . . status quo":

Bodies must now act without expectation, producing movements without memory. Can a body act without emotion? Must a body continuously affirm its emotional, social, and biological status quo? Perhaps what is necessary is electronic erasure with new, intimate, internalized interfaces to allow for the design of a body with more adequate inputs and outputs for performance and awareness augmented by search engines.[30]

Stelarc's body-in-performance is abstracted, seemingly contentless and affectless. Of this body, he writes, "It is no longer meaningful to see the body as a site for the psyche or the social, but rather as a structure to be monitored and modified."[31] Such a body, rhetorically defined as *only* an object to be controlled and manipulated, contrasts dramatically with the performative bodies of Flanagan and Athey, which openly navigate the torturous structures of masochism, externalizing internal pain and provoking politicized thought about personal afflictions.

In Stelarc's suspension pieces, per Krpan's and Massumi's arguments, the artist could be said to be concretizing the sci-fi fantasy of the body as meat. Through suspension and disconnection, as in *Event for Support Structure,* Massumi argues, Stelarc produces the body as a vacuum, marking the coextensivity of (the body's) matter with "what is normally mutually exclusive of it: the abstraction of the void." In turn, the body-as-vacuum marks the "degree-zero of the corporeal [as the] state of its indistinction with thought."[32] While Flanagan and Athey theatricalize, narrate, and otherwise fill their already full bodies with content, Massumi's point emphasizes the way in which Stelarc attempts to abstract and void the body, aligning it with the abstraction of thought itself.

The claims that Stelarc submits his body to external control, treats it as a manipulable object, and is establishing its obsolescence miss a crucial point that is provided by the theory of masochism: the masochist wants to be hurt, and his motivation (his will, his direction) places his body in a position of passivity and calls for the other to hurt him.[33] Stelarc, by mobilizing situations that put his body in pain, reclaims control over "the body" that his rhetoric wants to objectify—the

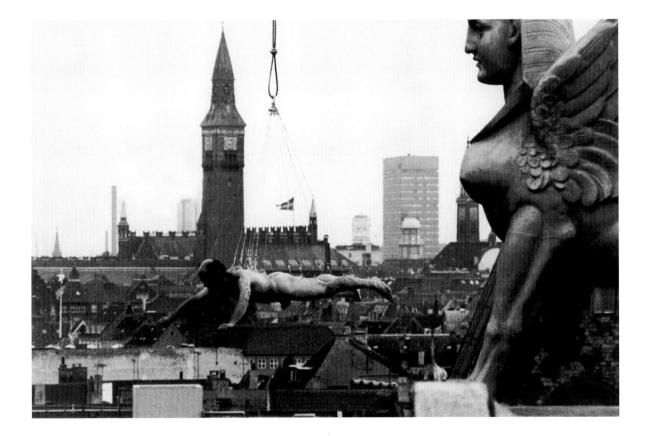

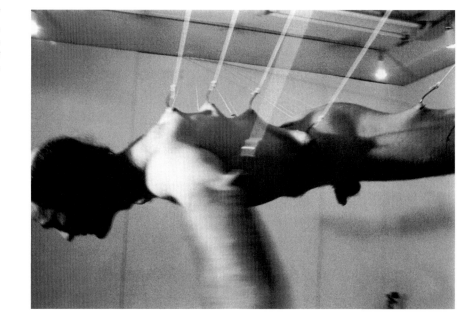

body that is otherwise pure "meat," subjected completely to technologization. Stelarc can insist that he is not working from a basis of masochism, but in effect, the masochistic spectatorial dynamic is in place as we view his pain in the suspension pieces. Far from opening himself to random interpretive input, Stelarc produces himself specifically as a pain-filled subject (and object) to produce a kind of interpretive response, even to produce a specific kind of interpretive subject.

As Flanagan, Athey, and, seemingly against his will, Stelarc make clear in their public stagings of bodily pain, the self-violated body is subjectified (it chooses and has inflicted its own pain). It marks the collectivity of individual cases of bodily pain, which become social—and highly emotive—through the kind of visceral identification it solicits.

"Hollow" Body Performances

Beginning in the 1970s, Stelarc performed several pieces that involved having medical personnel assist him in inserting an arthroscopic camera into his stom-

ach. The footage from these internal excavations was then projected for audience viewing. Of such pieces, Stelarc noted to fellow body artist Paul McCarthy, "I was intrigued about the notion of the body being a self-contained entity. . . . What people saw was the internal structure of my body on a video screen as well as the sealed external body."[34] In the 1993 performance *Hollow Body / Host Space: Stomach Sculpture,* for example, the camera was conceived as a kind of "sculpture" tracking his bodily interior. In this case, as Stelarc argues, "technology invades and functions within the body. Not as a prosthetic replacement but as an aesthetic adornment; the hollow body becomes a host, not for a self but simply for a sculpture."[35]

Once again, Stelarc's rhetoric contradicts the literally *visceral* affect and effects of the piece. First of all, the external body (as his earlier sewing of orifices made clear) is not "sealed." The body is porous, permeable, and enmeshed in the flesh of the world. Second, as the viewer watches Stelarc's gleaming stomach walls and its contents slosh about on a video screen, he is proclaiming there is nothing there—that the body is "hollow." (This claim is central to his idea of the hard, invulnerable, yet obsolete body: "The strategy should be to HOLLOW, HARDEN, and

Microfilm image of the inside of the artist's stomach, Yaesu Centre, Tokyo, 1973. Photo by Mutsu Kitagawa.

DEHYDRATE the body to make it more durable and less vulnerable. . . . THE HOL-LOW BODY WOULD BE A BETTER HOST FOR TECHNOLOGICAL COMPONENTS.")[36] This supposedly empty body whose contents are rendered visible is a reminder of the nefarious psychoanalytic claim that women have "nothing" as genitals—a phantasmagorical, projection of "lack" that says far more about the person who imagines it than about the body supposedly marked by its regime of absence. Ste-larc's rhetorically defined "hollow body," then, seems to point to his anxieties about his own potential nothingness, emptiness, and mortality—not (as the viewer can see) to its actual or literal lack.

A powerful counterexample to Stelarc's *Hollow Body,* which penetrates the body and makes visible the wet, sloshing folds of its interior, is Mona Hatoum's *Corps Étranger* (1991). Hatoum also corralled the help of medical professionals to have an arthroscopic camera run across the surfaces and penetrate all of the orifi-ces of her body.[37] In the final installation, the video footage from this exploration is projected onto a circular screen built into the floor, approximately five feet wide, accompanied by the eerie sounds of the body's internal workings. The vis-itor enters a small circular white booth to loom over the video screen, with its plummeting trajectory through sucking orifices and passageways, surrounded by the pulsating rhythms of Hatoum's breath, heartbeat, and gurgling viscera.

The "strange" or "foreign" body might, variously, be construed and felt as the camera probing Hatoum's corporeal form; as Hatoum as the *other* at whom we gaze, inside and out (a Palestinian immigrant living in England, she is *other* in more ways than one in relation to the dominant culture of the art world and be-yond); or as ourselves.[38] We feel radically aware of our own wet embodiment, of the continuous folds of flesh that, like the surfaces of a Möbius strip, endlessly slither from exterior to interior. Rather than acting as a boundary defining the limits of the corporeal self, the flesh in Hatoum's pieces refuses the role of limit-ing contour. It is continuous and never ending. At one point, it is esophagal, at another nasal, at another the smooth surface of the stomach. When it becomes vaginal, the specificity of the viewer's own bodily identifications is provoked.

While using the same technological devices (more or less) as Stelarc in his *Hollow Body,* Hatoum interrogates—and, through video projection, recreates—a corporeal, cognate subject who is far from abstract. The imagery is viscous, tun-neling, wet, pulsating; it could be anyone's body and yet clearly is not. That mole,

Stomach Sculpture, Fifth Australian Sculpture Triennale, NGV, Melbourne, 11 September– 24 October 1993. Photo by Anthony Figallo.

those dark swathes of facial hair are particular. That vaginal canal couldn't be just anyone's.[39] In response, the visitor experiences her or his own particularity— through *identification* or not. (I have marveled before, in writing about this piece, at how a man, heterosexual or gay, might experience the voyage through the vaginal canal.)[40]

In contrast, Stelarc's spectator is not sucked into the penetrated flesh, as the spectator is with Hatoum's voracious tunneling screen. Stelarc's spectator is the alienated viewer *out there* who is left to wonder at the insistence of the artist's desire to avoid (and to void) the body, to call it obsolete, done, finished, and yet to do so through an obsessive manipulation of its brute materiality. He dreams a "phantom body" that is "hollow." But *his* body, I can see it now, is still (as he describes that annoyingly persistent physical body) "ponderous and particular"— and wet, folded, penetrable—in its refusal to fade away into obsolescence.[41] I can even, by imaginative projection, *smell* the acid-filled contents of his stomach as it does its everyday digestive work. In this way, a gagging response—one of the most direct "proofs" of embodiment in all of its gross vicissitudes—is one of many that the piece might provoke.

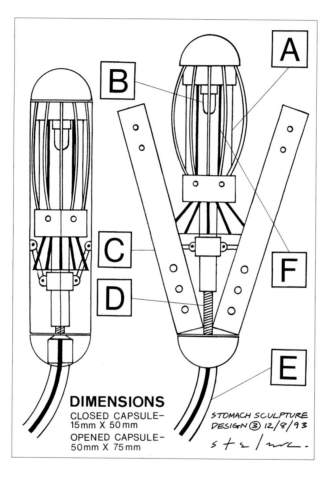

Both Stelarc and Hatoum produce imagery of the sloshing internal waste and flesh that comprise the body. Hatoum's body collapses into the screen of representation such that the screen *becomes* the skin of the other, to be touched by the gravity-weighted body of the viewer. This skin/screen art historian Christine Ross concludes, is marked through such touch as abject.[42] Stelarc's body is (as Massumi put it in the quotation above) "stranded through abjection." Stelarc's abjection is self-inflicted (or at least willfully self-exacerbated) and managed through the containment and control of his body. The *failure* of his attempts at

management, in my view, makes the "hollow" body performances effective. The gag response we experience recalls us so powerfully to our embeddedness in the flesh of the world and our ultimate failure to control the body's responses to this unpredictable world. As Ross suggests, Hatoum's abjection, in contrast, explicitly calls on the viewer to engage with it in a politicized way. Hatoum's abjection encourages the visitor experiencing the piece to acknowledge his or her own inexorable state of abject disarray (mortality, vulnerability, flow) and thereby to admit the *otherness within the self*—no matter how white, heterosexual, and male this self might appear to be.

Prostheses

Through his myriad works involving extending the body through mechanical (sometimes digitally controlled) prostheses, Stelarc concretizes the fantasy of the Bionic Man. Again, the ambiguity and wrenching melancholy of these works— as evoked for me in my experience of his *Third Hand* piece—is compromised by his verbal rhetoric, which insists that these works are all about prosthetically improving the body, forcing its more rapid evolution so it can function more efficiently (and apparently less emotively but in a more abstracted and Cartesian fashion) in the highly saturated information age in which we live.

But Stelarc's robotic pieces all involve fantasies of control and domination, whether by his own cognate-corporeal volition, as in the original *Third Hand* works (where his stomach and arm muscles determined the movement of the prosthesis), or by Internet signals that are prompted either by users or by random Internet noise. In the latter type works, such as *Ping Body: An Internet Actuated Performance* from 1996, the artist ostensibly relinquishes this volition to nondirected informational input. In Stelarc's words, "Random pinging over 30 global Internet domains produce[s] values from 0 to 2000 milliseconds that are mapped [onto various muscles in the arms and legs] . . . via a computer-interfaced stimulation system . . . initiating involuntary movements."[43]

Stelarc is at the forefront of artistic experimentation with robotics.[44] While technotheorists wax euphoric about the capacity to expand bodily functions through prosthetics, Stelarc calls them at their game, enacting a prosthetic body that points to the abstract limits (if not the concrete, literal ones—here he is still

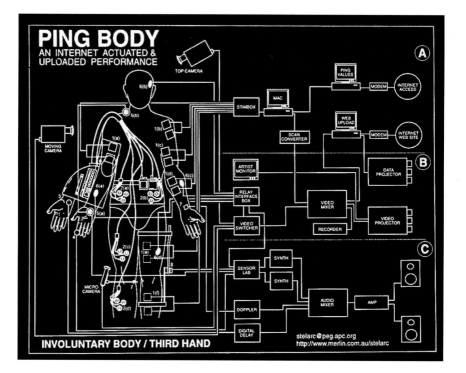

utopian) of the flesh/machine interface. In this way, Stelarc's Internet-driven *Ping Body* makes an abstract point about the everyday experience (now, for many of us) of being technologically extended: for example, communicating by keyboard through the Internet or by cell phone while driving a car.[45] As Massumi puts it, his works point to "*cyber-'space' [as] . . . a dynamic field of transduction,*" of transformative relays that substantiate "the networked coincidence of the subject and object." Stelarc's body, a plugged-in body-self, "*is* the network—a *self-network*."[46]

A number of artists have deployed apparent technological prostheses in less utopian ways, however, explicitly pointing to the tendency of the field of technological "transductions" to affect different subjects in different ways, depending on their perceived identifications and specific modes of occupying social and political spaces. Although Stelarc's work is both literal (he concretizes the technological invasion and extension of the body) and abstract (his technologized body

may appear to be without explicit content), artists such as Guillermo Gomez-Peña have produced cyberbodies (or at least "virtual" or fake ones) that, like Hatoum's "foreign body," interrogate the *specificity* of technology's bodily effects.

In his recent collaborative project, the live performance entitled *Etno-Tecno: A Living Diorama of Fetish-ized Others* (2002), Gomez-Peña deploys largely fake technological extensions and projected video footage to perform and at the same time take apart cultural stereotypes of various nonwhite, apparently non-first-world subjects.[47] Three platforms display four different "ethno-cyborgs" who now and again come off their designated platforms to interact with each other and members of the audience (the latter of whom are free to mill around the small theater), while a large screen conveys video clips from other cultural interventions by Gomez-Peña and his collaborators.

One of the four flamboyantly stereotypical characters is the chain-smoking, rage-filled Mexican immigrant turned border guard, El Mad Mex. Gomez-Peña's absurd and overwrought cyborg character sports an array of masculine and feminine costumes (including an "Aztec kilt [of] authentic Scottish design but made of zarape" and red high-heeled women's shoes). He also wears metallic "high-tech" body extensions that might have come from the shelves of Toys "Я" Us (arm and knee "lowrider" braces) or that might be slightly outmoded devices hearkening back to the predigital age (such as a dysfunctional megaphone).[48] Robo-xolotl's hard (but definitely not dry) brown body gleams with sweat and tattoos as he brings to life the always already technologized and commodified body of the third-world working-class subject. The Hawaiian Doll grotesquely exaggerates a South Pacific feminine subject type whose pliancy is so aggressive that it becomes menacingly predatory. The excessively "hot" Femma Latina Extrema gyrates through choreographies seemingly drawn from diverse sources ranging from tango to pornographic film. In concert, these excessive characters produce what Gomez-Peña calls "an intermediate cultural space: a border zone located between . . . Latino and Anglo-America; . . . between the Pre-Columbian past and the digital future."[49]

Gomez-Peña's program notes to the performance/installation are explicit: "'Etno Tecno' . . . shows how the global media demonstrates, sexualizes, or fetishizes the various cultural 'otherness[es]' that are not included in the so-called 'global project.'"[50] The notes and the performance point to the spaces of high

technology not as virtual sites of abstracted, utopian transduction—as Massumi (and, he argues, Stelarc) would have it—but as alternative networks of global capitalist tourism where cultural stereotypes are reiterated with discursive and (as such) concrete effects on specific embodied cognate subjects. Correlatively, enacting these subjects through hyperbolic and obviously "unreal" performative expressions, Gomez-Peña and his collaborators mark them as mutable: they can be exploded through excess.

Gomez-Peña activates what he has called his "Chicano robotics" and "hand-made lowrider prosthetics"[51] even more dramatically in his CyberVato prototypes and other versions of El Mad Mex, where he and his collaborators sport what look like Fisher-Price versions of telephone headsets and fake metal arm extensions—technobody parts that eerily echo Stelarc's wired high-tech third arm. In one version of El Mad Mex that functions as a direct parody of Stelarc's heroicized robotic performances, Gomez-Peña, sporting long braids and a bustier, has his robotic hand (which looks like an expensive toy) "betray" him, viciously tearing at his mouth. Elsewhere, Gomez-Peña contextualizes this work: "What if Stelarc had been born in Tijuana? His second (robotic) hand suddenly would betray him and deform his identity, *que no?*"[52] Far from heroically extending his bodily power, Gomez-Peña's arm attacks him as if to say "technology is *not* always your friend" (nor is it always as seamlessly incorporated into the body and mind as some technotheorists would imagine). Gomez-Peña's project unhinges first-world claims of technological transcendence through theatrical excess and the re-iteration of cultural stereotypes about the so-called third world.

Through this strategy of what he calls "reverse anthropology," the performances that Gomez-Peña orchestrates (often with the collaboration of partners such as Roberto Sifuentes) stage the way in which—in industrial-era colonialism as well as in the highly technologized postcolonialism of global capitalism—self-proclaimed first-world cultures such as the United States relegate the "Mexican" body to a static past (marked as deliberately *fake*) through global capitalist stereotyping.[53] In this way, Gomez-Peña reiterates—but again, through a disruptive excessiveness—the dynamic of fetishism whereby "foreign" or "third-world" objects (coextensive with "foreign" or "third-world" subjects) are constructed as static (without history) in opposition to the subjects of Western rationality and dynamic cultural "progress."[54] As Gomez-Peña characterizes this dynamic, "Caught

between a pre-industrial past and an imposed modernity, we are identified as manual beings—*Homo fabers* per excellence, imaginative artisans (not technicians), and our understanding of the world is [viewed as] strictly political, or at best metaphysical, but certainly not scientific."[55]

The obvious fakeness of Gomez-Peña's technological extensions parodies the yearning for technocommodities that first-world discourses put into play, exposing what (to return to Jennifer Gonzalez's points) is at stake in the "montage of organic bodies and machines" in Stelarc's complex and provocative robotic works. Gomez-Peña's virtual robotic works—with their overtly erotic excess and irrational, hysterical fakery, among many other things—engage Stelarc's rationalism and turn it inside out, honoring his preeminence in the field of experimental robotic aesthetics while exposing the limitations of utopian, technotheoretical fantasies of transcending the body through technology.

Wet and Inconclusive Conclusions . . .

If nothing else, I hope here to have mitigated the certitude of Stelarc's own rhetoric by returning his body to a productive state of fluidity and disorder (one obviously conditioned here by my own interests, desires, and concerns, as well as by my own embodiment). Arthur and Marilouise Kroker have argued that, like Stelarc, "we use the body to react against the body."[56] In contrast to this idea, the logic of which reinforces Stelarc's antagonism to the body, I have tried explicitly to "use" Stelarc's body to react *in favor of* embodiment. When I viewed his performance of the *Third Hand* live, this was, in fact, the use I made of him. Without thinking, I reacted in such a way as to substantiate (rather than mitigate or disavow) my own embodiment.

Let me end by interrogating one more example of what we might call the "Stelarcian imaginary": his recent fantasy of virtual lovemaking, in which a person's hand touching his own body would be wired into a "sensual and sensory loop," transferred across the Internet to trigger sensations of erotic pleasure in a remotely located "lover."[57] Stelarc celebrates the "cybersexual possibilities" of such a networked eroticism through an idea that, if implemented, would concretize the supreme narcissism of the postmodern condition, as identified in discourses about postmodernism from the 1960s onward.[58]

Once again, Stelarc's fertile imagination, coupled with his ongoing desire for bodily transcendence, enables him to push the boundaries of our deepest conceptions of self and other, which ultimately pivot around the inexorable "problem" of our morality as well as around the erotic self/other relation. At the same time, there are limits to this fantasy of transcendence—limits that are marked by the specificity of Stelarc's as well as our own bodily identifications. As Derek A. Burrill observes about Stelarc's practice, "The body of power which extends over the Net, across the globe, and into our P.C.s is a corpus closely associated with the masculine body."[59]

Stelarc's repeated claims that birth itself can be obviated through technology seem to substantiate this problematic alignment. In a 1991 article "Prosthetics, Robotics, and Remote Existence: Postevoluntary Strategies," Stelarc thus argues that with new technologies of fertilization outside the womb and artificial support systems for the fetus, "THERE WILL TECHNICALLY BE NO BIRTH."[60] In combination with his earlier statements about wanting to mimic the pain of childbirth through his suspensions, this comment looks suspiciously like an expression of Stelarc's desire to replace the anatomically female body (whatever that may be—it's not so clear these days) entirely with his pain-filled, prosthetically enhanced one. The male fantasy of sex and procreation without the bother of involving female bodies is an ancient one in the tradition of Western thought.

But more is at stake than transcending embodiment and gender roles, which are psychically and biologically motivated if not (we are now, given technological "advances," forced to realize) biologically determined in the last instance. Later in the same article, Stelarc argues that with body "redesigned in a modular fashion to facilitate the replacement of malfunctioning parts, then TECHNICALLY THERE WOULD BE NO REASON FOR DEATH. . . . Death does not authenticate existence. It is an outmoded evolutionary strategy."[61]

Finally, the proverbial cat's out of the bag: all of these proclamations are really, then, about escaping death itself. As with all fantasies of transcending the body, the fear of death is the most powerful motivating factor. In a poignant way, Stelarc returns us (in spite of his rhetorical insistence on the disembodied *post*human subject) to a kind of perverse humanism (or posthumanism?). We can theorize all we want about obsolescence, but hidden behind all the technorhetoric is the violent terror we experience in the face of contemplating (or failing to con-

template) our own death, the planned obsolescence not only of our bodies but of the consciousness that animates them. As far as we secularists know, *this* particular obsolescence is inexorable and unavoidable, at least at this point in time.

Stelarc's foreclosure of body-to-body contact in this newly articulated fantasy of wired lovemaking, his conflation of self-body with other-body (of love object with loved self-as-object), produces the ultimate rationalized, instrumentalized, explicitly onanistic postmodern subject: one who makes love by stroking himself while imagining he is consorting with another. One might be inspired to ask whether the remote lover is necessary at all in this fantasy of networked eroticism. The danger here is that the obliteration of otherness leads to more confirmation of the "self same."[62]

At any rate, why this kind of closed circle of erotic "fulfillment," seemingly evacuated of emotional content, would be a goal to shoot for is anyone's guess. The thought of it does not appeal to me. My refusal of Stelarc's idea forces me to acknowledge the extent to which I am still deeply mired in—clinging to—my embodiment as proof of my being alive (the conundrum being that such proof comes at the cost of recognizing the inevitability of death). For what would my pain (bodily, emotional, mental, and intellectual all at once) *be* if it were not attached to my corpus? What would my desire *be?* What would be the point of consciousness if there were no death, no ultimate mitigation of the illusion of free will?

Finally, to avoid seeming more critical of than enthusiastic about Stelarc's work, let me emphasize that my crankiness is born of the unpleasant and difficult thoughts that his complex practice has productively forced me to confront. Stelarc deserves close attention for the way in which he pushes our buttons (fleshy and otherwise). A Stelarcian proclamation that I find agreeable and even empowering expresses a need for transformation and acknowledging "new desires" rather than reiterating age-old tropes that seem to reinforce a masculinist view of the world: "Alternate operational possibilities [of the body] . . . create new desires and new ways of integrating with the world."[63] It is the energizing, utopian hope of (figuratively) rewiring embodied consciousness to allow for "new ways of integrating with the world" that is worth maintaining—but only with the caveat that these ways acknowledge the specificity of the bodies (and subjects) that are in question at every moment and in every "operational" situation.

Notes

1. At the "Performative Sites" conference, Pennsylvania State University, University Park, PA, 24–28 October 2000.

2. Janet Koplos, "Stelarc at The Kitchen," *Art in America* 81, no. 12 (December 1993): 104.

3. Timothy Murray makes note of this tension, implying—as I argue here—that Stelarc's practice is far more productively ambiguous than his categorical and incendiary statements suggest. Timothy Murray, "Coda of the Paradox of Shed Skin: Stelarc 'and' the Philosophical Ping," in Marina Gržinić, ed., *Stelarc: Political Prosthesis and Knowledge of the Body* (Ljubljana, Slovenia: Maska, 2002), 81–93.

4. Stelarc, "Special Feature: The Function of Art in Culture Today," *High Performance* 11, nos. 1–2, issues 41–42 (Spring–Summer 1988), 70.

5. Stelarc, "Prosthetics, Robotics, and Remote Existence: Postevolutionary Strategies," *Leonardo* 24, no. 5 (1991): 592.

6. Klaus Theweleit, *Male Fantasies,* vol. 1, *Women, Floods, Bodies, Histories,* and vol. 2, *Male Bodies: Psychoanalyzing the White Terror,* trans. Stephen Conway, Erica Carter, and Chris Turner (Minneapolis: University of Minnesota Press, 1987, 1989). Theweleit's model is psychoanalytical, and he interprets the actual armor of the male soldier (his uniform and weapon-prostheses) as metaphorically reinforcing the shattered, formless ego: "The soldier males' ego-functions are disseminated across the whole range of totality-machines within which they function." Theweleit, *Male Fantasies,* 2:223.

7. Stelarc, cited in James D. Paffrath and Stelarc, eds., *Obsolete Body/Suspensions/Stelarc* (Davis, CA: JP Publications, 1984), 8. Other authors have pointed to this aspect of Stelarc's rhetoric and to its problematic Cartesianism. Most notably, in this same volume, Ryoichi Hirai states that it is impossible to "objectify the body because it *is* a part of nature. YOU CAN'T ESCAPE FROM YOUR SKIN!" (13). And in an unpublished paper, Derek A. Burrill has noted that Stelarc's "science fictive experiments attempt to transcend politics and ideology" and reiterate many conflicts embedded in utopianism. Derek A. Burrill, "Stelarc and the Virtual Utopia," unpublished portion of "Twentieth-Century Digital Boy: Masculinities, Performance, Video Games, and the Digital Imaginary," diss., UC Davis, 2001, p. 127. I am indebted to Burrill for sharing this section of his dissertation with me.

8. Simone de Beauvoir, *The Second Sex,* trans. and ed. H.M. Parshley (New York: Knopf, 1953). (Original work published in 1949.)

9. Simon Penny, "The Virtualization of Art Practice: Body Knowledge and the Engineering Worldview," *Art Journal* 56, no. 3 (Fall 1997): 31. Penny's work and his personal recommendations to me for readings in neuroscience have been very useful to me in writing this essay.

10. Noah Kennedy, *The Industrialization of Intelligence: Mind and Machine in the Modern Age* (London: Unwin Hyman, 1989), 6, as cited in Penny, "The Virtualization of Art Practice," 31.

11. Hubert Dreyfus, *What Computers Still Can't Do: A Critique of Artificial Reason* (Cambridge, MA: MIT Press, 1999), xx–xxv. (Original work published in 1972)

12. Francisco Varela, Evan Thompson, and Eleanor Rosch, *Embodied Mind: Cognitive Science and Human Experience* (Cambridge, MA: MIT Press, 1992), xx. As Penny puts it, "Consciousness . . . is a physiologically distributed bodily thing, and arises from the interdependence of parts in a decentralized system." "The Virtualization of Art Practice," 35.

13. Antonio R. Damasio, *Descartes' Error: Emotion, Reason, and the Human Brain* (New York: Quill/Putman Berkeley, 2000), xvi.

14. Merleau-Ponty develops these terms in his essay "The Intertwining— The Chiasm," in *Visible and Invisible* (1964), trans. Alphonso Lingis, ed. Claude Lefort (Evanston: Northwestern University Press, 1968), 130–155.

15. Stelarc, "Special Feature: The Function of Art in Culture Today," 70. He reiterates this claim frequently—for example, arguing that "The body not as a subject but as an object—NOT AS AN OBJECT OF DESIRE BUT AS AN OBJECT OF DESIGNING. . . . having confronted *its image of obsolescence,* the body is traumatized to split from the realm of subjectivity and consider the necessity of reexamining and possibly *redesigning* its very structure." Stelarc, "Prosthetics, Robotics, and Remote Existence," 591.

16. That Stelarc implicitly reiterates the rather conservative idea of the body preexisting technology is another problem that I will not address at any length here. Suffice it to say that this idea has roots in longstanding tropes of Western thinking. On the other side are the arguments launched in the Enlightenment and beyond that recognize the human subject *as itself a machine.* Thus, in the eighteenth century, Julien Offray de la Mettrie declared "man a machine," using this metaphor to counter Cartesianism. De la Mettrie argues that the body/machine is also a thinking and spiritual entity: "the diverse states of the soul are always correlative with those of the body." Julien Offray de la Mettrie, *L'Homme machine (Man a Machine),* trans. Gertrude C. Bussey and M. W. Calkins (La Salle, IL: Open Court, 1961), 97. (Original work published in 1748.)

17. Brian Massumi, *Parables for the Virtual: Movement, Affect, Sensation* (Durham: Duke University Press, 2002), 130.

18. I discuss this repression of the body in my chapter "The 'Pollockian Performative' and the Revision of the Modernist Subject," in *Body Art/Performing the Subject* (Minneapolis: University of Minnesota Press, 1998), 53–102; and in my essay "Body," in Robert S. Nelson and Richard Shiff, eds., *Critical Terms for Art History,* 2nd ed. (Chicago: University of Chicago Press, 2003).

19. Murray, "Coda of the Paradox of Shed Skin," 87. "The Anaesthetized Body" is available at http://www.stelarc.va.com.au/anaesth/heading.gif.

20. Stelarc, "Special Feature: The Function of Art in Culture Today," 70.

21. I am extremely grateful to Jurij Krpan, director of Kapelica Gallery (a performance space) in Ljubljana, Slovenia, for our e-mail dialogue on Stelarc's work in which he made this point (among many other interesting arguments about Stelarc). Massumi's chapter on Stelarc is tough to understand much less to summarize (that is part of his point). As far as I understand him, he is essentially arguing that Stelarc's moving body—overtly and aggressively technologized through suspensions, prosthetics, and inserted cameras—explores the problem of "[h]ow . . . the body thinks itself . . . tweak[ing] the human body-object into a sensitivity to new forces," staging sensation collectively, and thereby encouraging the audience to confront the interrelations among cognition and embodiment. Massumi, Parables for the Virtual, 90, 112, 120.

22. Jennifer Gonzalez, "Envisioning Cyborg Bodies: Notes from Current Research," in Chris Hables Gray, with Heidi J. Figueroa-Sarriera and Steven Mentor, eds., The Cyborg Handbook (New York: Routledge, 1995), 273.

23. See Rachel Rosenthal on Stelarc's tendency to refer to himself as "the body" in her essay "Stelarc, Performance, and Masochism," in Paffrath and Stelarc, Obsolete Body/Suspensions/Stelarc, 70. Massumi addresses identity politics only at the very end of his chapter (in this volume), where he argues for the usefulness of Stelarc's abstracting approach to the body. He argues that instead of explicitly examining social inequities owing to specific bodily identifications or arguing directly against bodily oppression and discrimination, Stelarc is an "experimenter in criticality" rather than a "reflective critical thinker [who] anchors discussion in the 'no's' of will not/should not." As an experimenter, Stelarc's "desire is to affirm the conversion" (the transformations in human embodiment and subjectivity) to "enable [human justice issues] . . . to be reposed and operated on in an entirely new problematic," 183–184. In general, I am in favor of abstract philosophical thought about how an abstracted approach to embodiment and to technological and social oppressions might create a space for human justice issues to be readdressed. Unfortunately, however, I don't see that Stelarc's work facilitates such discussions. The discourse surrounding his work is either complimentary and largely uncritical or in some cases guardedly critical (like Burrill's feminist critique, noted above). His work has rarely been discussed in ways that indicate that issues of human justice are being reconsidered at all.

24. I am aware of several problems with this argument, which nonetheless I feel compelled to make. I am assuming that Stelarc experiences himself as completely enfranchised. But Stelarc is a member of a Greek Cypriot immigrant family that has surely experienced its own discriminations in Australia. My assumption is clearly an oversimplification. More important, I am instrumentalizing the meaning of the body, which Massumi warns against: "Meaning . . . props up the old body—the will-

controlled body-object—over the abyss of its obsolescence." Massumi, *Parables for the Virtuous,* 119. In so doing, I am in danger of appearing to deny the subtle claims that Massumi makes for Stelarc's project—that it is exploring a process already in motion, "affirming the conversion" of the body that has already taking place, and through experimental manipulations of it, encouraging the reposing of human-justice issues in nonseemingly essentializing, corporeally linked terms (see the previous note).

I am rather flat-footedly claiming a relationship between the body's appearance and its probable social experience, however, because I do not feel we are at a point where it is advantageous (speaking as an advocate of "social justice") to act as if such relationships have been surpassed in the dominant cultural logic that motivates our intersubjective relations and political systems. The body's appearance and the perceptions of its apparent identifications still deeply (over-)determine social experience as well as internally felt world understandings. It is disingenuous to suggest that we are ready to shift the terrain to a kind of practice that works completely abstractly, supposedly to open the way to a new logic of postembodiment. Too much is wrong with the world—specifically in terms of bodily identifications—to encourage flying unguardedly into abstractions or embracing the idea that the body is in concept or in fact obsolete.

25. Stelarc's caption illustrating the photograph of the piece in Gržinić, *Stelarc: Political Prosthesis,* 42.

26. Massumi, *Parables for the Virtual,* 105.

27. Cited in "Preface," Paffrath and Stelarc, *Obsolete Body/Suspensions/Stelarc,* 8.

28. For complete descriptions of Athey's events, see http://www.ronathey.com.

29. I discuss this latter prochoice piece by Flanagan and Rose in "If Men Could Get Pregnant . . . : Bob Flanagan and Sheree Rose's *Issues of Choice,*" *New Observations* (New York) 100 (March–April 1994): 21–26.

30. Stelarc, "Parasite Visions: Alternate, Intimate, and Involuntary Experiences," *Art & Design* 12, nos. 9–10 (September–October 1997): 69.

31. Stelarc, "Towards the Post-Human: From Psycho-body to Cyber-system," *Architectural Design* (1995): 93.

32. Massumi, *Parables for the Virtual,* 114.

33. See my essay on male masochism and body art, "Dis/Playing the Phallus: Male Artists Perform Their Masculinities," *Art History* 17, no. 4 (December 1994): 546–584.

34. "The Body Obsolete: Paul McCarthy Interviews Stelarc," *High Performance* 6, no. 4, issue 24 (1983): 18.

35. Gržinić, *Stelarc: Political Prosthesis,* 64.

36. Stelarc, "Prosthetics, Robotics, and Remote Existence," 592.

37. Well, maybe not her anus. I did not "experience" this particular penetration in viewing the piece, but I might have missed it.

38. In Ewa Lajer-Burcharth's terms, Hatoum projects the otherness *within* the self by turning her body inside out. Lajer-Burcharth, "Strange Bodies: Video in the Nineties," paper presented in the Department of Art History, UCLA, 12 April 1996.

39. This is not to deny that subjects with XY sex chromosomes, born anatomically without a vagina, can now have an approximation of one surgically excavated into their flesh. Rather, many of us experience the wet opening of the vagina structurally from our earliest moments of self-reflection and hence would tend to identify in a particular embodied way with this particular penetratory moment in Hatoum's video footage. Allow me a moment of partial essentialism here.

40. I discuss Hatoum's piece in these terms in "Televisual Flesh: Activating Otherness in New Media Art," PARACHUTE, *Digital Screens* 113 (2004): 70–91.

41. Stelarc, "Towards the Post-Human: From Psycho-body to Cyber-system," *Architectural Design* 118 (Nov.–Dec. 1995): 95.

42. Christine Ross, "To Touch the Other: A Story of Corpo-Electronic Surfaces," *Public* 13 (1996): 55–56.

43. Gržinić, *Stelarc: Political Prosthesis,* 63.

44. For a general overview of robotic art, see Eduardo Kac, "Foundation and Development of Robotic Art," *Art Journal* 56, no. 3 (Fall 1997): 60–67.

45. I say for many of us because many poor areas of the world do not support universal or even partial access to Internet and other technologies. Even in the United States, there are vast areas of impoverishment where citizens' only access to the Internet is at a local library (where the computers might be antiquated and hours might be cut back because of budget cuts).

46. Massumi, *Parables for the Virtual,* 127.

47. I saw this piece performed as part of the International Latino Theatre Festival of Los Angeles, Frida Kahlo Theatre, Los Angeles, 1 November 2002. Gomez-Peña's collaborators for this piece were Juan Ybarra (playing Robo-xolotl), from Mexico City and California; Michelle Ceballos (Femma Latina Extrema), from Colombia and Arizona; and Leilani Chan (the Hawaiian Doll), from Hawaii and Los Angeles.

48. These quoted descriptions are from an e-mail sent to me by Gomez-Peña, 26 November 2002. I am extremely grateful to the artist for being in dialogue with me about this work.

49. Gomez-Peña, "Artist Notes," handed out at the performance.

50. Program notes, in the program for International Latino Theatre Festival of Los Angeles, 1–20 November 2002, no. p.

51. Gomez-Peña, diary notes, 1998 (copy furnished to the author).

52. The piece is illustrated in Guillermo Gomez-Peña, *Dangerous Border Crossers: The Artist Talks Back* (New York: Routledge, 2000), 49; see also *CyberVato Pro-*

totype #227, illustrated on 53. Gomez-Peña's Stelarc comment comes from his diary notes, 1998 (copy furnished to the author).

53. On reverse ethnography, see Gomez-Peña, "Ethno-cyborgs and Genetically Engineered Mexicans: Recent Experiments in 'Ethno-Techno' Art," in *Dangerous Border Crossings,* 45–57. See also Gomez-Peña's contribution (in collaboration with Roberto Sifuentes and Matthew Finch) to the forum I organized on "The Body and Technology"; this piece is entitled "Aztechnology," *Art Journal* 60, no. 1 (Spring 2001): 33–39.

54. On this dynamic, see Timothy Mitchell, "Orientalism and the Exhibitionary Order," in Donald Preziosi, ed., *The Art of Art History: A Critical Anthology* (Oxford: Oxford University Press, 1998), 455–472.

55. Gomez-Peña, diary notes, 1998 (copy furnished to the author).

56. Arthur and Marilouise Kroker, "We Are All Stelarcs Now," in Gržinić, *Stelarc: Political Prosthesis,* 73; a later version of which appears in this monograph.

57. Stelarc presented this idea at the "Performative Sites" conference, note 1. These quotations are from that presentation.

58. On postmodernism as a "culture of narcissism," see the reactionary account by Christopher Lasch, *The Culture of Narcissism: American Life in an Age of Diminishing Expectations* (New York: Norton, 1979). This kind of onanistic practice parallels but also poses a strong contrast to the masturbatory hysterics of performance artists such as Paul McCarthy and Vito Acconci from the 1970s and, in McCarthy's case, following decades. Both of these artists, in contrast to Stelarc, focus their onanism in a way that explodes fantasies of the self-sufficiency of the male sexual subject or of the transcendence of the male body. I discuss Acconci's work in "The Body in Action: Vito Acconci and the 'Coherent' Male Artistic Subject," in *Body Art,* 103–150; and McCarthy's in "Paul McCarthy's Inside Out Body and the Desublimation of Masculinity," in Dan Cameron and Lisa Phillips, eds., *Paul McCarthy* (New York: New Museum of Contemporary Art, 2000), 125–133.

59. Burrill, "Stelarc and the Virtual Utopia," 134.

60. Stelarc, "Prosthetics, Robotics, and Remote Existence," 593.

61. Ibid.

62. See Luce Irigaray on patriarchy's construction of masculinity as the self same in her important book *Speculum of the Other Woman,* trans. Gillian C. Gill (Ithaca: Cornell University Press, 1985). (Original work published in 1974)

63. Stelarc in a 1995 interview with Nicholas Zurbrugg, cited in Nicholas Zurbrugg, "Technology, Polypoetry and the Aura of Poly-performance," *Voicimage,* special issue of *Visible Language* 35.1, no. 9 (2001), 29.

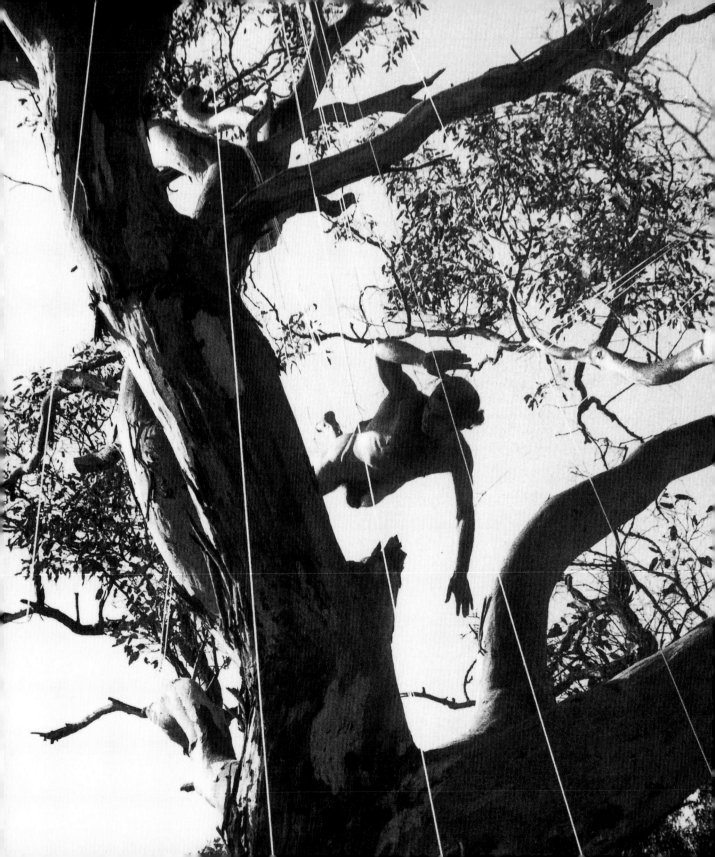

THE EVOLUTIONARY ALCHEMY OF REASON[1] Brian Massumi

PROJECT: "extend intelligence beyond the earth."[2]

MEDIUM: the body

Correction: the body is "obsolete."

Now there's a bind: a "body artist" who wants to operate on intelligence. Wouldn't that make him a "conceptual" artist? He gives every sign of wanting to have it both ways, making his medium the body *and* ideas. But then he goes and says that the first is "obsolete,"[3] all the while protesting that his work operates entirely outside of the "outmoded metaphysical distinctions of soul-body or mind-brain."[4] Talk about difficult to please.

One thing that is clear is that Stelarc is not a conceptual artist. He is not interested in communicating concepts *about* the body. What he is interested in is experiencing the body *as* concept. He thinks of his performances—which involve minutely prepared, "austere" probings of the functional limits of the body—as a direct "physical experience of ideas."[5] In performance, "expression and experience join," making the body an "actual manifestation of a concept."[6] The *manifestation* of a concept: the concepts Stelarc is interested in cannot be communicated about in the performance because they come into being only through the performance. The ideas he takes as his medium, on a par with the body, do not preexist their physical expression. That is why his first performances were accompanied by no "notices, manifestos or written explanations."[7] Only after the manifestation of the ideas began in the body were they able to be disengaged

enough from it to enter speech and writing. Stelarc's art starts from and continually returns to a point at which idea and body have not yet split or at which they have rejoined. His medium is the body as a *sensible concept*. Problem: In what way is the body an idea and the idea bodily? In what way can probing one extend the other? "*How is it that the body thinks itself?*"[8]

This is the problem that Stelarc's work poses. And this is the problem that the art writer must repose if the concern is to approach the work on its own terms—or even meet it half-way—rather than impose an outside frame of judgment on it. The challenge is to write the rejoining of body and thought that Stelarc performs. This requires a willingness to revisit some our basic notions of what a body is and does as an acting, perceiving, thinking, feeling thing.

The Matter of Intelligence

Imagine for a moment you that are an intelligent insect. Would things be different? This is the question Stelarc seems to be asking in some of his first performances, in which the artist and the audience donned helmets designed to scramble binocular vision by superimposing fragmented rear and side views onto the normal frontal view, producing a technologically assisted humanoid version of the compound eye of the insect.[9] If you had compound eyes, would the properties of the things you perceived be the same? Couldn't be. If their properties were different, would they be the same things? More or less.

In other words, no. This is not an argument for the relativity of perception. Far from it: it is an argument for its necessity. What does the bee see and smell in the flower? Enough to extract pollen from it. A creature's perception is exactly proportioned to its action on the thing. The properties of the perceived thing are properties of the action more than of the thing itself. This does not mean, on the other hand, that the properties are subjective or in the perceiver. On the contrary, they are tokens of the perceiver's and the perceived's concrete inclusion in each other's world. The perception lies *between* the perceiver and the perceived. The sight of the flower is an actual bodily conjunction, a joint material connection of the perceiver and the perceived to different ends of the same reflected light wave, in different ways. That differential conjunction is the latency of a next conjunction. The contour and fragrance of the flower are the presence, to both perceiver

and perceived, in different ways, of a possible touch, where once were only sniff and see. It is an understatement to say that a creature's perceptions are exactly proportioned to its actions. Its perceptions *are* its actions—in their latent state. *Perceptions are possible actions.*[10] They belong to two orders simultaneously: an order of substitution (one conjunction relayed by another—action) and an order of superposition (the latent presence of the next conjunction in the actual one it will relay—anticipation). Both orders are real and express a material necessity (nourishment).

Orders of substitution and superposition are orders of thought, defined as *the reality of an excess over the actual*. This is clearest in the case of anticipation, which in a real and palpable way extends the actual moment beyond itself, superposing one moment on the next in a way that is not just thought but also is felt bodily as a yearning, tending, or tropism. But the definition also applies to substitutions, which never come in ones. There are any number of possible next connections. The bee may be laden and skip the flower. Or instead of collecting, it may return to the hive to signal the source of food. Or it may be duped by a blossoming mimic into trying to mate instead. Or it may mate and eat. Substitutions are cases in a combinatoric (a system of *either-ors* sometimes conjoined as an *and*). Not all possible actions are present as perception to the same degree. All of the permutations composing the combinatoric are not actionably present to the same degree in every perception. Each perception is surrounded by a fringe of unlikelihood, of impalpable possibility.[11] Perception shades off into a systematicity whose exact contours can *only* be thought.

Perception and thought are two poles of the same process. They lie along a continuum. At one pole, more than one substitution is actively superposed, enveloped in the feeling of anticipation of a next action that is not yet determined. This is the perception pole. At the other pole, all possible substitutions are present, deactivated and without overlap, unenveloped in feeling. They are unfolded from action and feeling, arrayed in extrinsic (either-or) relation to one another, determined as alternatives to one another. This is the thought pole. The poles of perception and thought are at the limits of the same continuum. One limit is the mixture of experience as it passes on: action under way and on the way to the next; sensory plug-in; the recognition of having actively plugged in before, memory or the already thought; the feeling of tending to act-think again. The other is

a purification of experience, thought out (the only-thought). At any given con-junction, a creature's activity or lack thereof will place it in the perceptual in-mix *and* simultaneously at a certain degree along the continuum toward the out-thought, depending on the extent to which it can project into a future an array of action substitutions to choose from. This forward projection of perception into latent action choice is its *possibilization*. To possibilize is to stretch perception down the continuum in the direction of the only-thought. Each actual conjunc-tion is a dynamic mixture of different orders materially combining the experi-ence of the actually under way with possibilizing extensions beyond itself. The inextricability of the experiencing and the extension make perception an *analysis in action* and the perceived "thing" a sensible concept.

Every creature connecting with a flower will think-perceive it differently, extending the necessity of its perception into the only-thought of possibility to a varying degree. The lower the degree of possibilization, the vaguer the anticipa-tion, and the more mixed are the alternatives it presents with each other and the feeling of tending enveloped in the action under way: the less thought out it is. The flower is each of the thought-perceptions in which it is implicated, to what-ever degree of thought-perception. This is not to say that there are as many flow-ers as there are florally conjoined creatures. The flower-thing is *all* of the thought-perceptions in which it is implicated. Latent in the flower are all of the differential conjunctions it may enter into. The flower, as a thing "in itself," is its connectibility with other things outside itself. That connectibility is not of the order of action or thought-out anticipation and is therefore not in the mode of possibility. It is of the order of *force*. Each connection is a shared plug-in to a force emitted or transmitted by the flower thing—like a light wave.

The latency in this case is in the mode not of the possible but of energetic *potential*. There is more potentially emitted or transmitted by the flower than any necessary perception that it picks up on (more . . .). The bee's hungry or horny perception is not "relative" to the flower; it is selective of it (. . . *and* less). Per-ception, even before its thinking out, is a limited selection, an actualization of po-tential plug-ins. There is *more* in the "thing" than in the perception of it. The feeling of anticipation as such—as enveloped in action underway in all its mixity and as distinct from the alternatives it can think out into—is a registering of potential. This pending feeling of being selectively plugged in to forces, this reg-

istering of a nextness betokening always more: this may be called *sensation.* Sensation is the registering of the multiplicity of potential connections in the singularity of *a* connection actually under way. It is the direct experience of a more to the less of every perception.[12] It may be considered a third pole or limit of experience, accompanying each degree of action-perception (that is, it is a limit of experience immanent to every step along the continuum).

The latency of the potentials in the flower constitutes an order that follows different rules of formation and is broader in bandwidth and more complexly woven than any possible combinatoric extracted from it. The thought system of the possible is a necessary *loss of order* relative to potential.[13] The latency of the flower is inexhaustible. There are no doubt insectival ways of plugging into floral forces that no bug has yet experienced. More than that, the humblest flower enfolds forces that no creature, not even a human, will ever know to connect to: colors outside the visible spectrum, forces too small, too large, too subtle, or simply too different to conjoin. To answer the question, the flower that the bee sees is not the "same" flower that a human sees. It is a particular, need-oriented selection from the experience of the singular multiplicity that is its inexhaustible complexity as a thing "in itself" (in its potential connections).

So what does a human see in a flower? More than the bee but by no means the full range of its inexhaustible complexity. A human will see enough to extract not just pollen for immediate collection but, to cite but one example, a pharmaceutical for profitable distribution. Human perception is unique in the degree to which it can extend itself into the only-thought and thus into the future in more and more varied ways. It can do this because it is capable of connecting with a thing as if it somehow existed outside of any particular perception of it. Saying that a thing might be considered to be *outside* any particular perception is very different from saying it is *not all in* any particular perception. Taking a thing as "not all in" the particular is to singularly sense the multiplicity of the potential for perceptions it connectively envelops. Taking it as "outside" the particular is to approach it *in general,* as if unconnected. Both are operations of abstraction. The mode of abstraction pertaining to the thing in general concerns the possible, purified of any unplanned interference from unselected-for potentials. The possible is not just an active selection of potential but a systematic simplification of it (as if . . .). Taken in general, the flower-thing becomes the object of a set of

regularized floral connections systematized to ensure the maximum repeatability of the largest number of actions with the maximum uniformity of result. Predictability: anticipation perfected. The *object* is the systematic stockpiling for future use of the possible actions relating to a thing, systematically thought out on the general level of abstraction. Existing only in general, the object is imperceptible. The thought-unseen flower-object doubles each given flower-thing in the order of the possible. It is the future-looking shadow of the actually repeatedly perceived, blooming scentless. Regularized, repeatable, uniform connection—the systematicity of a thing—constitutes a profitable disengagement of the thing's thinking from its perceiving in such a way as to maximize its extension into thought under a certain mode of abstraction.

Paradoxically, this perfecting of the order of substitution is an intensification of the order of superposition pertaining to potential at the same time as it is a disengagement from it. Objectivity makes more possibilities more anticipatable and thus more accessible as next connections. Objectivity shadows the perception with an increased charge of possibility, which cycles back into perception to augment the potentiality of the thing it began by purifying or thinking out. The forces enveloped in the thing have actually gained in the diversity of effects into which they feed. The connectibility of the thing has been increased: it now has more potentials. They have been surcharged, intensified. The thing's general selection returns to it as an augmentation of its singular multiplicity. Its simplification returns to it as a complexification, its loss as a gain in order. Possibilization and potentialization, simplification and complexification, fold into and out of each other. The loss of order is only a moment in an expansive process in which perception and thought form a positive feedback loop (as do things and thought, by way of perception). Things, perceptions, and thoughts are in a reciprocal movement into and out of each other and themselves. They are moments or dimensions of the same process of mutual reinforcement and coconversion. Sensation is the point of coconversion, through which the variations of perception and thought on each other and themselves play out. It is the singular point where what infolds is also unfolding.

The overall process of actual extending into the possible and then looping through sensation into a mutual intensification of potential, perception, and thought: this is *intelligence*. The part of that process consisting in the systematiza-

tion of intelligence in the general mode of possibility is what goes by the name of *instrumental reason*. Instrumental reason is by no means all of intelligence and is not even the only only-thought. It is a thought variety (an analytic variety of the only-thought). Intelligence is an outgrowth of need. Instrumental reason is the extension of need into utility. A greater copresence of possibilities enables a systematic construction of a combinatoric, and by virtue of that a calculated choice is enabled between possible next connections. Even a methodical invention of new connections is possible as previously inaccessible aspects of forces emerge in the course of probings of the thing designed to set its limits of possibility. A bee intelligently analyzes-in-action the flower, toward the fulfillment of a need. The instrumentally reasoning human extends the analysis-in-action in thought toward the invention of utilities. There is no clear and distinct dividing line between intelligence and instrumental reason. Every thought-perception is both, to a varying degree, in mixture and coconversion.

What else does a human see in a flower besides pharmaceuticals? Poetry, for one thing. The extension from need to utility can extend again.

Stelarc's bug goggles fulfilled no need. They extended no need into no utility. And they extended no utility into "art." They were an exercise in the perceptual poetry of instrumental reason.

We started out saying that Stelarc was a body artist and are now saying that his art is in some (poetic) way objective. This is not a contradiction. For the object is an extension of the perceived thing, and the perceived thing is a sensible concept, and the sensible concept is a materialized idea embodied not so much in the perceiving or the perceived considered separately but in their between, in their felt conjunction. But are the terms independent of the conjunction? What is a perceiving body apart from the sum of its perceivings, actual and possible? What is a perceived thing apart from the sum of its being-perceiveds, actual and potential? Separately, each is no action, no analysis, no anticipation, no thing, no body. The thing *is* its being-perceiveds. A body *is* its perceivings. "Body" and "thing" and by extension "body" and "object" exist only as implicated in each other. They are differential plug-ins into the same forces, two poles of the same connectibility. The thing is a pole of the body, and vice versa. Body and thing are extensions of each other. They are mutual implications: cothoughts of two-headed perception. That two-headed perception is the world.[14]

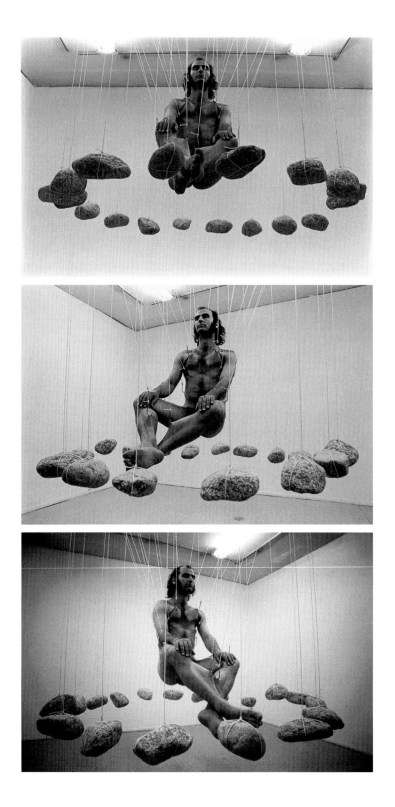

Extensions. The thing, the object, can be considered a *prosthesis* of the body—provided that it is remembered that the body is equally a prosthesis of the thing. *Matter*—as it enters into the double analytic order of necessary substitution and superposition and then extends again into utility, as it enters into things and objects—*itself is prosthetic.* Things and objects are literally, materially, prosthetic organs of the body.[15] But if bodies and objects exist only as implicated in each other, in necessary and useful reciprocity, then isn't it just as accurate to say that the body is literally, materially, an organ of its things? In mutual implication, it is not clear who is used by whom.[16]

Having a instrumentally reasoning body for an organ can be most useful to a thing. A flower in which humans see a pharmaceutical will grow in abundance. Is the flower an aid to the perpetuation of the human, or is the human, like the mimic-duped bee, a reproductive organ of the flower? Both. You can have it either way. It's just a question of which pole you approach the question from. Human and flower are in differential, polar cofunctioning. They meet in the reciprocity of perception. But the reciprocity is not a symmetry, since they plug in differently to contrasting poles of shared forces and travel, through their forcible conjunction, in different directions: one toward individual health maintenance, the other toward species reproduction. Thought-perception is *asymmetrical prosthetic symbiosis.*

A flower in which humans see poetry rather than pharmaceuticals will also grow widely. And differentiate. The poetics of roses has led to a multiplication of strains, each bearing the name of its first human prosthesis. Need and utility lead to self-same reproduction. Uselessness, on the other hand, lends itself to invention.

This link between uselessness and invention even applies to instrumental reason: a true invention is an object that precedes its utility. An invention is something for which a use must be created. Once the utility is produced, it rapidly self-converts into a need. This is the direction of flow of the history of technology (of which bodies, things, and objects are the first artifacts): backward. With invention, the perceptual direction of travel between the poles of necessity and utility, between the intelligence and instrumentality, possibility and reason, is reversed. An invention is a sensible concept that *precedes and produces its own possibility* (its system of connection-cases, its combinatoric). An invention is an in situ plumbing of potential rather than an extrapolation of disengaged possibility. It is a trial-and-error process of connecting with new forces or in new ways with old forces,

Sitting/Swaying: Event for Rock Suspension, Tamura Gallery, Tokyo, 11 May 1980. Photos by Kenji Nozawa.

to unanticipated effect. Invention is a plug-in to the impossible. It is only by
plumbing that connection that anything truly new can arise.

The goggles that Stelarc invented effected an inventive reversion from hu-
man instrumental reason to humanoid insect intelligence—needlessly. The goggles
are still waiting for a use to be created for them (and doubtless have a long wait
ahead of them still). Stelarc's art, in its first carefully engineered gesture, sets itself
the project of applying instrumental reason in such a way as *to suspend need and
utility.* His technically accomplished body-objects precede their possibility—but
stop short of producing it. If he is a body artist whose medium is also ideas, then
he is not content with his medium. He converts. He begins by approaching ideas
as materialized thoughts and making them into *unthinkable objects*—artifacts that
can *only be sensed,* pure sensation. Then he puts the unthinkable objects on the
body to see what might become of it. The body and thought converge toward a
shared indeterminacy. They are together in the sensation. You can't begin to know
what a bug goggle can do until you don it. You have to experience it even to be-
gin to imagine what a use for it might be and what your body is with it. *Imagine*
is still too reasoned a term. Any eventual use is impossibly enveloped in a def-
initely felt but still undefined experience, compoundly unpreviewed, which is why
the goggles were deployed in *performances* requiring audience participation.[17] The
goggles were the trigger for a collective thought-body event ever so tentatively
suggesting the just-beginnings of a symbiosis: a pending tending-together.

Stelarc's is an art of sensation. Sensation is the direct registering of poten-
tial. It is a kind of zero degree of thought-perception, of the possibility that it dis-
engages, at the point at which it all folds vaguely together only sensed—pending
action and a reconnect to need and utility (whose impending is also sensed, only
just). Despite its constitutive vagueness, it is a pole *of* thought-perception whose
every conjunction is accompanied to a varying degree by sensation—by the real
unthinkability of things, the as yet unnecessary and stubbornly useless, register-
ing as a tending, as a to-come-to-be in the world. Sensation is an extremity of
perception. It is the immanent limit at which perception is eclipsed by the sheer-
ness of experience, as yet unextended into analytically ordered, predictably re-
producible, possible action. Sensation is a state in which action, perception, and
thought are so intensely, performatively mixed that their in-mixing falls out of
itself. Sensation is fallout from perception—endo-fallout, *pure mixture,* the

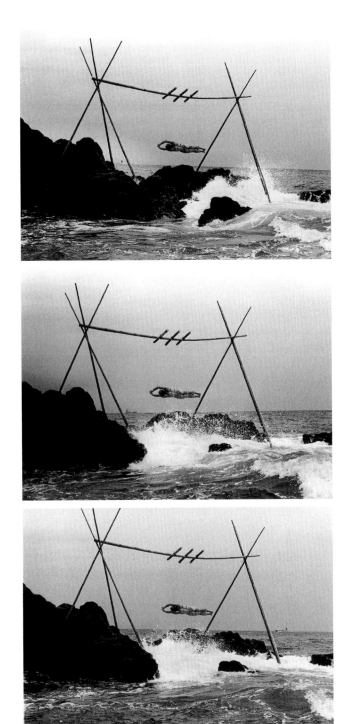

in-mixing-out of the most mixed. A receding into a latency that is not just the absence of action but, intensely, a poising for more: an augmentation. However poised, sensation *as such* is inaccessible to active extension and systematic thinking out. It is an always accompanying, excessive dimension of the purely infolded. Like the possibility that thoughtfully unfolds, it doubles present perception. Two modes of abstraction, doubly doubling perception: the only-thought and the only-felt, the possible and the impossibly potentialized. These modes can be understood as concurrent movements of abstraction running in opposite directions (before feeding back), one receding into felt tending, the other laying out thinkable alternatives for the active unfolding of what had been only in tendency. The world concretely appears where the paths movements cross.

Both generality (thought possibility) and singularity (sensed potential) are in excess over any and every actual conjunction—the first because it projects itself outside into a systematic alternative to the actually given and the second because it folds into every given connection so intensely that it falls out of it into pure mixture (reciprocal immanence). Sensation and thought, at their respective limits as well as in their feedback into each other, are in *excess over experience:* over the actual. They extend into the nonactual. If the alternative mode of abstraction into which perception extends is the possible, the intense mode of abstraction into which sensation potentially infolds is, at the limit, the *virtual*. Intelligence stretches between the extremes of thought-perception from the actual to the possible, dipping at every connection into the vortex of the virtual.

Note: Although the distinction between the virtual and potential will not be crucial here, a quick indication of yet another pair of poles is in order. As Deleuze was fond of saying, always multiply distinctions. This time the poles are of sensation itself. The potential and the virtual can be considered the constitutive limits of the endo-fallout that is sensation. The virtual would be the highest degree of infolding-out. Potential would be its least degree, as it just begins to recede from action-perception and thinking-out, into nonpossible latency. In what follows, "pure potential" can be taken as a marker of the "virtual": sensation most latent. The continuum between potential and virtuality is of degrees of latency-by-infolding or of intensity. The continuum of thought and perception with which this essay is most concerned is composed of degrees of extension (development or unfolding).

If you were an intelligent insect, would you be reading this?

Suspended Animations

At a certain point, Stelarc realized that fourteen hooks weren't enough.[18] A doctor advised him that he should use eighteen at minimum so that the weight of his body would be more evenly distributed. That way his wounds would be smaller, and there would less danger of his flesh tearing.

Stelarc's body suspensions were careful, calculated, literally antiseptic. They weren't about risk. They weren't about danger for danger's sake. They weren't shamanistic or mystical or ecstatic. And they most certainly weren't masochistic. The pain wasn't sought after or reveled in. It was a soberly accepted by-product of the project. Notions such as shamanism and masochism applied to his work are "irrelevant," "utterly wrong."[19] The point was never to awe the audience with the artist's courage or hybris. Neither was it to treat the audience to a dramatic staging of symbolic suffering to shed light on or heal some supposedly founding agony of the human subject. For one thing, there wasn't an audience (and if there were, it is not clear that they would have seen that symbolism through compound eyes).

So what's the project again? *"Extending intelligence beyond the earth."*[20]

Hold that thought.

"What is important is the body as an object, not a subject—not being a particular someone but rather becoming something else."[21] Stelarc applies instrumental reason—careful, calculated, medically assisted procedure—to the body, taken as an object, to extend intelligence into space by means of a suspension. Now how does suspending the body–object extend intelligence? And what is the something else that the body becomes beyond its objectivity and subjectivity?

To begin to answer these questions, it is necessary to clarify what precisely is suspended. It is not simply the actual body of the artist because once again the body as an *object* is in excess over any given actual conjunction it enters into, by virtue of the shadow of generality that is one with its objectivity (reproducibility, predictability, uniformity of anticipated result). By targeting the body as object, Stelarc is targeting the body in its generality; he is targeting the generality of the body. But how, without symbolizing, without communicating to an audience, can a particular performance target a generality? How can a single performance raise itself to the amplitude of the objective? It can't.

I didn't honestly think I'd be doing more than one suspension event, but there have been a series of ideas that I felt compelled to realize. In the first four suspension events, the body was rotated through 360 degrees in space. The next series of suspensions were involved with all kinds of structural supports. . . . More recently there have been the environmental suspensions.[22]

On second thought, maybe it can: if suspensions, like substitutions, do not come in ones. Rolled up in the first suspension event was an indefinite series of others that were unanticipated. These were present in the first and were somehow implicit in it but not in a way available for conscious elaboration. The first accomplished suspension event set in motion a serial unfolding of variations that were implicit in it or immanent to it. That first event explored only what comes of suspending the body in one particular way. But what of other ways? Is it the same to be suspended upright as horizontal? Upside down as right-side up? Inside from a frame of poles and outside from the top of a building in Manhattan or over a rocky seaside? James D. Paffrath and Stelarc's *Obsolete Bodies/Suspensions/Stelarc* (1984)

Moving/Modifying: Suspension for Obsolete Body, Espace DBD, Los Angeles, 1982. Photo by Daniel J. Martinez.

facing page:
Event for Stretched Skin No. 4, Art Academy, Munich, 8 August 1977. Photo by Harold Rumpf.

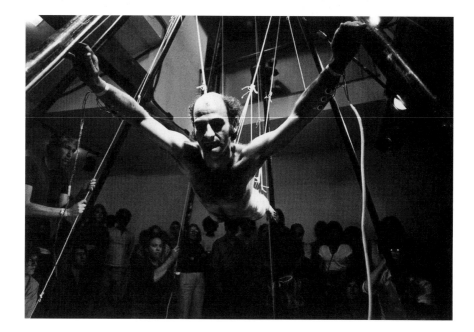

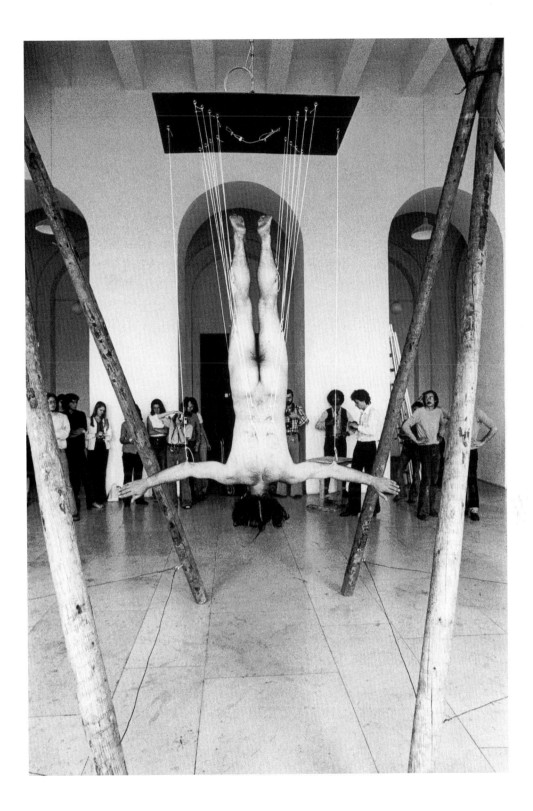

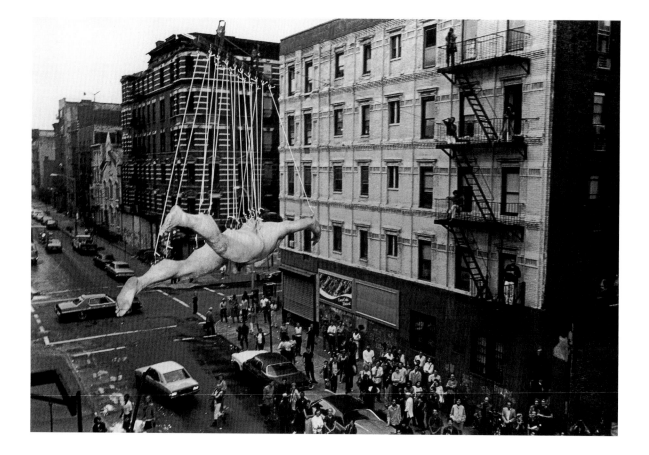

follows the unfolding exploration of the field opened up by the implicitly serial ur-idea of suspension. Each developed event was a variation on that idea, approached from a different angle—permutations in an unfolding combinatoric.

The suspended body is a sensible concept: the implications of the event are *felt* first before being thought out. They are felt in the form of a "compulsion": an abstractness with all the immediacy of a physical force. The apparatus of suspension set up the body's unfolding relation to itself as a problem, a compulsion, and construed that problem in terms of force. The compulsion was a problem-posing force that moved through the series. It was its momentum, immanent to the first event and each after as well as bridging the intervals between them. The compulsive force of unfolding was thus responsible for the felt intensity of each event taken separately *and* for their continuity.

This serializing force of compulsion operated in relation with other forces. The basic device employed throughout was an interruption of the body's necessary relation to the grounding force of human action: gravity. The hooks turned the skin into a countergravity machine.[23] The consequences of using the resident forces of the flesh—its elasticity and strength—to counteract gravity were not clearly anticipatable. In fact, the first suspension event was blocked at the last minute by the sponsoring institution, which feared that it might be left with a shredded artist.[24] Stelarc's suspensions methodically unraveled the implications of hooking up the body as a countergravity machine. Only after a wide range of the possible countergravity connections were actualized—only after the combinatoric implicit in the first event was close to being exhausted—did the artist feel uncompelled to continue. This process took over ten years.

The suspension variations should not be confused with answers to the problem posed. The problem posed by a force cannot be "solved," only *exhausted*. In a need- or utility-oriented context, the permutations comprising the combinatoric of possible action doubling the given conjunction can indeed be thought out as cases of solution that inform and precede a choice, the selection of the "right" (most functional) solution. The combinatoric is based on an analysis of past conjunctions, abstracted from the singularity of their occurrence, then generally projected into the future in the form of a set of functional alternatives to choose from. But here it is precisely need and utility that are suspended and with them the linear projection from past conjunctions to generally laid-out alternatives.

Street Suspension, Mo David Gallery, 604 East 11th Street, New York, 21 July 1984. Photo by Nina Kuo.

The regularized, needful, useful actions of the human body all hinge in one way or another on its bipedal upright posture, the body's usual way of counteracting gravity. If you interrupt that, you have profoundly disconnected the human body from its normal realm of activity: from its possible actions. The suspended body is in no position to extend its present situation into a logically expressible next step by choosing from a set of possible actions. It is not only in a needless and useless condition; it is in an utterly dysfunctional one. It is in no condition to choose. No analysis-in-action leading to selection here. Not even a presentiment of eventual use-value, as with the bug goggles. The usual mode in which the body *functions* as a sensible concept—possibility—is radically suspended. The body is placed at the limit of its functionality.

What is being suspended is embodied human *possibility*. Each suspension in the series was not a possible answer but a reposing of a problem that stubbornly remains a problem from end to end of its serial unfolding and that refuses solution as long as the human body is the kind of sensible concept it normally is and functions the way it does. The repeated explorations resolved nothing. Each time, the body was left hanging. By the end of the series, the body was, well—exhaustively hung. Nothing more. No need, use, effectively conveyed symbolism, or even communicable meaning was generated. A process simply had been set in motion and had run its course.

What is important to Stelarc is approaching the body as an object—as an objectivized sensible concept whose abstract mode is that of possibility. Stelarc starts at the end. He starts from the pole of possibility *as a limit,* the outside limit of the body's functionality, its already-extension into the only-thought of instrumental reason. He assumes the body as a known object of instrumental reason with known, regularized functions of need and utility. Then he applies that same instrumental reason—in the engineering of scaffolding, in the medical knowledge used to take health precautions—in a way carefully calculated to cause it to self-interrupt. That the suspensions were not initially operating in a mode of possibility is amply demonstrated by the fact that their seriality was unforeseen. Only retrospectively can the series be resolved into a combinatoric of possible alternatives or permutations. Only *retroactively* are the suspension events an operation on possibility, on the body at the limit of its generality.

Normally, possibility comes before for a better after: it consists in a certain abstractive operation on the past that projects it usefully into a future or extrapolates it. Each step toward that future is seen to be conditioned by the possible: what that future comes to be, in particular, is affected by the possible alternatives laid out before it. The possible moves in linear fashion from past particulars, through a generality doubling each present conjunction (the combinatoric of alternatives), to a next and future particular (selected from the combinatoric). With Stelarc's suspension series, things are radically different. There is no extrapolation. Here, the possibility of the series *results from* the series rather than conditions it.[25] The possible appears only at the end, after the movement it concerns has exhausted itself. The limit state in which Stelarc's suspensions place the body has possibility only in its pastness. Since the momentum carrying the series forward into the future has already lost its momentum by the time its combinatoric is apparent, there is nowhere for its possibility to go. The possible belongs to the suspension series as a *pure past,* unprojected, arrived at only after everything is already over. The body's limit state prior to its possibility, before it catches up with its past in the course of its serial unfolding, is an onward momentum of becoming "something else." The body is in a state of invention, pure and not so simple. That inventive limit state is a prepast suspended present. The suspension of the present without a past fills each actual conjunction along the way with unpossibilized *futurity:* pure potential. Each present is entirely filled with *sensation:* felt tending, pending.

Stelarc's project is to use particular bodily conjunctions to counteract generality and thereby pack the body's singularity into sensation. That singularity is experience falling out of the particular moment—not into a generality but rather into the impending moreness of serial continuation immanent to each body event, save the last. Actually, including the last. There is still something immanent to the last: another first, no less. A whole new series, beyond suspension. The momentum will leap series in a move that will be as unanticipated, as aberrant (from the point of view of any normal logic of linear development) as was the transition from goggles to hooks. The end of possibility envelops *more* and more varied potential: multiplicity. The project is to invent an indeterminate bodily future in an uncommon intensity of sensation packing more multiplicity into bodily singularity. Paul Virilio, so obstinately wrong about so many aspects of Stelarc's work,

Up/Down: Event for Shaft Suspension, Hardware Street Studio, Melbourne, 17 August 1980. Photos by Anthony Figallo.

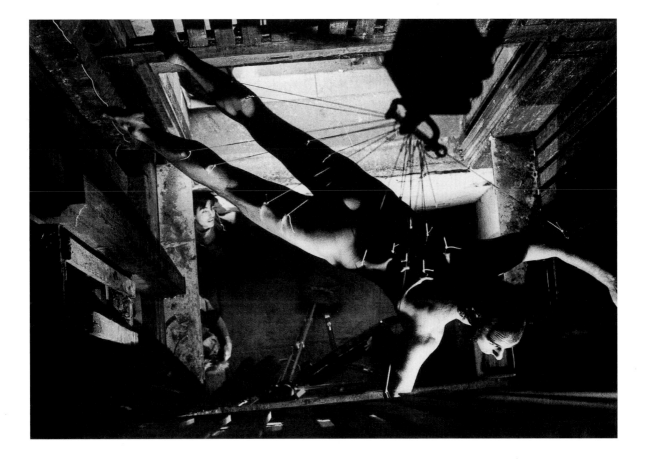

*Pull Out/Pull Up: Event for
Self-Suspension*, Tokiwa
Gallery, Tokyo, 2 March 1980.
Photo by Nina Kuo.

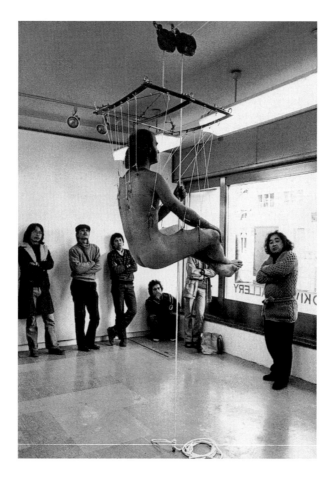

got this one right: Stelarcian suspensions approach the body as object to "negate"
it (counteract it) it "in favor of pure sensation."[26]

In the only suspension in which the body was actively doing something
while suspended (hoisting itself on a pulley), what Stelarc registered was a "split
between what the body was feeling and what it was doing."[27] The mix of activ-
ity and suspended animation made perceptible the divergence between action and
sensation: the way in which sensation falls out from action-perception into a fu-
turity that precedes and doubles the body's past. The seriality of the performances

was a multiplying of that infolded future-singular before it was the laying out of a combinatoric.

Why explore sensation when the project is intelligence? The suspensions in themselves do not extend intelligence beyond the gravitational field of the earth. If they did, they would not be suspensions of the human body-object but free-floating continuations of it. What they do is prepare the ground. The suspended body expresses nothing of need or use, nothing of symbolic or semantic value. As a sensible concept, it is undetermined from the point of view of function and meaning. It is a corporeal *opening*. Etymologically, the "extrapolation" of possibility is an "altering out." Here, the body, infolded, is "altered in." Stelarc's art is an *interpolation* of the body's openness.

Functions, as well as meanings, are expressions. Every action of a body is a physical expression of its analysis-in-action of the perceptual world, of the plug-in to forces of which the body and its things are complementary poles. The hung body is not actively expressive. But it is expressive nevertheless. Stelarc repeatedly evokes the pattern of ripples and hills that form on the hook-stretched skin, calling it a "gravitational landscape."[28] The body visibly expresses the force whose counteracting posed the problem. The "something else"—the something other than an object that it becomes by being approached as an object in this way—is a *transducer*:[29] a local organization of forces (epidermal elasticity and strength) that responds to and transformatively prolongs another force (gravity). A transducer transformatively "manifests rhythms and flows of energy."[30] The body transducer transforms gravity from an invisible condition of station, locomotion, and action into a visibility.[31] Lightwaves are not the only sensible force into which gravity transduced. Many of Stelarc's suspension events also amplified the sounds of the body. The rush of blood through the artist's veins as his body rises in a state of heightened receptivity to the effects of gravity are transformed into amplified sound waves that spread to fill the room. The transducing of the body is extended beyond the skin to propagate through the surrounding space.[32] The transductive physicality of the body extends to the limits of its spatial containment. The body as transducer literally, physically fills its space, becoming architectural, as blood flows sonically to the walls, echoing its built limits.[33] The body, in becoming a transducer, has become two more things: a visibility of gravity and a sonic architecturality. A corporeal opening onto sound, image, architecture, . . . and more.

The future. Sensation is the key to accessing the more than regularized action and perception that is the body-thing.

The suspended more-thans of sound and vision are already extensions but not yet of intelligence. It is better to call them extend*abilities* than extensions because there is no receiver, no audience: there is no one present to register and relay them. They expire with the event. They are beginnings of extensions, incipient extensions. Among the many directions in which a gravitational landscape and a sonic body-architecturality might be extended is a mystical symbolism of nature-culture fusion, with inevitable overtones of shamanism and exalted masochism. The absence of an audience works precisely to block that extension. The audience will be included again in Stelarc's art only when the conditions are right for an extension in an entirely different direction: a machinic direction toward the cyborg that is reached by extending the plug-in to gravity, across an interseries leap, to another fundamental force of human existence: electromagnetism.[34]

In retrospect, the suspension events composing the series can be considered to have been most exhaustively performed in their mutual implication, most intensely rolled into each other in indeterminate futurity, most problematically enveloped in a singular event—one that was not to be repeated. That event is the veritable "first," even though chronologically it came in the middle. It is the first in the sense of taking a logical precedence of sorts, embodying as it does the sensible concept of the suspended body in an unthinkably extreme form. It is the most intense embodiment of the ur-idea of suspension. All the others were multiples of this event. It comes "first" in the sense that it is the *virtual center* of the suspension series:

The body was contained between two planks and suspended from a quadrapod pole structure in a space littered with rocks. The eyes and mouth were sewn shut. Three stitches for the lips, one each for the eyelids. The body was daily inserted between the planks and in the evening was extracted to sleep amongst the rocks. Body participation was discontinued after seventy-five hours.[35]

All bodily expression was closed down. Barely glimpsed between the planks, the body generated no gravitational landscape by day. By night, it slipped into a surrounding landscape, reduced to one gravity-stranded object among others, a body

mineral in among the rocks, in darkness, unseen even by itself. Not only did the body not transduce and externalize its sounds; it could not speak. It had ceased to speak, to see and make visible, even to eat. It was shut down. Unplugged. Disconnected from every form of meaningful, need-based, useful function. Delivered supine unto the force of gravity. Stranded abject object.

It was argued earlier that there was not a difference in nature between object and organ. The terms are just conventional designations for differential regions of the same polarized perceptual field. If the transductive suspensions in which the body began to extend into in image and sound were counteractions of the body's objectivity, then the sewn suspension goes one step further, countering the organicity of the body. A body that can express nothing, not even incipient let alone possible action, is supremely dysfunctional. It is what Deleuze and Guattari call a body without organs.[36] On hold. Sewn and suspended, the body folds in on itself to the point that it not only is no longer an object or an organism but is stretched to the limit of things. This is what Stelarc dubs the *Anaesthetized Body*.[37]

Distraught and disconnected.[38]

The body was pacified, but the mind was restless.[39]

The body is corporeally challenged; its active engagement with the world, interrupted. But the forced passivity of the interruption is filled with ferment. The "restlessness" of the body is not "action," since it produces no outward effect and disengages no possibility. It is a kind of activity prior to action. It is like the unextended, incipient expression of the unsewn suspensions, only even more incipient, not even an unheard echo, only a gravitational vibration still swaddled in the matter of the body.

The body is no longer a transducer but rather a *resonation* chamber, a resonating vessel compulsively, ineffectually registering the force of gravity—as what? In states of near sensory deprivation[40] and more important of deprivation of expression, the mind cannot stop, but neither can it continue. The dividing line between sleep and waking blurs: "Imploding the dichotomy."[41] At the dividing line, their mutual limit, there is a ferment of what might be action or might be thought, an hallucinatory (or hyperlucid?) indistinction between mind states and body states, between actions and echoes, sights and dreams, thoughts and adventures. Since there is no follow-through, no perceivable effect of any kind, it is

impossible to tell and all the more impossible to stop. The dividing line between passivity and activity blurs. The body, passified to the limit, separated from any possibility of being active, becomes uncontrollably *activated,* inwardly animated. That inwardness is badly served by the word *mind.* Nothing is conclusively distinguished. Everything impinges. Everything is felt. Between the planks, the force of gravity, carried to its inertial extreme, materially registers and resonates, its effect transformatively infolded in the sensitized flesh. The body turns into a hobbled receiver tuned to the frequency of gravity. The received force undergoes the beginning of a transduction. But instead of being unfolded again, continued, extended into a perceptible, actionable, or thinkable transmission, it bubbles into every mode at once, compulsively, with no let up and no outlet: "Everything in motion, connected and contained."[42] This is the zero degree of sensation, sensation as the zero degree of everything that a body can do. *Suspended animation:* "Between gravity and fantasy."[43] Thought and action return together to the body, and the body compulsively rebegins them and their every mix, spontaneously regenerating all that goes into making a body and its complements. Sensation is body-substance, the indeterminate matter from which the body and its objects and organs unfold: felt futurity. Resonating, animated body-substance: corporeal unfolding infolded. Not transductive enough to be called a thing, it is the stuff of things, turned in on itself: restless matter, action wanting, waiting for perception. The sensible concept of the body turned ur-idea of potential.

"Everything in motion": compound eyes are adapted "for perceiving motion almost exclusively."[44] The bug goggles really were looking forward (or inward) to this moment. Without even knowing it, they focused the project of performing the body as sensible concept away from the peripheral problem of the form of things (their objectivity or organicity) and onto their modalities of motion. It is this problem that lies at the virtual center: what constitutes a transformative movement, extraplanetary or otherwise? The suspensions make clear that across intervals of intensive movements the body becomes "something else." This raises the further problem: how can extensive movements turn intensive and contribute to a transformation of the very nature of the body (as opposed simply to adding permutations on its actions as the object it already is, with the organs it already has)? What subsequent extensions might then unfold? These problems are reperformed, exhaustively, in a nonsuspension series of experimentations with

prostheses (including the *Exoskeleton, Extra Ear, Third Hand,* and *Virtual Arm*) and then in a further series of cyborg experimentations where the body takes its place in a cybernetic network rewiring its motional limits in a radically new ways (*Split Body, Fractal Flesh, Stimbod, Ping Body, Virtual Arm, Virtual Body, Parasite, Movatar*).[45] All of Stelarc's performances can be seen as operations that, to use Deleuze and Guattari's most arthropod formula, "look only at the movements"[46]—eyes sewn shut (or goggled open).

At virtual center, with the sewn-body ur-idea of potential, instrumental reason has returned to activated matter, the transformative stuff of things, sweeping everything associated with intelligence back with it. The direction of perception has been reversed,[47] and the reversion pushed to the limit where the inverse movement, into extension, is suspended. But unsew the still suspended body-substance, hook it up again, and amplify it, and you get the beginnings of visible and sonic extension. The matter of the body starts to unfold again, to re-extend, feed forward—still shy, however, of utility and need. Lower the ropes, stand it up, attach a robotic arm to it—and you can perhaps just begin to imagine a use. The body starts to reorganize in response to the unaccustomed connection. Its matter just starts to resystematize. Its analysis-in-action just barely starts to be possible. You can feel utility just over the horizon. But it won't arrive until the world can accommodate its budding usefulness in more than a presentiment. When a way is invented to attach the robotic arm to a computer and remotely control it—now there are possibilities. It really could be used in hostile off-world environments for equipment repair or mining. It could fulfill so many wondrous functions. Why, it would be a necessity in any extraterrestrial extension of the body's sphere of movement.

This is as much as to say that the obsolescence of the body that Stelarc waxes long on must be *produced*.

Outer space? Who needs it? The body is perfectly suited to its current terrestrial habitat. If anything, it is too well adapted to it. The evolutionary success of the human species is its own greatest threat. There are, however, existing solution cases to the problems of overpopulation and environmental degradation. An equitable, sustainable, postcapitalist economy for one. There is no reason why the current human body-object could not find a niche in that possible future. The terrestrial body will be obsolete from the moment a certain subpopulation feels

compelled to launch itself into an impossible, unthinkable future of space colonization. To say that the obsolescence of the body is produced is to say that it is compelled. To say that it is compelled is to say that it is "driven by *desire*" rather than by need or utility.[48]

But in less millennial terms, isn't each little change on earth an adjustment of the functioning of the human body and its system of objects and combinatoric of possibilities? And doesn't every adjustment imply on some level an interruption of the old functioning to make an opening for the new? Isn't always inexorably under way? Then in a very real sense, the body is always already obsolete, has been obsolete an infinity of times, and will be obsolete countless more—as many times as there are adaptations and inventions. *The body's obsolescence is the condition of change. Its vitality is in obsolescence.* We are all astronauts. We are all moonwalkers without organs, taking small perceptual steps into the future, on virtual legs (six of them, if my goggles are on right). The body without organs that Stelarc sews himself into is not so singular after all. Or rather, it is singular, but the singular accompanies and conditions any and every particular, every action, every adjustment, and every extension of these particularities into the general. The

City Suspension, **Above the Royal Theatre, Copenhagen, 1985. Photos by Peter Danstrom.**

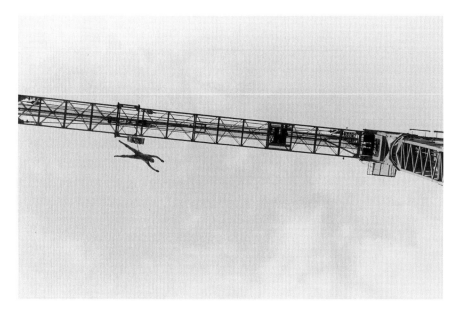

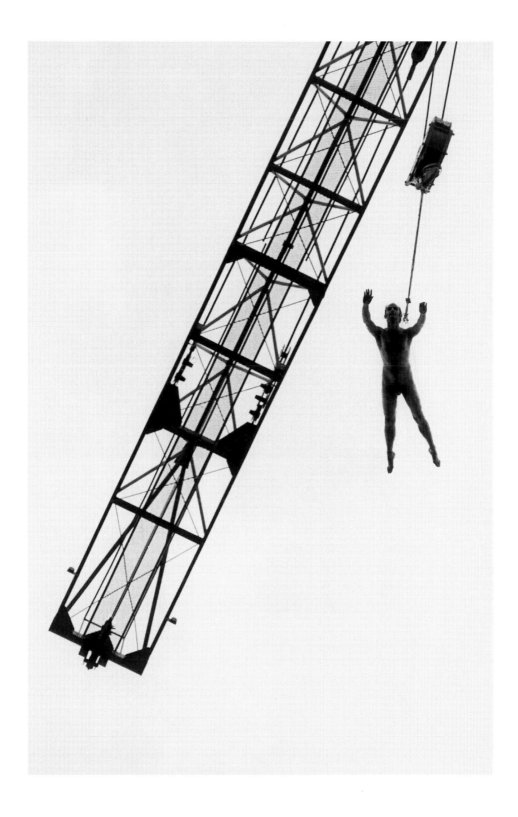

body without organs—the reversion of thought and perception-action into pure sensation—is a constant companion of the organism, its future double.

Operative Reason

Stelarc's art produces the hung body. Hung things have entered science and lore under the aegis of chaos theory. The focus of chaos theory are events called *bifurcation points* or *singular points.* A singular point is that peculiar state of indecision when a system's next state will be entirely unpredictable. The unfolding of the system's line of actions interrupts itself. The system momentarily suspends itself. It has not become inactive. It is in ferment. It has gone "critical." This "chaotic" interlude is not the simple absence of order. It is in fact a superordered state: it is conceived as the literal copresence of all of the possible paths that the system may take, their physical inclusion in one another. Critically occurs when normally mutually exclusive alternatives pack into the materiality of the system. The system is no longer acting and outwardly reacting according to physical laws unfolding in linear fashion. It is churning in its system-substance its own possible states. It has folded in on itself, becoming materially *self-referential*—animated not by external relations of cause and effect but by an intensive interrelating of versions of itself. The system is a knot of mutually implicated alternative transformations of itself in material resonance.[49] Which transformation actually occurs and what the next outward connection will be cannot be predicted by extrapolating from physical laws. The suspended system is in too heightened state of transformability. It is *hypermutable,* hyperconnectible—by virtue of having functionally disconnected itself. The system hesitates, works through the problem of its critical self-referentiality, and "chooses" an unfolding.

When scientists use words like *choice,* they are not implying that the system reflects and uses instrumental reason to choose from a set of preset possibilities arrayed before it. But it is no exaggeration to call the system's intensive animation *thought,* defined once again as "the reality of an excess over the actual." The self-referentiality of the critical system is indeed that. The possible futures are present but only in effect—incipient effect (resonance and interference, vibration and turbulence, unfold*able* into an order). Possibility has, *in effect,* materialized. The matter of the system has entered a state where it does not disengage a possibility

but instead absorbs it into its animated matter. Materially present possibility, once again, is *potential*. The system's critical condition is as actual as any other state. But the self-referentiality, or infoldedness, of its criticality is not. What the self-absorbed critical system infolds is present only in potential, which doubles and animates the actual conjunction without being reducible to it.

A certain form of thought is called *operative reason* as opposed to instrumental reason. It is materially self-referential as opposed to reflective; absorbs possibility without extensively thinking it out or extrapolating from where it is; embodies a superorder of superposition without disengaging an order of substitution; infolds without extending; does not imply a distance between successive states of a system mediated by an intervening action but rather their immediate proximity to each other, their inclusion in one another; chooses according to principles unsubordinated to the established regularities of cause and effect; and poses an unpredictable futurity rather than anticipating outcomes. This is not a purposive analysis-in-action or a hesitant self-definition in suspension, not an extending out of matter into thought, not a doubling of perception by thought (a folding of thought into matter as such). Instrumental reason makes thoughtfully explicit what is materially implied by the criticality of operative reason. It is its unfolding or extension. Even as it doubles perception, it is already arraying futurities in extrinsic relation to each other: as mutually exclusive possibilities standing outside and against each other in principle. Possibility is extended potential—a prosthesis of potential. It is an outworn double of the double that is potential, the thought-shadow it retrospectively projects. It pales in comparison with the felt intensity of the critical.

Now the critical point may be an interregnum between two different serial orders, two different systemic organizations with their characteristic paths of actions and reactions. Or it may constitute a threshold between disorder and order, an entropically disordered past and a future of systemic organization. The most celebrated example of the latter case is the Bénard instability, which occurs when turbulent patterns of diffusion in a heated liquid spontaneously order into convection cells. The ordering is not predictable in terms of heat diffusion alone. In fact, according to the theory of heat diffusion, it is so improbable that, in principle, it must be considered practically impossible.[50] But it effectively happens. Theorists of such "dissipative structures" explain that the self-organizing of liquid

into a convection system is triggered because the instability of situation suddenly makes the liquid "sensitive" to gravity.[51] Gravity suddenly registers and resonates. The "sensing" of a force that up to that point was not pertinent to the system's transformation and had been "ignored" triggers the self-ordering. Gravity, normally a potent force of entropy, induces a locally negentropic effect: an emergence of order from disorder. Sensed, gravity has triggered or *induced* negentropy. Gravity has appeared as a negentropic inducer of hypermutability and its unfolding. Given the turbulence of the situation, the particularities of the convection system induced by the sensation of gravity are not predictable; even when or if the ordering will occur is not certain. However many times the experimenter succeeds in achieving the effect, it is always a surprise. Induction is the experimental production of the practically impossible. The "impossible" is practiced when a countereffect is produced to the normal unfolding of the natural laws in play—achieved not by contravening them but by combining them in a way that creates an ineradicable margin of objective indeterminacy from which a new order spontaneously arises.

This suggests a definition of operative reason as implemented by humans (in other words, as mixed with purposive analysis in action in an extended situation). Operative reason is the experimental crafting of negentropic induction to produce the practically impossible. It is *pragmatic* rather than analytic. It doesn't master a situation with exhaustive knowledge of alternative outcomes. It "tweaks" it. Rather than probing the situation to bring it under maximum control, it prods it, recognizing it to be finally indomitable and respecting its autonomy. Operative reason is concerned with effects—specifically countereffects—more than causes. It deploys local interventions in an attempt to induce a qualitative global transformation: small causes with disproportionate effect, excess effect, a little tweak for a big return. Operative reason is inseparable from a process of trial and error, with occasional shots in the dark, guided in every case by a pragmatic sense of the situation's *responsivity* (as opposed to its manipulability). Like Stelarc's art and in spite of (or perhaps because of) its thoroughly pragmatic exercise, it is closer to *intuition*[52] than to reflective thought (hence the serviceable but inaccurate evocation of poetry earlier in this essay). Following another suggestion of Stelarc's, his art is more akin to *alchemy,* the qualitative science of impossible transformations, than to high chemistry or physics, quantitative sciences of elemental

causes. In a more recent vocabulary, Stelarc's project is to practice art as a "minor" science.[53]

As part of that project, Stelarc's suspensions return intelligence to the degree zero of sensation. There thought rejoins action, the body rejoins matter, and the animate rejoins the inanimate. These no sooner rejoin than reunfold, divergently reextend, to enter into extrinsic and often mutually exclusive relations with one another (in keeping with and revising the combinatoric of their possibility). Suspension is the countergravity ground zero of differential emergence. Differential emergence from matter: the definition of *evolution*. What else would the ur-idea be? Stelarcian suspensions are a contrived induction of the conditions of evolution, that most global of qualitative transformations—an artful rehearsing of its repetition. Stelarc's project is to tweak the human body-object into a sensitivity to new forces or neglected aspects of familiar forces to induce it into a state of hypermutability that, if inventively desired and operatively extended, might bring the big result.

Multiplex

Curiously, Stelarc bristles at any suggestion that his own project has evolved. He repeatedly points out that he was already working on the idea of the suspensions at the same time he was designing the bug goggles[54] and that the first suspensions were contemporaneous with the development of the robotic *Third Hand* that was to become the hallmark of his cyborgian experiments.[55] The nonlinear leaps between series overlapped. Their unanticipated unfoldings, the "periods" of Stelarc's art practice, are copresent dimensions: *phases* in Gilbert Simondon's sense of the term.[56] Each infolded in every other as a potential transformative extension of it. What was said of the series of suspensions applies to the larger series of his work: each event reposes the same problem differently. The problem is evolution. No final solution is offered to it. No particular utopic future for humankind is elaborated. No clear possibilities disengage from which the artist would exhort his audience to choose. Instead, the same problem, the same critical condition, is replayed in multiplying variations. The same potential is rejoined, each time to different and unforeseen effect. Possibility is analytically thought out into a combinatoric to predictable effect. Potential is pragmatically, impossibly reinfolded in

continual experimental variation. Possibility is general by nature: analyzable into set of solution cases disengaged from more than one particular conjunction. Potential is singular: a multiple in- and unfolding into each other of divergent futurities, only the *divergence* of which is reproducible. The particular nature of each divergent conjunction in the series is precisely what is problematic. Multiple in- and unfolding: singularity is *multiplex*. The multiplex divergence of the singular is not to be confused with the *disjunctive* simplicity at the basis of the system of possibility. The multiplex is in mutual inclusion. Possibility develops disjunctively toward the extension of a next actual step. Multiplex potential envelops, around an intensely suspended (virtual) center.

If Stelarc's work has to do with desire, it is not desire *for* something in particular: no utopia. In more ways than one, it is desire without an object. It is desire as a process, purely operative rather than object-oriented: the process of reason rejoining desire.

What are the phases of Stelarc's project?

I

OPERATION: suspension/disconnection
MEDIUM: the sensible concept as sensation
MODE: induction

The first phase is the state in which all of the dimensions are most intensely infolded in one another. It is a degree zero of the corporeal in the same sense that the vacuum is the degree zero of matter itself. The vacuum, physicists inform us, is not an absence but an overpresence. The vacuum is the physical copresence of all possible particles, shooting into and out of existence, folding into and out of each other too fast to be instrumentally perceived with any predictive accuracy, resonating with each other in real excess over the actual. The vacuum is the operative ur-idea of material existence. It is the state of indistinction of matter with what is normally mutually exclusive of it: the abstractness of the void. Just as the degree zero of the corporeal is the state of its indistinction with thought, the two zero degrees are in fact facets of the same multiplex excess-over.

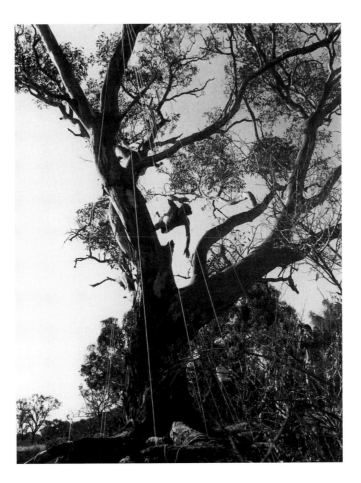

Prepared Tree Suspension:
Event for Obsolete Body, No. 6,
Black Mountain, Canberra,
10 October 1982. Photo by
Norman Ainsworth.

Stelarcian sensation or suspended animation is the human body-object in a corporeal vacuum state. It is the operative ur-idea of human corporeal existence. In Stelarc's suspended body, humanity particles speed in and out of existence faster than can be perceived. Ideas, dreams, pains, yearnings, visions, needs, objectnesses and organlets, intelligences and instrumentalities, begin, abort, and transform into each other. The vivid sensing by the flesh of a force previously taken for granted (gravity) induces a state of hypermutability, a hyperconnectibility that is blocked as soon as it is triggered. In sewn suspension (the limit state

of sensation), a state of intense activation and readiness is induced, but all outlet is blocked. The felt trigger-force to which the body matter has been sensitized cannot transduce into anything in particular. The sensation is all particulars, singularly. Everything a body can do, everything a body can become: the condition of evolution. Disconnected. There is a suspension variation in which sensation is doubled by a displaced action, as if toying with the idea of its perceptual reconnection and extension. That is the pulley suspension, where one hesitant, still countergravitational outlet is allowed. The countergravitational function of locomotion is displaced from the legs to the arms, ensuring that the force of gravity is still uncommonly felt. The body is split, one side extending hesitantly into organic perception-action, the other side still steeped in the matter of sensation.

2

OPERATION: suspension/connection
MEDIUM: the sensible concept as expression
MODE: transduction

In the second phase, the forces absorbed by the sensitized body just start to unfold again, to extend again beyond the skin (the baseline objective extent of human body matter, the extensive envelope of human intensity at its default setting). This dimension overlaps with the first in the suspension events. The skin itself becomes a visible expression of the trigger-force ("gravitational landscape"), which also manifests as a sound space. The resonation echoes. The extensive envelope of the intensive is reextended as far as the walls. But it goes no further because there is still no audience to walk away with the countergravitational event. Gravity has effectively transduced. It has been transformatively relayed into other forces, visibility and sound. But the relay is walled in, contained. Connection is reestablished, only to be closed. The body begins to express in extension the force it was induced into sensing intensely, but the expression takes place in a communicational vacuum. The performances focusing most directly on the sensible concept as expression are the events for the *Amplified Body:* "Amplified body processes include brainwaves (EEG), muscles (EMG), pulse (plethysmogram), and bloodflow

(doppler flow meter). Other transducers and sensors monitor limb motion and indicate body posture. The body performs in a structured and interactive lighting installation which flickers and flares in response to the electrical discharges of the body. . . . Light is treated not as an external illumination of the body but as a manifestation of the body's rhythms."[57] Also expressive are *Hollow Body* events, in which the interior of the stomach, colon, and lungs is filmed with a miniature video camera.[58] The probes disable the default envelope of intensity by following the infolding of the skin into the body through the orifices. The extension into visibility of the body's inside reveals its sensitive-intensive, palpitating interiority to be an infolded—and unfoldable—exteriority that is as susceptible to transductive connection as any sampling of body substance. The body is hollow. There is nothing inside. There is no inside as such for anything to be in, interiority being only a particular relationship of the exterior to itself (infolding). This highlights the nonactuality of sensation. Sensation, the substance of the body, is not the presence of the flesh in its envelope but is the presence in the flesh of an outside force of futurity (in this case, a portent of the asymmetrical symbiosis of the physiological and the technological as it extends to new frontiers).

3

OPERATION: reconnection
MEDIUM: the sensible concept as extension
MODE: possibilization

By the third phase, the body is no longer suspended. The door opens. The audience is let in. There are signs that the transductive expression wants to follow through into an actual invention, a transformative unfolding of potential into new need and utility. This phase corresponds to the prosthetic projects, like the bug goggles, the *Third Hand,* and the more recent *Exoskeleton.*[59] The body's potential is reconnected to objects that promise to be useful but in fact are not (or not yet). Possibility is just beginning to array itself before the body. The notion of prosthesis, once again, can be misleading. If it is construed as an object attachment to an organism, then the body is being treated as something already defined, as

Exoskeleton Cyborg Frictions,
Dampfzentrale, Bern, 1999.
Photo by Dominik Landwehr.

facing page:
Exoskeleton, Australaska
Pomlda, Cankarjev Dom,
Warehouse, Vrhnika, Slovenia,
14 May 2003. Photo by
Igor Skafar.

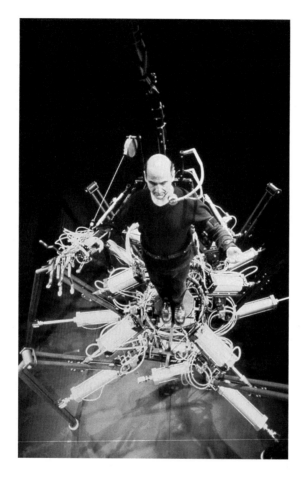

operating within a preestablished realm of possibility. In that case, its extension is limited to its prior definition: more of the same. If the extension is taken beyond the earth's orbit, then it is not a question of evolution but of *colonization:* the neoimperialism of space as the last human "frontier." But if it is remembered that the body organism and its objects (and even matter) are mutual prostheses, then what is being extended is that *reciprocal action.* The extension, whether off-world or not, is no longer a colonization but a symbiosis. The body is opening itself to qualitative change, a modification of its very definition, by reopening its *relation* to things.

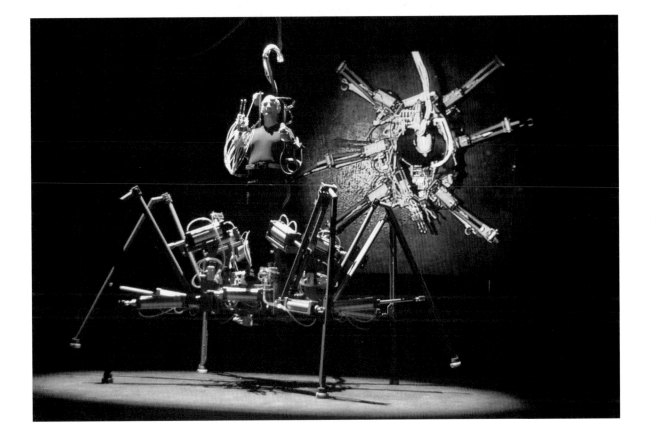

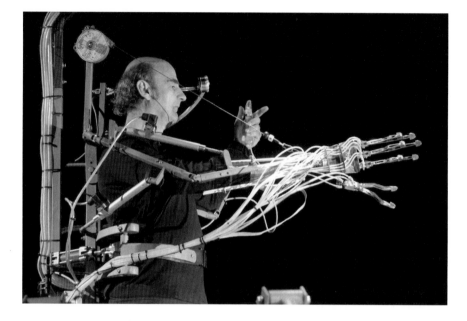

Exoskeleton, Australaska
Pomlda, Cankarjev Dom,
Warehouse, Vrhnika, Slovenia,
14 May 2003. Photos by
Igor Skafar.

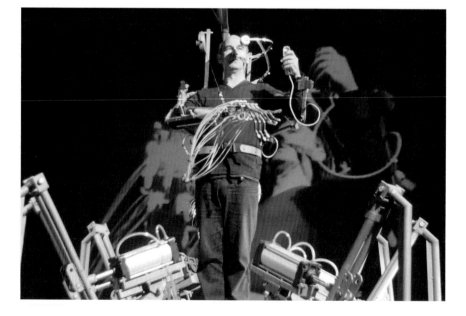

4

OPERATION: relay
MEDIUM: the sensible concept as contagion
MODE: virtual transmission

By phase four, the body is no longer suspended. The door has been opened. The audience is let in, and the transduction just starts to follow through. But to what effect? Certainly not yet to the desired disproportionate effect. The audience of a Stelarc performance has not been launched off-world. But even so, things can get spacey. The audience may be induced into a state of stupor. The 1995 performance *Split Body: Voltage in / Voltage Out* is a good example.[60] There is little explanation of the nature of the event: no manifestos, no introductory remarks by the artist or a commentator, just a minimal handout with a brief explanation of the computer system that doesn't seem to reach most of those present. In any event, the room is too dark to read it. The intent is evidently not to communicate in the sense of imparting information or interpretation. The event is basically unframed verbally, creating an air of uncertainty that quickly turns to foreboding, as a near-naked man walks silently onto the stage and is helped into a cyborgian contraption. His body is peppered with electrodes connecting to the computer by wire. On his right arm is attached the *Third Hand,* a robotic double of that limb.

An assistant starts the computer program—and the left side of the body moves. That movement is closely followed by a gestural echo on the part of the robotic arm, as it whirrs in slightly delayed response to the movements of the left flesh arm and leg. The body goes through a dissociated dance accompanied by even stranger sound effects, verging on music but not quite. As the performance proceeds, the pace of the movements increases and with it the rhythm of the "music." By the end, the flesh onstage is visibly exhausted, seeming to have endured a slowly intensifying pain throughout.

Those in the audience who have managed to read the handout will know that the robotic arm wasn't responding directly to the left-side movements. There was a disconnect, a "splitting." The computer was plugged by electrode into the left flesh arm and leg. The computer operator could produce a set of left-side gestures in any order by pressing icons on a touch-screen. A series of touch-screened

gestures could be replayed continuously by activating a loop function, adding computer-generated gestural feedback. An improvise function allowed random gestures to be superimposed. Electricity transduced into organic movement. The robotic arm, however, was not being remotely controlled. It was wired to right-side stomach and leg muscles, controlled voluntarily in symphony with the involuntary left-side movements (that is, as voluntarily as a body can act when most of it is given over to continuous input of remotely controlled gesture-inducing energies). Organic movement was transduced back into electricity before re-emerging again as organic movement at a new body site. This relocational transductive relay between muscle power and electricity occurred across the split between the computer-programmed gestural sequencing and the robotic-arm accompaniment.

What filled the interval was voluntary action. The human will was not all-directing from outside. It was doubled: it was at the terminal, partially controlling from the edge of the relay, and it was *in* the relay, folded into the split between the left and right sides of the body across which the transduction passed, controlling even more partially, obliged to respond and choreograph. The human was relegated to a position of adjacency to the relay while *at the same time* it was integrated into its very heart. There, in the split, the human will was in a kind of a micro-suspension, contributing to a rhythmic transduction of electromagnetic into organic forces and organic into electromagnetic: a beat at the heart of an expanded body integrating flesh, metal, and silicon, in mutually prosthetic cofunctioning, for relocation and relay.

There was no explanation of the sounds. But the parallels between the sounds' rhythm and the pace and magnitude of the gestures suggested another bodily relay. In fact, the music was generated on the basis of electrical impulses picked up from the brain, the movement of the muscles, and, as in the suspensions, the flow of blood through the body. Members of the audience, whether or not they understood the details of the plug-ins and relays, were confronted with a compelling spectacle of the body made into a literal transducer—relaying between artificial and natural intelligence, human will and programmed motion, organic and mechanical movement, electrical magnetic force and organomechanical force—with the extraction of beautifully ghastly sound expressions from the matter of the body, with the openness of the wired body, pained, exhausted,

austere, to inhuman forces vibrating through its flesh, with the strangeness of its dissociated dance so devoid of necessary function, with the voluntary relegated to local intervention in the split. The discomfort is palpable. The onstage body's vulnerability, with its constitutive openness and integrability, has been communicated to the audience. Nervousness has replaced the initial uncertainty. No one speaks for a while, suspended and restless. When conversation rebegins, various responses are heard, ranging from outrage to excitement to bemusement to awe.

What has been communicated is not information or interpretation, not verbalized ideas. What has been transmitted is sensation itself, the body as sensible concept. The operation on the audience consists in inducing in them a momentary state of unhooked suspended animation: of stupor. The onstage body has effectively transduced and relayed the force of electricity. But the audience is out of the electronic loop. Sensation is repeated as an excess effect of the reconnection of the once suspended body. It also is doubled: once on stage in the openness and pathos of the artist's body and again in the stupor of the audience. *Stupor* is received sensation. Sensation is spun off, centrifugally, landing and reimplanting itself in the audience. Rather than reconnecting, the audience bodies are only feeling, in some small way entering a hypermutable state. After a moment, the spectators collect themselves and their thoughts and translate the sensation into a divergence of emotionally charged verbal ideas as they walk away with the effects of the sensation. Is their verbalized reaction the same reaction they would have proferred before seeing the performance in response to a description of it? Has something extraverbal happened that has then transformatively unfolded (transduced) into phonemes? Has something changed? Will there be a difference, even a slight divergence, in the way some of the spectators—newly sensitized to the electromagnetic forces and the beating of the integrated will—live their corporeal connectibility?

The artist has tweaked. He has no mastery over the situation, no effective control over which ideas the spectators verbalize or over how or if they subsequently connect. And he seems entirely unbothered by that fact, even pleased at the range and unpredictability of the responses. His project is induction and transduction. Meaning is incidental. What, after all, would be the sense of performing, rather than reciting or writing, if meaning—the sensible concept out-thought— were the target medium of the concepts in play? "Information is the prosthesis

that props up the obsolete body."[61] Meaning—whether informative, interpretive, or symbolic—props up the old body, the will-controlled body-object, over the abyss of its obsolescence. Meaning adheres the body-object and its voluntary human control to the immediate past rather than splitting it with futurity.

If the artist's project is induction and transduction, subsequent connection is the *audience's* project. Stelarc's art limits itself to being a science of indeterminate transmission: *virtual transmission.* Not meaning, not information, not interpretation, not symbolism is transmitted: only sensation, the germ of what may eventually unfold as new possibility. What is transmitted is potential *inventiveness.* Rather than providing answers, the performance reposes the problem of the body's reconnectibility toward change. What in particular is transmitted is *by design* beyond the artist's contentedly limited powers. He does, however, have a general direction in mind-body—outer space. But his transmissions will launch in that direction only if his desire is doubled many times over—only if the countergravitational compulsion animating the ur-idea of Stelarcian sensation is met, redoubled, and impossibly extended in that particular direction. Stelarc is prodding us. You can't blame a body for trying.

He is most powerfully prodding when the phases of his project combine. *Fractal Flesh* combines expressive and prosthetic elements in a new relay apparatus. This superimposition of phases is what Simondon calls a *dephasing.* In dephasing, the body and its objects dissolve into a field of mutual transformation where separate phases enter into direct contact. That field is defined less by the already established structure of the objects and organs involved than by the potentializing relay that brings them into dynamic continuity across the intervals that normally separate them, making them structurally distinct (the "splits"). The field is defined by the qualitatively transformative movements of energy *between* structural segmentations (computer/human, left side of body/right side of body, organic arm/*Third Hand,* control/response, and so on). What the overall transformation is toward (aside from the question of what particular inventions, needs, and utilities might eventually follow from it) is the integration of the human body and will into an expanding *network* to such an extent that the very definition of the body (and the human) might change.

This kind of performance set-up stages sensation collectively. After all, human bodies never come in ones. A single body evolving is an absurdity. The

individual, isolated body of the suspensions was a default position of sensation, just as the skin is the default container of human intensity. And just as the body has already extended beyond the skin into a mutual prosthesis with matter from its first perception, so too is the individual body always already plugged into a collectivity: "There is no focus on the individual . . . words like *I* are just a convenient shorthand for a complex interplay of social entities and situations."[62] The isolation of the suspension events was a contrivance designed to return the body to its sensation for it to reextend into the always-already collective on a new footing. The conditions of sensation, like those of evolution, are fundamentally collective. Simondon insists on this: the transformative field of bodily potential is "preindividual" (or better, "*transindividual*").[63] Sensation, even as applied to an artificially isolated individual, is induced by collective stagings (the artist is always assisted) and, as a connective compulsion, always tends toward transductive contagion. To return to the point where thought rejoins the body and the human rejoins matter is to return to the point of indistinction between the individual and the collective—which is also the point of their emergent redivergence.

The Stelarcian project truly begins to unfold when the audience is let back in. The big result it tweakingly pursues involves a reinvention of the individual in its relation to the collective. In this day and age, that involves a new kind of transductive connection between individuals, taken at least by twos and implemented through (collectively developed and deployed) technologies of communicative transmission. In other words, Stelarc's project is by nature cyberspatially oriented and was so prospectively before the fact. The bug goggles were distant forerunners of the virtual reality helmet.

5

OPERATION: interconnection
MEDIUM: the sensible concept as evolution
MODE: networking

Finally, in the fifth phase, a different dimension is reached when the audience is reinvited to participate in the performance, as with the goggles and other early

events. A member of the audience might be invited to cocontrol the "split body" by punching a sequence of gestures into the computer or might even be hooked to the electrodes and share the sensation directly. But the network dimension comes into its own with the Internet events of the late 1990s and early 2000s (*Ping Body, Parasite, Movatar*). The stage was set for a reposing of *Fractal Flesh* as Telepolis in 1995. The idea was to hook up the computer controlling the split body's electrodes to the World Wide Web. In practice, the fledgling Web was still too slow, so a dedicated network of modem-linked computers was substituted.[64] The basic elements were now in place. The body and the *Third Hand* were in Luxembourg. Other bodies in Paris, Helsinki, and Amsterdam gathered at the specially networked terminals to remotely control the body's gestures. The effects of their input was made visible for them through a screen feed. The body in Luxembourg could see the faces of its part controllers on its own screen. A visual feedback loop

Split Body/Scanning Robot, TISEA, Museum of Contemporary Art, Sydney, 10 November 1992. Photo by Anthony Figallo.

facing page:
Event for Video Robot, Involuntary Arm and Third Hand, La Mama, Melbourne, 29–30 October 1992. Photo by Anthony Figallo.

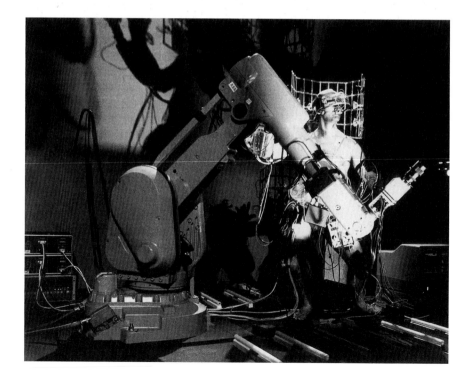

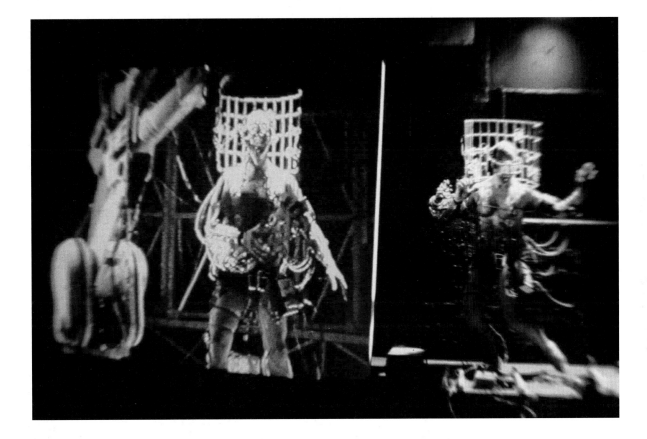

Event for Video Robot,
Involuntary Arm and Third
Hand, La Mama, Melbourne,
29–30 October 1992. Photo by
Anthony Figallo.

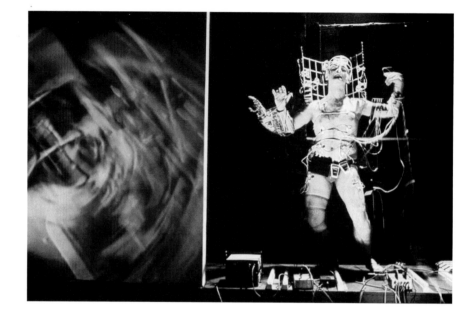

was thus added to the electromagnetic/organomechanical loop. "Look only at the movements" was now "Also look at the movements." For the audience was in the loop. It had become part of the performance. The distance between the performer's and the spectator's actions is remotely abolished, to the extent that it is no longer clear which is which. Sensation has unfolded into a transindividual feedback loop of action and reaction, stimulus and response: "Electronic space becomes a medium of action rather than information."[65] Action-perception is welcomed back to accompany the staging and contagion of sensation.

Since the situation is still entirely needless and useless, since it is outside established, regularized tried-and-true action-perception circuits, this is not a full-fledged return to analysis in action. The performance uses instrumental reason to set up an experimental exercise in operative reason. In this mix with instrumentality, operative reason dominates. The action-perception circuits opened are tried but in no sense "true." For they still precede their logical possibility (this is perhaps the meaning of Stelarc's formula "high-fidelity illusion"). The performance potentializes a material interconnection of bodies. What, if anything, will

unfold from it in the way of instrumentally reasonable uses and needs is unforeseeable, a sheer futurity that will come to pass only after an indefinite series of subsequent reposings of the same problem in varying conjunctions. What new possibilities will this serially expanding transductive activation of electronic space produce for the human collectivity? Networked, Stelarcian potential finally just begins to *repossibilize* in an evolutionary direction.

The form in which the emergent possibilities begin to express themselves is futurist speculation. In material posted on Stelarc's Web site, speculation is encouraged on the eventual uses of remote actuation. Space travel figures large. Possible uses of other Stelarcian set-ups are also brought into the picture. The *Hollow Body,* for example, returns in a possible scenario of nanotechnological symbiosis as technology is implanted in the innermost folds of the body. Could this, combined with prostheses applied to the external envelope of the body, extend not only the spatial parameters of life beyond the earth's gravitational field but also its time parameters beyond their normal limits, making free-floating cyborg immorality a possibility as human organs are supplemented or supplanted by technological objects?[66] The fantastic solution cases for the problems posed by Stelarcian sensation as it just reconnects to action-perception begin to order themselves into a future combinatoric. But these are still impossible possibilities, uses predicated on as yet undeveloped technology. Disengaged, only-thought utilities rise like a shadowy vapor directly from the ferment of potential, skipping over the necessary intervening steps through fully fledged instrumental-developmental action-perception. Impossible possibilities are prospective shadows. This is not a utopian moment because it does not matter, to the artist or anyone else, if anyone really takes them seriously—yet.

What is important is not the fantastic solution cases themselves but the new and compelling problem their speculation poses. If these disengaged possibilities engage—if the things, objects, organs, thoughts, and anticipations that they shadow come to stand by them, together with new operative and instrumental interconnections—will we still be human? Can humanity tweak itself into a new existence? The only way anyone will ever know is if the human collectivity applies itself to the development of the intervening technologies, which are then set up to sensitize and potentialize humanity particles toward launching themselves instrumentally into their own futurity. By then, anyone (or anything) in

a position to know will no longer be human. Effective knowledge of these disengaged solution cases is humanly impossible, which is why they are necessarily the stuff of futurist speculation. In any case, the knowledge will be attained by someone or something only if there is a sufficiently shared desire among humans for the launch, a strong enough collective compulsion. It won't happen through a triumph of the will, through an application of knowledge of outcomes, or even through through natural selection. The will is unlikely to will itself relegated to adjacency and (insult added to injury) fully integrated into the transformative machinic relay. Reflective knowledge of evolution (all reflective knowledge for that matter) is by nature retrospective. Natural selection, for its part, is only evolution's unfolding. No, if it happens, it will only be through *desire*. Desire is the condition of evolution.

When Stelarcian sensation rebegins to unfold, it is in a new countergravitational landscape—in which the relations between the possible and the impossible, desire and will-directed instrumental reason, instrumental reason and reflective analysis, and instrumental reason and operative reason have been reconfigured in an evolution-ready manner.

It needs to be emphasized that the activation of information operates through the sensitization of the human body-matter to electromagnetic *force*. More than a container of information, cyber- *"space" is a dynamic field of transduction*. Computer-assisted transductive interconnection is literally and materially a potentialization. The informational content of that connection—the meaning of the words and images transmitted—is important only as a trigger or catalyst. Information is but a local bit player in the project of inducing a global transformation effect whose reason is of another order. Immediately after *Fractal Flesh* at Telepolis, Stelarc began plans for an Internet project: *Ping Body* (1996). The momentum is rolling. A new series is under way, generating variations on itself.

This time, the body would be plugged into the network in a way that its gestures would be controlled by the quantity of information traveling the wires: "Instead of people from other places activating the artist, Internet data moves the body. By pinging over forty global sites live during the performance and measuring the reverberating signals, it was possible to map these to the body's muscles with the muscle-stimulation system. The body does a data dance; it becomes a barometer of Internet activity. If we ping China, the signal comes back in only

hundreds of milliseconds (therefore not much Internet activity there), whereas if we ping the USA, it comes back in thousands of milliseconds. The arms and legs also have sensors that produce sounds indicative of the position and velocity of the fingers and limbs. Internet activity composes and choreographs the performance."[67] The body plugs into the *mass* of information. As a mass, information is not itself. Its content is neutralized. Information impinges on the body directly as a force, which is why voluntary control is designed out of this loop. In this variation, the emphasis is on making the *force of information* visible. It visibly expresses the evolution readiness of the body networked. Because it makes the network an expressive medium (superimposing phase two on phase five), the body is once again suspended (superimposing phase one). It is alone under the mass of information, like the sewn body once was under the weight of rock. It feels the future-force of information. The involuntary movements induced are not relayed into incipient action-perception or fed back to other bodies, as was the case in *Fractal Flesh*. The body becomes a resonating vessel for the force of information, to which it is now singularly sensitized. This device encompassed a restaging of the zero degree of sensation tuned to the cybernetic potential of the body. It composes a virtual center for the Internet series of events.

As the transformed return of sensation illustrates once again, the dimensions of the Stelarcian multiplex are not "periods" in the artist's work adding up to an evolution. They are continually varying, operative foldings into and out of each other. *Ping Body* will be followed by *Parasite: Event for Invaded and Involuntary Body* (1997),[68] and *Parasite* by *Movatar* (2000),[69] each enacting different phase combinations (partial, selective dephasings potentializing qualitatively different unfoldings). All of the phases and events are present—potentially, differentially—in each. There is, however, a logical order of precedence indicated by the numbering of the phases here. There is no necessity for the chronological order to follow this logical order. That it did in Stelarc's case is an accident of history. The main reason that it did so was that the technological prerequisites for the network (incipient reextension phase) were simply absent in precyberian 1970. But the desire was there, compulsively beginning to work itself out, waiting for objects and organs to fall into place.

It should be borne in mind that Stelarc's project has to do with performing the *conditions* of evolution. The conditions of evolution are not yet evolution.

That is why Stelarc is right to resist speaking of an evolution of his project. The project can accurately be said not to evolve but only to repose serially at its furthest point just beginning to unfold. To perform of the conditions of evolution is to reproblematize them. For in an immortalized cyborg future-present, natural selection would no longer be the operative principle of evolutionary unfolding. The old way of generating evolutionary solution cases will no longer obtain. What Stelarc is projecting is a *postevolutionary* evolution of the human. Paradoxically, postevolution will be achieved only by an *actualization of the conditions of evolution,* such that what comes "first" (sensation as world-corporeal potential) also comes last and what is infolded unfolds as such—nonobjective and asubjective, not yet thought and incipient action, activated and supended, individual and collective, all rolled up together, all in one process: everything a human body can do or become (except remain all or too human). The alchemical trick is to induce a temporal feedback loop, making the moments or dimensions of the project operatively self-referential even as it unfolds: material, qualitative autotransformation, at once local and global (multiplex), in serial succession, and everywhere at a virtual center. An onrolling infolding for an unfolding of change: the project, evolutionary in desire, is *involutionary* in its actual operation. That is why it is so thoroughly problematic.

Stelarc's human body-object involutionarily "stretched between what it never was and what it can never hope to be"[70]—suspended between the prehuman and the posthuman.

"Time to vanish."[71]

Nodally Yours (The Human)

A final warning on prosthesis, since it seemed to have established itself as the master concept in a great deal of theorizing of cyberspace and the cyborg in the 1990s. As commonly used, the term refers to the replacement of an organ with an artificial double designed to fulfill the same function. Prostheses by this definition are need and utility oriented and belong to an order of substitution. The possibilities for organic functioning precede the fabrication of the prosthesis. The actual artifact is a use-oriented image (an instrumentalized sensible concept) materializing a set of restorable organic functions. In other words, the prosthesis is the sensible

concept of a preset system of possibility. It never leaves the orbit of the organic human body-object.

The operation in play in Stelarc's project, on the other hand, has to do with *extension* rather than substitution: "on the other hand"—exactly. The robotic *Third Hand* attaches to the right flesh arm rather than replacing it. It is a *prosthesis* in the etymological sense of the word: "to put in addition to." As an addition, it belongs to an order of superposition. The tendency of Stelarc's events is toward superposition. In the expressive events, the body is probed so that its inside is *also* an exterior. In the Internet events, the body inputs information to the computer to express it or relay it as a force: the body places itself between information *and* force. The left side of the body receives programmed gestures fed in from a machine, to which it then choreographs a circumscribed voluntary response: programmed *and* involuntary. The body relays electromagnetic movement into organic movement and back again: organism *and* machine. Computer *and* robotic arm. Infolding *and* expression. Sensation *and* incipient action-perception.

In the networked fifth dimension or phase, the serial probings, sensitizations, expressions, transductions, relays, and transmissions of the body are coaxed into copresence with each other. All of the operations are held in ready reserve as randomly accessible openings. The body as *random-access opening* (RAO) can connect in any number of ways to itself, its objects, and other bodies. It can open, split, and reconnect at any point, inside or out. It is no longer an objective volume but an extend*ability*. Its dimensionality has increased beyond the three of spatial presence: from the three dimensions of the voluminous, it leaps to a fifth dimension of the *extensile*. This dimension is actually fractal, between dimensions—split and extend, the basic operations used to generate fractal figures. The fractalization of the body is no metaphor. It is an operation: the posthumanizing operation.

The operation of fractalization is posthumanizing because, featured prominently among its "ands," is subject *and* object. In the Internet events, the body was acting instrumentally as a subject when it sent out meaningful information, installed remote-control terminals, and generally staged the event. But in the event, it was also on the receiving end. Information flowed back to it, not meaningfully but felt as a controlling force (*Ping Body*). This force of information impinged on the body split open: the body as an operationally opened, sensitized object. The cybernetic network makes the body a subject and an object simultaneously and

asymmetrically (since in its different capacities, it effects different kinds of movement—voluntary and involuntary, for example). Of course, the body is always and asymmetrically both a subject and an object. But in normal human mode, it is a subject for itself and an object *for others*. Here, it is a subject and an object *for itself*—self-referentially. The one accustomed conjunction in which a human subject is also an object for itself is in reflective thought. Reflective thought aspires to self-mirroring symmetry. The networked coincidence of subject-object is neither reflective nor self-mirroring but operative and relaying. The "self" of this self-referentiality is of a qualitatively different kind, one that operationally includes in its being for itself other individual human body-selves, computers, telephone lines, electromagnetism, and any number of heterogeneous elements, forces, objects, and organs. The body-self has been plugged into an extended network. As fractal subject-object, the body *is* the network—a *self-network*.

It was asserted earlier that the body and its objects were prostheses of *each other* and that matter itself was prosthetic. The fractal body brings this extensile mutuality to full expression. It is precisely the full expression of this aspect of the human that makes it posthuman. The self-network expresses extendability to a degree beyond the human pale. But extensile mutuality is also *before* the human pale: it is a characteristic of every perceiving thing to the extent that it is capable of change. The extension into the posthuman is thus a bringing to full expression of a prehumanity *of* the human. It is the limit-expression of *what the human shares with everything that it is not:* a bringing out of its *inclusion* in matter, its *belonging* in the same self-referential material world in which every being unfolds. The potential cyborg extensions of the human, once it has entered a hypermutably open state, are existentially unbounded. The self-network is a *worlding* of the human. The moon's the limit. Or maybe not. Having counteracted the earth's force of gravity, the posthuman body-world is in its own orbit: the *becoming-planetary* of the human.

The speculative limit is not merely the envelope of the earth's atmosphere. More than a spatial bound, the limit is a critical self-conversion point bearing on the mode of existence of the human. Modally, the limit is *self-organization*—the self-network extended to encompass all aspects of what is, by virtue of that extension, exhuman life, so that the body doesn't ever have to plug in. Wherever it goes, it is preplugged—the Media Lab's dream of ubiquitous interface come

Skin for *Prosthetic Head,* San Francisco, Melbourne, November 2002. Image by Barrett Fox.

fantastically true.[72] The exhuman is now a node among nodes. Some nodes are still composed of organic body matter, some are silicon-based, and others, like the ancestral robotic arm, are alloy. The body node sends, receives, and transduces in concert with every other node. The network is infinitely self-connectible and thus infinitely plastic. The shape and directions that it takes are not centrally decided but emerge from the complex interplay of its operations. The self-organizing network is the embodiment of operative reason expanded to fill the world. A brave new world—even if it never does get around to leaving the earth's orbit.

This is the fundamental direction in which the Stelarcian project extends intelligence: the encompassing of instrumental reason in a system of operative reason tending toward pan-planetary reach. Instrumental reason is and remains highly relevant. How relevant reflective thought remains is not so certain. It is this uncertainty in particular that problematizes *agency*. The base meaning of the word *agency* in this context is the expression of intelligence in needful or useful action. Stelarc's proto-self-networking Internet events do not deny agency. Quite the contrary, they multiply it—emergently. The extension into action has not fully unfolded. No use or need is actually fulfilled. Again, *movement* is a better term for what is happening than *action*. Movement, as understood here, is between the intense vacuum *activation* of sensation and extended object-oriented action-perception. It is more forthcoming that the former but less outgoing than latter. It is the undergoing of qualitative transformation. The Internet events catch agency in movement.

Stelarc cites four kinds of movement in operation: voluntary, involuntary, controlled, and programmed.[73] Each is in turn multiple, arising in different ways at various points in the relay system. Take *Fractal Flesh* again as an example. *Voluntary* movement figures in the setting up of the stage, the donning of the contraption, and the inputting of the computer commands, as well as in the performing body itself when it untangles wires, subtly changes posture to relieve fatigue, or choreographs gestures. It is most evident in the stomach-controlled movements of the *Third Hand*. Voluntary movement exercises reflective thought and/or analysis-in-action. *Involuntary* movement is present in the usual organic functionings of the body's autonomic nervous system, as expressed in the sound relay. It is also produced in reactions to the electrode stimulation—for example, flinching in reaction to the pain or in the inability to successfully execute a willed movement

due to interference of the movements induced by the electrode stimulation. The movements of the left-side arm and leg are *controlled* by the electrode stimulation. Finally, the parameters of the robotic arm's movement and the repertoire of electrode-inducible gestures are *programmed*. All of these modes of agency cooperate in the network: "already the beginnings of a symbiosis between the human and technology."[74]

Any of these movements can be modulated. For example, the computer-controlled arm and leg movements run a continuum from "prompting" to full "actuation" depending on the intensity of the transmitted electromagnetic force.[75] They can also form mixes: at any level below full actuation, the body can voluntarily inflect the controlled movement by offering resistance to the stimulated movement or by following through on its momentum, extending or exaggerating it. Considered in their variations over the Internet series of events, they can in addition occupy any node in a relay system or more than one node at once. With multiple relays or feedback, the same node can exercise more than one mode of movement at the same time.

The point is that while voluntary movement is necessary, it is in no way sufficient. It takes its place in a proto–self-network whose effectivity depends on all four modes working in concert, in combined mode of intelligent exercise that can only be characterized as operative, the most ecumenical of reasons. Of the four modes, human agency is recognizably present only in the voluntary. The hallmark of the human is spun out to a peripheral position of adjacency to the network (the console operator), and it is integrated in the transductive relaying (the artist). The peripheralization and the integration are forms of subsumption. The integrative subsumption is the more interesting, since it prefigures the destiny of the human should the network ever actually reach pan–planetary scope. As integrated into the network, the human occupies a *gap* in the relay. It inhabits the "split." From the network's internal point of view, the human will is an *interruptor*. It is an irruption of transductive indeterminacy at its very heart. Whether peripheral or integrated, human agency enters the network as a local input of free variation: in other words, a variation not subordinated to the programming of the self-network. The variation is "free" in the sense that it is a given for the network, which itself expends nothing to produce it. Something for nothing: the human becomes a raw material or *natural resource* for the network. The human's twofold

"subsumption" through peripheralization and operational integration is not an obedience. If it is an exploitation, it is in the sense in which the word is used in mining and other extractive industries. Alternatively, it can be considered a *capture* because as a raw material the human is fed into a process that it isn't in a position to direct (or even digest).

Interruption of the operative principles of reason, indeterminacy, given variation: the properly human is the *unconscious* of the network. The way in which voluntary inputs are captured, transduced, and networked is a technological *symptom* of the ex-human. That symptom does not register in the network in the mode in which it is input. It is input as will, intention, and meaning, but is assimilated as relay motion. The humanity of the human is symptomatically transduced from the register of reflection and meaning to that of energetic transfer. As part of the same global transformation by which the human body becomes planetary, its humanity is translated into a local force. It is only as a local force that the properly human is registered and becomes conscious (operationally present) to the worlding network. Once the speculative pan-planetary self-network was up and running, all of this would apply to the human input of computer commands and even to the programming of protocols. For in a decentralized network, only certain program modules would be manipulable from any given node. There would be no single point at which the network as a whole could be reprogrammed.

In the self-organizing network, the human is no longer master and no longer central. It is *subsumed*. At the limit, in an integrative network, there is no center or periphery, only nodes. The human is fractalized. It is dispersed across the nodes and transversed by them all in the endless complexity of relay. The human is neither "all-here" nor "all-there,"[76] neither inexistent nor fully itself. It is part here *and* part there, symptomatically transduced and transformed.

It was argued earlier that the "pre-" and the "post-" coincide in the evolutionary condition. This is easy to see in the self-network. The human body node can transduce any mode of movement at any time. Its just-past perception or exercise of agency might be the next node's about-to-be mode, and vice versa. The trigger-force of electromagnetism can travel instantaneously from any point in the network to any other. The past and future of any particular node have already unfolded elsewhere in the network and not just its immediate past and future:

middling and remote pasts and futures also flicker across the Web. The particular node's entire combinatoric of possibility is actually present in dispersion. Not "engaged" with the present—electromagnetically embodied in it. But an actual possibility is not as much a possibility as a potential. But potential is by nature infolded. These "potentials" are extended. To complicate things even more, possibilities or potentials of agencies that the human body-node never was and can never hope to be (for example, a computer program or a mass of information or a robotic limb) are also looming just over the next node. Possibility and potential collapse into actual conjunction. They are actualized, in mixture, in a melding of analytic thought and the forces of matter. A new mode of extended existence— *an actuality of excess over the actual*—is invented by the dispersal of agency. The dispersed copresence of networked possibilities-potentials should not be seen as a mire of indistinction or a short-circuiting of change. It is not indistinction but an order of dispersed superposition that in fact represents heightening of differentiation, since every node will occupy an absolutely singular conjuncture in the complex, transductive, superpositive flow. And rather than a short-circuiting of change, it is its actual embodiment: the self-organizing ebb and flow of agency transfer makes the network a continuum of variation.

Will any of this ever happen? Should it ever happen? Doesn't this whole discussion ignore the impoverished and especially non-Western bodies that will be passed over in the postevolutionary rush, consigned to a thoroughly trashed planet? Doesn't this beg the questions of power and inequality? These are legitimate reflective questions, to which the majority of us still-humans would probably answer "no," "no," "yes," "yes." But they are beside the problem—not at all beside the point but beside the problem. The problem, which Stelarc's art both expresses and exacerbates, is that the process has already begun. However far the Media Lab is from achieving its dream interface, however far the Internet is from the apocalyptic possible futures speculated for it, however incompletely the new media have been implanted, however faltering is their present state of interconnection—the modal conversion of the human has sensibly begun. The Stelarcian body answers the nagging questions about it with a "yes," "yes," "not necessarily," "maybe, maybe not." The reflective critical thinker anchors the discussion in the "no's" of will not/should not, willing a clamp down on potential in the name of

justice. The experimenter in criticality starts from "yes" in the name of sensation and leaves the field wide open. The Stelarcian desire is to *affirm* the conversion, not to denigrate the importance of the human-justice issues that it incontestably raises but rather to enable them to be reposed and operated on in an entirely new problematic, one that may even now be waiting for us around the next node. This experimentally open, affirmative posture can be considered a socially irresponsible approach to the problem of human evolution only if the critical thinker can answer an unhedged "yes" to this counterquestion: *if all of this doesn't happen, will there be an end to impoverishment and inequality, and will the earth not be trashed?* Until that affirmation is forthcoming, there is no argument, only a clash of desires. Two desires implicating divergent modes of existence: affirmed exhuman intensity and all-too-human moralism.

Notes

1. This text was first published as "The Evolutionary Alchemy of Reason: Stelarc," in Brian Massumi, *Parables of the Virtual: Moment, Affect, Sensation,* 89–132. Copyright 2002, Duke University Press (ISBN 0-8223-2882-8). All rights reserved. Used by permission of the publisher.

2. Stelarc, "Portrait robot de l'homme-machine," interview with Jean-Yves Katelan, *L'Autre journal* 27 (September 1992): 28.

3. Stelarc, "The Body Obsolete: Paul McCarthy Interviews Stelarc," *High Performance* 24 (1983): 14–19; James D. Paffrath and Stelarc, eds., *Obsolete Body / Suspensions / Stelarc* (Davis, CA: JP, 1984).

4. Paffrath and Stelarc, *Obsolete Body,* 134; Stelarc, "Stelarc: Interviewed by Martin Thomas," special issue on *Electronic Arts in Australia,* ed. Nicholas Zurbrugg, *Continuum* 8, no. 1 (1994): 389; conversation with the artist, December 1995.

5. Stelarc, interview with Martin Thomas, 379, 383; Stelarc, "Portrait robot de l'homme-machine," 27.

6. Stelarc, "Portrait robot de l'homme-machine," 27; Paffrath and Stelarc, *Obsolete Body,* 8.

7. Ken Scarlett, "Early Performances: Japan / Australia," in Paffrath and Stelarc, *Obsolete Body,* 20.

8. Stelarc, "Portrait robot de l'homme-machine," 26.

9. *Event from Micro to Macro and in Between,* 1970; *Helmet No. 3: Put On and Walk,* 1970. Both performances are described in Ann Marsh, *Body and Self: Perfor-*

mance Art in Australia 1969–92 (Melbourne: Oxford University Press, 1993), 25–26, and in Stelarc, "The Body Obsolete," 15.

10. Henri Bergson, *Creative Evolution,* trans. Arthur Mitchell (Mineola, NY: Dover, 1998), 11–12, 96–97, 188.

11. Bergson, *Creative Evolution,* 48–49.

12. On the direct experience of moreness in transition ("the immediate feeling of an outstanding *plus*"), see William James, *Principles of Psychology,* vol. 2 (New York: Dover, 1950), 151–152.

13. Chapter 6 of my *Parables of the Virtual* ("Strange Horizon") makes some suggestions on how this hypercomplex order might be conceptually approached.

14. "The world does not exist outside of its perceptions." Gilles Deleuze, *Leibniz and the Baroque,* trans. Tom Conley (Minneapolis: University of Minnesota Press, 1993), 132. If the proliferation of "poles" has gotten confusing, a simple distinction will help. The poles of perception, thought, and sensation concern an ongoing *process* (the rolling of the world into a nextness). The poles of the body and the thing concern a *structuring* of that process as it goes on (the germ of subject-object relations). To say with Deleuze and Leibniz that the world does not exist outside of its perceptions (that it is "not all in" them) is to say with Alfred North Whitehead that it is composed of sensation (the actual registering of the potential more of which perception is not all; its tending, pending envelopment in each connection). *Feeling* is Whitehead's term for what is called *sensation* here: "the philosophy of organism attributes 'feeling' throughout the actual world. . . . when we observe the causal nexus, devoid of interplay with sense-presentation [that is to say, pending perceptual reconnection], the influx of feeling with vague qualitative and 'vector' definition [tending] is what we find." David Ray Griffin and Donald W. Sherburne, eds., *Process and Reality* (New York: Free Press, 1978), 177. The usage of *sensation* here departs from its usage in psychology and analytic philosophy, where it is synonymous with "sense-presentation" or "sense-datum." In the present vocabulary, both of these terms are associated with *perception,* which, as this quote from Whitehead asserts, is different from feeling/sensation. As Whitehead remarks (and as is shown later in relation to Stelarc's suspension events), sensation involves a "voiding" of perception. Sensation is itself a continuum that stretches between its own extrema or poles. One pole is pure sensation (pure potential), experience as radically voided of perception as possible. The other is the point at which sensation just starts to recede from perception (still mixed potential). The continuum of sensation fills intervals of *destructuring,* since sensation is where experience falls away from perception, action, and thinking out. These intervals of destructuring paradoxically carry the momentum for the ongoing process by which thought and perception are brought into relation toward transformative action.

15. Bergson, *Creative Evolution,* 161: "All the elementary forces of the intellect tend to transform matter into an instrument of action, that is, in the etymological sense of the word, into an *organ* . . . inorganic matter itself, converted into an immense organ by the industry of the living being."

16. Bergson, *Creative Evolution,* 206: "neither does matter determine the form of the intellect, nor does the intellect impose its form on matter, nor have matter and intellect been regulated in regard to one another by we know not what preestablished harmony, but that intellect and matter have progressively adapted themselves one to the other in order to attain at last a common form."

17. Anne Marsh, *Body and Self: Performance Art in Australia 1969–92* (Melbourne: Oxford University Press, 1993), 25–26.

18. Stelarc, "The Body Obsolete," 18.

19. Stelarc, "Special Feature: The Function of Art in Culture Today," *High Performance* 11 no. 1–2, issues 41–42 (Spring–Summer 1988): 70; Paffrath and Stelarc, *Obsolete Body,* 8.

20. Stelarc, "Portrait robot de l'homme-machine," 28.

21. Artist's statement, "The Function in Art and Culture Today," 70.

22. Paffrath and Stelarc, *Obsolete Body,* 17.

23. Paffrath and Stelarc, *Obsolete Body,* 66.

24. Marsh, *Body and Self,* 66.

25. Henri Bergson argues that this is always what happens. The possible is always a retrospective projection, he argues, and its forward-looking operation is a trick of consciousness (undoubtedly another example of the time-slip capacities of consciousness, in addition to the Libet lag analyzed in chapters 1 and 6 of my *Parables of the Virtual*). Stelarc's practice, then, would be a *making felt* of the retrospective nature of possibility. See Bergson, "The Possible and the Real," *The Creative Mind,* trans. Mabelle L. Audison (New York: Philosophical Library, 1946), 107–125.

26. Paul Virilio, "Rat de laboratoire," *L'Autre journal,* 27 (September 1992): 32; and Paul Virilio, *The Art of the Motor,* trans. Julie Rose (Minneapolis: University of Minnesota Press, 1995), 109–119.

27. Paffrath and Stelarc, *Obsolete Body,* 100.

28. Paffrath and Stelarc, *Obsolete Body,* 16, 21, 117, 120; Stelarc, Paolo Atzori, and Kirk Woolford, "Extended-Body: Interview with Stelarc," *Ctheory.net* 6 September 1995, available at http://www.ctheory.com.

29. Stelarc, interview with Rosanne Bersten, *Internet.au* (1995): 35. On transduction, see Gilbert Simondon, *L'individu et sa genèse physico-biologique* (Grenoble: Millon, 1995), 30–33, 231–232. See also Muriel Combes, *Simondon: Individu et collectivité* (Paris: PUF, 1999), 15–20.

30. Paffrath and Stelarc, *Obsolete Body,* 8, 66.

31. Paffrath and Stelarc, *Obsolete Body,* 20.

32. Paffrath and Stelarc, *Obsolete Body,* 144.

33. Paffrath and Stelarc, *Obsolete Body,* 16.

34. Paffrath and Stelarc, *Obsolete Body,* 21.

35. Paffrath and Stelarc, *Obsolete Body,* 57. See also Stelarc, "The Body Obsolete," 16.

36. Gilles Deleuze and Félix Guattari, *A Thousand Plateaus: Capitalism and Schizophrenia,* trans. Brian Massumi (Minneapolis: University of Minnesota Press, 1987), 149–166.

37. Stelarc, "The Anaesthetized Body" (n.d.), http://www.stelarc.va.com.au/anaesth/anaesth.html; Stelarc, "From Psycho to Cyber Strategies: Prosthetics, Robotics, and Remote Existence," *Canadian Theatre Review* (1996).

38. "Distraught and disconnected the body can only resort to the interface and symbiosis" into the next series. Stelarc, "From Psycho to Cyber Strategies."

39. Paffrath and Stelarc, *Obsolete Body,* 59.

40. Stelarc, "Stelarc: Interviewed by Martin Thomas,"

41. Paffrath and Stelarc, *Obsolete Body,* 147.

42. Paffrath and Stelarc, *Obsolete Body,* 105.

43. Paffrath and Stelarc, *Obsolete Body,* 153.

44. James, *Principles of Psychology,* 2: 174n.

45. For details on these projects, see Stelarc's official Web site at http://www.stelarc.va.com.au.

46. Deleuze and Guattari, *A Thousand Plateaus,* 282. The infolding that is described here rejoins a virtual center immanent to every event in a series of transformations. It is what Deleuze and Guattari call "involution." They call the intensive movement of involution "absolute movement" and assert that evolution occurs through involution (267).

47. Bergson, *Creative Evolution,* 218–220.

48. Stelarc, "The Function of Art in Culture Today," 70.

49. "Internal resonance is the most primitive form of communication between different orders of reality; it comprises a double process of amplification and condensation." Simondon, *L'individu et sa genèse physico-biologique,* 31n. See also 25.

50. Ilya Prigogine and Isabelle Stengers, *Order out of Chaos* (New York: Bantam, 1984), 142–143.

51. Prigogine and Stengers, *Order out of Chaos,* 163–165; Prigogine and Stengers, *Entre le temps et l'éternité* (Paris: Fayard, 1988), 59–60.

52. Paffrath and Stelarc, *Obsolete Body,* 153; Bergson, *Creative Evolution,* 186–195; Bergson, *The Creative Mind,* 126–153.

53. Deleuze and Guattari, *A Thousand Plateaus,* 361–374.

54. Stelarc, "The Body Obsolete," 15.

55. "The *Third Hand* is a human-like manipulator attached to the right arm as an extra hand. It is made to the dimensions of the real right hand and has a grasp-release, a pinch-release, and a 290-degree wrist rotation (CW & CCW). It is controlled by EMG signals from the abdominal and leg muscles. This allows individual movement of the three hands. Electrodes positioned on four muscle sites provide the control signals. By contracting the appropriate muscles you can activate the desired mechanical hand motion. After many years of use in performances the artist is able to operate the *Third Hand* intuitively and immediately, without effort and not needing to consciously focus. It is possible not only to complete a full motion but also to operate it with incremental precision. It is not capable though of individual finger movements. The *Third Hand* is effective as a visual attachment to the body, sometimes mimicking, sometimes counterpointing the movements of the actual hands. Amplifying the motor sounds enhances these small hand motions." Stelarc, "The Involuntary, the Alien, and the Automated: Choreographing Bodies, Robots, and Phantoms," at http://www.stelarc.va.com.au/articles/index.html.

56. Simondon, *L'individu et sa genèse physico-biologique,* 23, 229–230; Combes, *Simondon,* 10–15.

57. Stelarc, "Amplified Body," at http://www.stelarc.va.com.au.

58. Stelarc, "Stelarc: Interviewed by Martin Thomas," 388.

59. "*Exoskeleton* is a . . . pneumatically powered 6-legged walking machine with a tripod and ripple gait. It can move forwards, backwards, sideways (left and right), sway, squat, stand-up, and turn. . . . The body is positioned on a turntable so it can rotate on its axis. . . . The 6 legs have 3 degrees of freedom each. The walking modes can be selected and activated by arm gestures. An exoskeleton wraps around the upper torso embedded with magnetic sensor, which indicate the position of the arms. Small gestures are magnified into large strides—human arm movements are transformed into machine leg motions. Human bipedal gait is replaced by an insect-like traversing of space. The body also is extended with a large 4-fingered manipulator, which has 9 degrees of freedom. Compressed air, relay switches mechanical sounds and signals from the machine and manipulator are acoustically amplified. Choreographing the movements of the machine composes the sounds." Stelarc, "The Involuntary, the Alien, and the Automated."

60. Saw Gallery, Ottawa, September 1995.

61. Stelarc, "From Psycho to Cyber Strategies."

62. Interview with Martin Thomas, 381, 389.

63. Simondon, *L'individu et sa genèse physico-biologique,* 29; Combes, *Simondon,* 47. See also chapter 2 above.

64. Conversation with the artist, Melbourne, 28 September 1996.

65. Stelarc, "From Psycho to Cyber Strategies"; Stelarc, "High-Fidelity Illusion," at http://www.stelarc.va.com.au.

66. Stelarc, "Stelarc: Inverviewed by Martin Thomas," 391.

67. Stelarc, at http://www.stelarc.va.com.au/articles/index.html.

68. In *Parasite,* the visual feed is no longer expressive but becomes operative, part of the incipient action-perception loop: "A customized search engine was constructed to scan the www live during the performance to select and display images to the body through its video headset. Analyses of the JPEG files provide data that is mapped to the muscles through the Stimbox [the computer-controlled console first used in *Fractal Flesh*]. The body is optically stimulated and electrically activated. The images you see are the images that move your body. You become sustained by an extended and external nervous system of search engine software code and Internet structure. In these performances the body is in effect telematically scaled up to perceive and perform within a global electronic space of information and images." Stelarc, "The Involuntary, the Alien & the Automated: Choreographing Bodies, Robots and Phantoms section 6 Involuntary Body" at http://www.stelarc.va.com.au/articles/index.html.

69. Here is Stelarc's project statement for *Movatar:* "An exoskeleton for the arms is being constructed that will be in effect a motion prosthesis allowing four degrees-of-freedom for each side. This would produce a kind of jerky, GIFF-like animation of the arms. Embedded with accelerometer, proximity and tilt sensors, this will be an intelligent, compliant servo-mechanism which will allow interaction by the dancer, interrupting the programmed movements—stopping, starting, altering the speed and inserting selected sampled sequences. Now imagine that this exoskeleton is the physical analogue for the muscles of an intelligent avatar. Attaching the exoskeleton means manifesting the motions of a virtual entity. It is an avatar imbued with an artificial intelligence that makes it somewhat autonomous and operational. It will be able to perform in the real world by accessing a physical body. So if someone wears the device and logs into the avatar, it will become a host for an intelligent virtual entity—a medium through which the motions of the avatar can be expressed. A phantom possesses a body and performs in the physical world. And if *Movatar* is a VRML entity based on a website, then anyone anywhere will be able to log into it. And from the point of view of the intelligent avatar, it would be able to perform with any body, in any place either—sequentially with one body at a time or simultaneously with a cluster of bodies spatially separated but electronically connected to it. A global choreography conducted by an external intelligence. What would be interesting would be a kind dance dialogue by a combination of prompted actions from the avatar and personal responses by the host body. The experiences would be at times of a possessed and performing body, a split body. Not split vertically left and

right as in the Internet performances, but split horizontally at the waist. The pneumatically actuated exoskeleton motions of the prosthesis able to make the upper torso of the body perform in precise and powerful ways, whilst the legs can perform with flexibility and freedom. The avatar would be able to determine what is done with the body's arms, but the host would be able to choose where and for what duration it could be done. The issue is not one of who is control of the other but rather of a more complex, interactive performing system of real and virtual bodies. *Movatar* would be best described as an inverse motion capture system. And since sounds generated by the body would be looped back into the avatar's program to generate a startle response, *Movatar* would have not only limbs but also an ear in the world."

From the perspective of the present essay, the "phantom" that Stelarc refers to is not the avatar itself but rather the entire network that sustains its effects. The network is the "external intelligence," and it acts as much through the avatar as through the wires and the human bodies that it integrates. The network is the machinic subject of the movement, whose principle lies in the prosthetic mutuality of all its elements as they enter into operative continuity with each other.

70. Paffrath and Stelarc, *Obsolete Body,* 153.

71. Paffrath and Stelarc, *Obsolete Body,* 70.

72. Nicholas Negroponte, *Being Digital* (New York: Knopf, 1995).

73. Stelarc, "Portrait robot de l'homme-machine," 26.

74. Stelarc, "Portrait robot de l'homme-machine," 26.

75. Stelarc, "Stimbod," at http://www.stelarc.va.com.au.

76. Stelarc, "Stimbod," at http://www.stelarc.va.com.au.

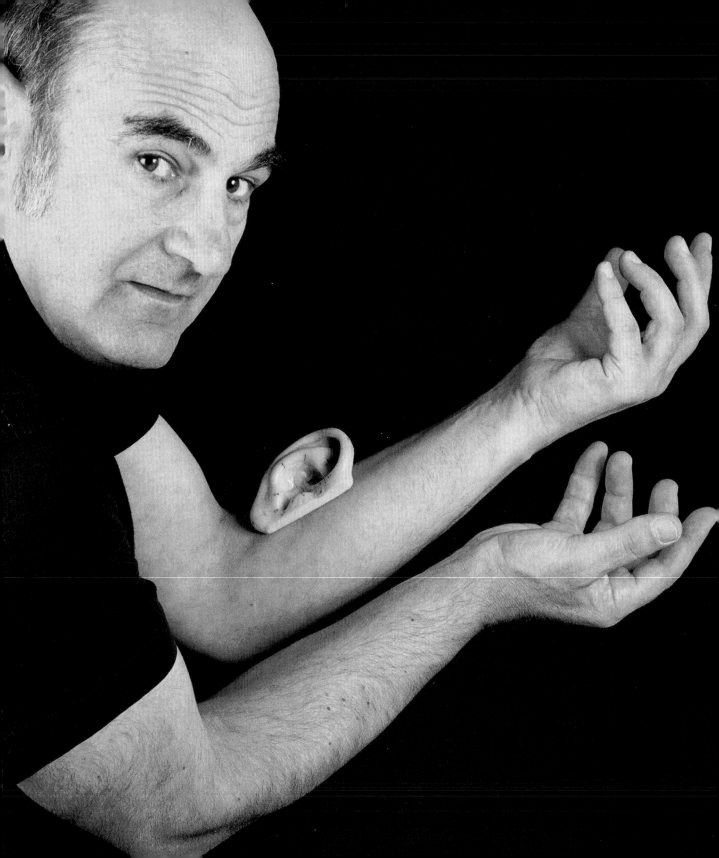

A SENSORIAL ACT OF REPLICATION Julie Clarke

The human ear is an exquisite mechanism. It is an open and welcoming structure that collects sound waves from the external environment and transmits them to the eardrum to be transformed into nerve impulses to the brain. We might imagine the ear as a haven with a wide outer opening that narrows off into a secret internal structure. In fact, the cochlea looks like a spiral shell. As much as the ear is welcoming, we protect it from anything that may crawl in and violate its integrity. Some of the horrors of childhood involve fear that an insect might lodge in the ear. The ear, then, can be a source of pleasure, sensation, or anxiety. It is no wonder that the human ear has fascinated a number of artists, including the Japanese artist Tomio Miki, who spent much of his artistic career from 1962 through 1978 producing hundreds of sculptures of the human ear.[1] According to Alexandra Munroe, Miki's ears "are presented as independent objects that have been amputated or torn from the head; their function as hearing organs is lost."[2] Miki placed no significance on his choice of ears as his subject of contemplation; however, he did say that he was interested in the act of repetition.[3] This act of repetition or replication may also be identified in Stelarc's aesthetic/prosthetic oeuvre, particularly the additions to his body of virtual and mechanical multiple limbs.

The Extended Ear

When Stelarc was living in Japan in the early 1980s, he made a rarely seen schematic drawing of a large ear that is a third of the size of the human body to

Schematic drawing of large
ear, Yokohama, 1983.
Drawing by Stelarc.

which it is attached. Because of its size, it evokes the large-scale ears sculptured by Miki. In Stelarc's drawing, the external-ear flap (auricle) extends outward from the right side of the neck and shoulder, and the middle ear (from the tipanic membrane, which transmits energy from sound vibrations in the air column, to the cochlea, which is the central hearing apparatus) flows into and occupies the space within the human body usually taken up with the trachea and lungs.[4] Given its immense size, this ear would have to be balanced by a second ear on the other side of the body to avoid having the body fall sideways under the ear's weight. Positioned

as it is, the ear is like a strange wing attached to the body, suggesting perhaps the relationship between information and freedom. This extended ear makes the individual body a giant receiver of information. The drawing provides a split view, its rear-view schematic graph depicts the flow of sound over an uneven terrain.

This drawing anticipates some of Stelarc's early ideas about the redesign of the human body and the possibilities of extending the body's capabilities for communication. This imaginary, overstimulated, and excessive bodily form also reflects Stelarc's thoughts at that time about the invasion of the mass media, the overload of information that it generated, and the redesigning of an obsolete body—not only in form but also in function.[5] The drawing clearly shows Stelarc's fascination with the exquisite intricacies of the ear's design, and given the accuracy of his depiction, it is uncanny that these intricacies are missing in the replica that he intends for his 2003 *Extra Ear 1/4 Scale* project. The replica is merely a shell of the original, for the superficial outer flaps mimic but do not perform like the human ear. The delicate apparatus of the ear and its complex functions will be replaced in the final design by a computer chip and a sensor that are suitable only for picking up data and electronic sounds from a computer environment.

Since human cognition relies more and more on dispersed networked systems for stimulus and information retrieval and computers have become, in a sense, an expanded external nervous system, it is not unreasonable to consider the function of the human ear as inadequate in such an alien environment. Stelarc's interest in depicting the mechanical aspects of a bodily part is also evident in his design of the transparent *Third Hand,* which reveals its intricate interior structure. Redesigning the human body so that it will be functional in a technological environment has been a continuing project for Stelarc, who says that "Maintaining the integrity of the body, prolonging its present forms is not only a bad strategy in terms of sheer survival, but it also dooms the body to a primitive and crude range of sensibilities—to a limited array of sensory hardware."[6] Stelarc's emphasis on the senses and their role in the production of perception, sensation, and intellect is linked here with survival. The acts of hearing and listening become paramount in an environment in which the body would otherwise drown in a sea of images. In this sense, then, the inferior and vulnerable human body appears obsolete compared to the bodily images generated and reproduced by technology.

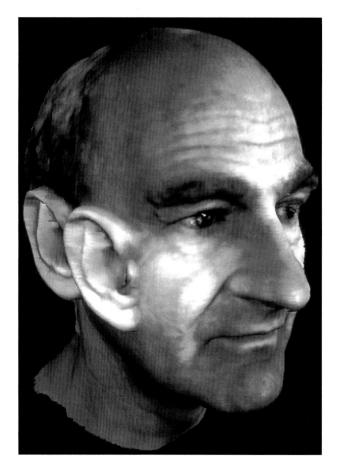

Extra Ear Visualization, Residency at Curtin University, Perth, 1997. Laser Scanning and 3D model by Jill Smith and Phil Dench of Headus.

Agency

Rather than purely modifying the human body to point to its malleability under the reign of medicine and imaging technologies, Stelarc is more concerned with extending the body's potential in alternate, intimate, and involuntary ways. As he says about his *Extra Ear 1/4 Scale* project,

The problem is that it goes beyond mere Cosmetic Surgery. It is not simply about the modifying or the adjusting of existing anatomical features (now sanctioned in our so-

ciety) but rather what's perceived as the more monstrous pursuit of constructing an additional feature that conjures up either some congenital defect, an extreme body modification, or even perhaps a radical genetic intervention.[7]

His use of aesthetic prosthetics is pragmatic. It allows him to experiment with various bodily forms that point to the mechanical and functional aspects of the body and with the potential for movement and connection that new bodily forms and new technologies offer. Stelarc says, "The body becomes not a site for inscription, but for reconstruction, regeneration, and replication."[8] A recent addition in his performance that enables this potential for remaking and rethinking the body is Stelarc's 2000 *Motion Prosthesis*—an upper-body exoskeleton that is constructed of stainless steel, aluminum, and acrylic, which are positioned on the back with computer-controlled, extending jointed segments that allow each arm three degrees of freedom (or sixty-four possible combinations). Strapped into the *Motion Prosthesis,* Stelarc may move only his upper body through the desire of an artificial entity, an avatar, or a remote other.

The notion of being either restrained or indeed liberated by the desire of another is explored in Steven Shainberg's 2002 film *Secretary.* The opening scene shows Lee Holloway (Maggie Gyllenhaal) walking around the office with her wrists restrained in an arm spreader bar—a device used in the S&M scene. The fetish fashion accessory is made of steel tubing that is attached to leather shackles and a buckle fastener. The contraption restrains Lee's arms and makes them conform to a particular regime that is consistent with crucifixion. As such, it invites a reading, which implies that one aspect of her embodiment has been sacrificed. In this restraint, she has to invent novel but achievable responses to her immediate environment. With the three degrees of freedom, located within her torso, she tilts her body to the side to pick up paper from the desk and uses her chin to operate the stapler. She puts sugar in a cup of coffee and then makes her way toward the boss's door (James Spader) with the cup in one hand, the stapled paper in the other, and paper in her mouth. She has allowed herself to be bound in the restraint to gain pleasure from the loss of control experienced and to negotiate alternative forms of gratification with her accomplice. The bondage scene has invariably been involved in postulating nonnormative ways to use the body to explore desire and to negotiate positions of agency in their relationships between individuals and

objects. The point here is that technology is often the impulse that enables individuals to conceptualize the body in different ways and rethink notions of agency.

Amanda Fernbach maintains that much of Stelarc's work with prosthetics would fall under what she classifies as "decadent fetishism"—that is, "the disavowal of cultural norms, in fantasizing new selves that stand out of the ideal or standard. The pleasures of decadent fetishism tend to emphasize the proliferation of difference, open-ended play, partiality, and multiplicity, rather than closure and completion."[9] By adding an ambiguous organ onto his body, one that mimics the ear but gives it another dimension, Stelarc alerts us to the pleasures of invention and experimentation with existing sites on the body and to new sites for extended functions. Stelarc says,

We can construct intelligence and awareness as not necessarily something that happens in your body or inside my body but rather that which happens between us in the medium of the language within which we communicate, in the social institutions within which we operate, in the cultures that we've been conditioned to at this point of time in our history, and so on . . . and that depends on our point of view or frame of reference. So the issue of choice, the issue of free agency, is a questionable one![10]

The *Motion Prosthesis* and the *Extra Ear 1/4 Scale* are two projects that enable an interface where the "us" of intelligence usurps the "I" of agency. Purposeful, intentional action that is usually perceived as motivated from an internal psyche is undermined by Stelarc in his *Movatar/Avatar* performance (1997) in which his body is moved not by his agency alone but by the desire of another to move him. This is enabled by an inverse motion-capture system "which allows an avatar, an artificial entity to access a physical body and perform in the real world." The *Avatar,* a virtual body without organs effectively acquires them by accessing a real body in actual space. Stelarc further proposes that "with an appropriate visual software interface and muscle stimulation . . . the computer-generated avatar could become a movatar."[11] In the performance, his body becomes part of a feedback loop between the computer-generated algorithms and with his image, which was projected onto a screen in front of him. The screen points to the way that technology extends the body into the virtual realm of illusion and the *Avatar* moves Stelarc's body through the motion prosthesis, generating an experience of being

invaded by multiple agencies. Although his upper body is restrained, he is able to use his feet to activate floor sensors and thus affect various aspects of the performance, such as determining the characteristics and speed of the *Avatar*'s behavior. In this feedback loop, his body becomes the prosthesis of the *Avatar* and thereby extends its limited scope of behavior. Unlike his earlier performances, in which the body was split vertically between its left and right sides in voluntary and involuntary movements, in both the *Exoskeleton* and *Movatar/Avatar* performances, the body is split horizontally, with the upper half involved in a compliance with an alien source that moves him. The *Extra Ear* would provide the potential for a similar scenario in which the concept of a sovereign self that acts independently from others is challenged. Stelarc's collaborative work acknowledges information flowing from one individual to another and eventuating in a corruption of the authorial position. The differences of others become integrated into the difference of self that is continually negotiated.

Negotiating ways in which to accommodate nonhuman others that threaten to invade and violate the human species has been the subject of many science fiction and technohorror films. The anxieties of the humanist subject who attempts to maintain a false sense of bodily integrity that is considered pure is investigated in a number of films by David Cronenberg, such as *Videodrome* (1983), *Crash* (1996), and *existenz* (1999), in which the main protagonists resist the "feminizing affects of penetrative and invasive technologies."[12] In each of these films, technology in its various manifestations is an impetus to an eruption of ambiguous openings on the body, and it inscribes and infuses the body with new desires. After much resistance, technology is accommodated as an erotic fusion of the human and the machine.

Parasite

Drawing on the major work of Emmanuel Levinas, Joanna Zylinska has identified "issues of hospitality and welcome, of embracing incalculable difference" in Stelarc's work.[13] She maintains that Stelarc's performances "seem to have been inspired by the idea of openness, of welcoming the unpredictable and the unknown."[14] Hospitality suggests the receiving of strangers and also suggests a host

that/who accommodates a guest and the nurturing of that guest. Stelarc's proposition of permanently attaching a parasitic organ(ism) onto his body provides an opportunity to welcome the strange and indeed the stranger, alien or other. It involves a reciprocity and symbiosis in which both the host and the parasite benefit. In fact, the human body already accommodates beneficial and harmful parasites that we are not always aware of, such as those that eat dead skin cells. As a parasite on the host body, the ear reciprocates by feeding the body information and generating a feedback loop between the self and other. The body as host could respond to the sounds generated by the ear, and in turn the body would nurture the ear. Entering into a symbiotic and parasitic relationship with remote others in which the body is a host is not new in Stelarc's performance praxis. He has said that the body "becomes not only a host for miniaturized technological components but also a body of multiple agencies remotely interacting with it, a body that has a much more fluid sense of self, not so much a split self from a body, but rather a self that is extruded."[15]

The ear that would "whisper sweet nothings" to the adjacent ear (if it is successfully grafted onto his head) evokes an intimacy that may be identified in Stelarc's desire to connect over long distances or, as Stelarc puts it, "collapsing spatial separation, of generating intimacy without proximity"—as in his *Fractal Flesh, Parasite,* and *Ping Body* performances.[16] "Sweet nothings" in this context suggests the discourse of intimates and glossalia—the language of lovers. The ear could then be imagined as an autoerotic instrument or receptable and as a relayer of the desires of the other. Alternatively, if the ear is grafted successfully onto his forearm, as depicted in the latest photographs, it might mean that some control could be exercised over how much the host is actually prompted by the sounds and information emitted by the ear.

There is a benevolence and willingness to connect in Stelarc's *Extra Ear 1/4 Scale* project. The ear, which is not programmed to discriminate against surface signifiers of cultural difference, would rely only on proximity with which to engage the other. So the soft prosthesis might unwittingly be a stimulus for breaking down the barriers of self from other. In Stelarc's *Fractal Flesh* performance, people at the Pompidou Centre in Paris, the Media Lab in Helsinki, and the Doors of Perception in Amsterdam were able to remotely access and actuate his

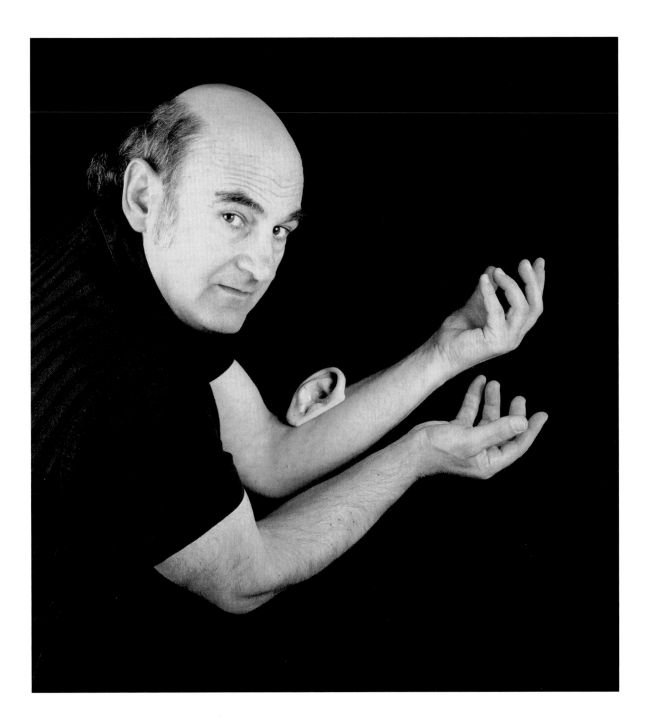

body, through a touch-screen interface. Electrical stimulation produced involuntary movements. His body became, in his words, a "host for remote and spatially separated agents to extrude their awareness and to use this body as a medium of action."[17] The *Extra Ear* could conceivably act as a wearable version for remote connection. Stelarc has undertaken many performances in which his body is partly "taken over by an external agency," and through these performances he alerts us to the great amount of external forces that constantly bear on our embodiment.[18]

Could this involuntary ear be one that persistently listens for a signal or faint pulses emitted from a distant and remote source like the immense radio telescope in Robert Zemeckis's 1997 film *Contact?* One imagines that Stelarc's extra ear will not only be a receiver and relayer of information but will also function as a watchful eye on the look out for strange and wonderful messages from the unknown. If fully realized, the *Extra Ear 1/4 Scale* project would be an involuntary ear, unlike the human ear, which is connected to the nervous system and works in harmony with the other senses to produce meaning from the external world. This ear, like the human ear, would be receiving information from a silent and unseen world that operates without our awareness.

Although humanity has used various devices for amplifying sound (headphones, megaphones, microphones), there is no device that enables us to listen, really listen, because we listen selectively. It may be that the *Extra Ear* will be a device like the know-bots and AIs that crawl the Web, selectively choosing information from the vast array of data available.

Transgenics and Biohybrids

Transgenic animals are genetically modified to be useful to humanity. The Oncomouse was one of the first transgenic animals to be produced for therapeutic purposes in the area of biotechnologies. It was genetically engineered to "carry an activated oncogene," and as such it was "a particularly useful model for testing the carcinogenicity of different compounds. It is also a useful model for researchers trying to develop treatments and cures for cancer."[19]

In 1995, Professor Linda Griffith and Dr. Charles Vacanti of the University of Massachusetts constructed another transgenic animal—a mouse with a hu-

man ear attached. They accomplished this by seeding a mold fashioned from "porous, biodegradable polymer, . . . with human cartilage cells." It was tucked "under the skin of a mouse bred without an immune system (to prevent rejection). Nourished by mouse blood, the cartilage cells multiplied, taking the shape of the dissolving polymer scaffold and creating a perfectly formed human ear."[20] The ear was developed to grow replacement parts for children who are born without ears or for those whose ears have been damaged in accidents.

Images of the mouse with a human ear attached was an inspiration for the Australian artist Patricia Piccinini, who produced a series of digital images that addressed hybridity. *Subset Blue* (from the *Protein Lattic* series, 1997), depicted the mouse with human ear sitting on the shoulder of a partly naked woman.[21] The biohybrid also inspired the Tissue Culture and Art project, begun by Oron Catts, Ionat Zurr, and Guy Ben-Ary in 1996. They said, "One of the events that triggered our interest in Tissue Engineering was the footage reels of the mouse with the human ear on its back (1995). We were amazed by the confronting sculptural possibilities this technology might offer."[22] The biohybrid was inspirational not only because it promised possibilities for future human organ replacement but because the unusual juxtaposition resonates with surrealist and postmodern sensibilities.

Stelarc initiated the *Extra Ear* project in 1997 during his residency at the art department at Curtin University of Technology in Perth, Western Australia. He sought advice from Dr. Stuart Bunt from the anatomy and human biology department of the University of Western Australia about the feasibility of his project. After investigating the possibility of using a donor ear and the direct consequences of having it attached to the right side of his head, the project remained incomplete due to the reluctance of medical practitioners to assist Stelarc in his project. Other factors—such as possible damage during surgery to his facial muscles and nerves and the need for immunodepressive drugs to ward off rejection of the donor organ—meant that the project has remained a work in progress. However, Stelarc is committed to this project and has advanced over the years the notion of a multifunctional ear: "Imagine an ear that cannot hear but rather can emit noises. Implanted with a sound chip and a proximity sensor, the ear would speak to anyone who would get close to it. . . . Or imagine the *Extra Ear* as an

Internet antennae able to amplify ReadAudio sounds to augment the local sounds heard by the actual ears."[23]

Although the project has not yet been realized, digitally manipulated images of its realization have been reproduced in magazines and on Stelarc's Web site since 1997. Perhaps the project was intended to be virtual rather than one that might eventuate in actuality. It didn't matter whether Stelarc actually had a real extra ear attached because the images supported the idea that this had already occurred. A permanent grafting of an addition to his body has not been attempted by Stelarc. His prosthetic *Third Hand, Extended Arm, Motion Prosthesis,* and *Exoskeleton* may be put on and removed by him at will.

Stelarc met with the Tissue Culture and Art project again in 2002, and its artists, like him, were interested in the possibilities that tissue technologies presented "as a medium for artistic expression." They began to explore ways in which they could use their knowledge in tissue engineering and their fascination with *partial life* to assist Stelarc in his quest for an extra ear.[24] The quarter-scale ear replica, grown from Stelarc's own human cartilage cells, would enable it to be grafted onto his body without the problems usually associated with rejection. Stelarc's proposed *Extra Ear,* like the human ear on the mouse, would also be a third ear, and like the mechanical and transparent *Third Hand,* it would be an extension of rather than a substitution of a bodily part. We might wonder why Stelarc has chosen to have an organic ear attached to his body rather than to integrate an artificial implant that could do the job that he describes just as well. The answer, put simply, is that the replica of his ear would fulfill his interest in replicating and relocating a part of the human body and in presenting an ambiguity.[25] Stelarc explains that the ear would "undermine the expectation of what an ear does, with the surprise of the sounds that it will generate."[26] Also, creating new and perhaps monstrous images of the body advances the notion that we are dependent on nonhuman others.

Paradoxically, the *Extra Ear,* which was to be attached to the right side of Stelarc's head, is now to be grafted onto his left arm. He has not only switched its location on the body, but any significance that might have been attached to his right or left side as representing the split body or the voluntary and involuntary actions of the body is now under question. Relocating the human ear onto another site on the body becomes less a question of why experiment and more to

do with how to experiment—not so much what the ear should do but what the replica ear might do once hearing is dismantled from its existing site of operation and what new sense of being can be realized through its relocation, replication, and reconfiguration.

According to Deleuze and Guattari, the body without organs is the "connection of desires, conjunction of flows, continuum of intensities" evident in much of Stelarc's performance oeuvre.[27] But what about organs without bodies? As partial objects created through the desire of the original body to recreate itself, organs without bodies are machines waiting for connection. Stelarc's ear replica is at the present time an organ without a body. However, this desiring machine— once grafted to the body and connected to communication technologies—renders the body as multiple, working against the hierarchical, organized, and rational body.

According to the University of Oxford, "Tissue engineering aims to develop biological substitutes for implantation into the body" to solve the problem of organ and tissue deficiencies and provide the next generation of medical implants. Its researchers describe the tissue or construct as consisting of "three-dimensional scaffolds and living cells with the desired structure and functionality. The constructs are cultured and conditioned in purpose-designed bioreactors, which provide the desired chemical and mechanical environment for cell proliferation and differentiation."[28] Tissue engineering is dependent on stem-cell technology (SCT), which falls into two specific groups. The first is embryonic stem cells, which are derived from the "inner mass of a four- or five-day-old blastocyst (a preimplantation embryo of about 150 cells), and adult stem cells that are found in organs and tissue (brain, bone marrow, peripheral blood, blood vessels, skeletal muscle, skin, and liver). Bone marrow stromal cells give rise to cartilage cells."[29] Although the quarter-scale replica of Stelarc's ear already produced by the Tissue Culture and Art Project was derived from donor cells, Stelarc's own bone marrow cells will be harvested from his hip, applied to a polymer mesh, nurtured in an appropriate culture, and grown in a sterile container. According to Oron Catts, "One of the options in regard to producing the ear with Stelarc's own cells is to take a bone marrow biopsy, isolate the bone marrow mesenchymal stem cells, and differentiate them into chondrocytes (cartilage cells) using special differentiation agents. This process will be considered as adult stem cells technology."[30]

Extra Ear 1/4 Scale, Small
replica of the artist's ear grown
with human cells, Galerija
Kapelica, Ljubljana, Slovenia,
13–20 May 2003. Photo by
Ionat Zurr

Stelarc feels that the potency of this project lies in the notion that the quarter-scale ear at present is a partial life form waiting to become a prosthetic attachment.[31] Looking very much like a four-week-old human fetus, the soft-tissue replica of Stelarc's embryonic ear, nestling in a sterile container, invites a reading consistent with those that surround the development of life outside the uterus— in vitro fertilization technologies, cloning, preimplantation diagnosis, and other technologies employed in reproductive technologies that isolate embryos to cleanse them of unwanted genetic material. In fact, the Tissue Culture and Art Project intends to grow four replicas of Stelarc's quarter-scale ear and select the one that is the best formed before attempting to graft it onto Stelarc's arm.[32] The proposition of selecting the most perfect, the most suitable ear for grafting—that is, an ear free of contaminants—is yet another way that this object of artistic and scientific enquiry is metaphoric of the *will to purity* and the *will to perfection* that is indicative of humanist endeavors in contemporary biomedicine.

Andrew Nicol's 1997 bioethical film GATTACA is an exemplary example of a genetic deterministic future in which embryos are routinely screened to detect unwanted genetic material and newborns are labeled valid (superior) or invalid (inferior) based on their genetic quotient. In a flashback scene, Maria and Anton (the parents of the main protagonist, Vincent) are shown in consultation with the geneticist who is monitoring the conception of their second child. Vincent was conceived naturally and labeled invalid due to his DNA analysis at birth, which predicted heart disease, attention deficit disorder, manic depression, and a neurological condition. Displayed on a computer monitor are four embryos. Three are considered inferior and discarded; however, the geneticist has genetically altered the fourth, which is implanted into Maria. She produces her second child, Anton, who is deemed valid.[33]

Because the quarter-scale ear replica is isolated from its usual place on the human head, it is an object of enquiry—dislocated, dismembered, subject to the will of those who have made it. The Tissue Culture and Art Program and Stelarc have announced an interest in *partial life,* and as such, they may be unwittingly implicated in some of the issues that surround it. According to Oron Catts, "The development of the partial life discussion can lead to the realization that our cultural perceptions of life are in many cases incomputable with the scientific understanding of life and the technological attempts to manipulate it."[34] Life, in a

Extra Ear 1/4 Scale (stained),
Small replica of the artist's ear
grown with human cells,
Galerija Kapelica, Ljubljana,
Slovenia, 13–20 May 2003.
Photo by Ionat Zurr.

cultural sense, is to have a body that exhibits signs of liveliness, even if that liveliness is greatly diminished (for example a brain-damaged individual who depends on artificial life support). But there is also the understanding that life itself is participatory and that the life body is functioning in ways that reveal its contribution to the wider economy of things, ideas, and action. An embrace of partial life suggests both a recognition of and benevolence to fragmentary, synecdoche, and fractal identities. A scientific understanding of life might give prominence to the notion of life as information carried in the DNA code of all living things. In this

sense, then, any tissue or organ grown from an original life source—whether or not the construct is attached to that life source—carries within it the potential for life and as such may be considered alive. However, this raises a number of questions: what happens to life forms that are considered to have no use value compared to the tissue and organs engineered for commercial purposes? Who is responsible for life—partial or otherwise—that is constructed in laboratories? What value do we place on everyday life if *partial life* may be easily discarded as inferior and unwanted? Who will benefit from this kind of technology? How do we sustain people in employment and care for those whose lives have been extended by replacement organs? And what value will be placed on those who do not have access to the technologies developed in Western culture? Individuals in developed countries already live well because others in underdeveloped countries are exploited and considered by some to be subhuman.

Stelarc has always worked with new technologies and is invariably implicated in the issues surrounding them. There are marked differences between an embryo that is being selected for its superior qualities and the growth of human body cells to reproduce a replica of a human ear. But some of the same ethical concerns that surround biotechnologies will have to be addressed in relation to tissue engineering, which is the current technology being used to create tiny replicas of human organs. Although Stelarc would deny any interest in social policies that advance notions of what may be considered human as opposed to nonhuman, his interest in redesigning the human body exposes a predisposition toward the humanist framework of controlling the production and experience of life through biomedical and communications technologies. The paradox is that as an artist his interest lies in the creative use of these technologies and the possibility of generating new perceptions gained by the creation of imaginary bodily images. As Brian Massumi has said, "The Stelarcian desire is to affirm the conversion, not in order to denigrate the importance of the human justice issues it incontestably raises, but rather to enable them to be reposed and operated upon in an entirely new problematic, one that may even now be waiting for us around the next node."[35]

Biomedicine already has the capacity to produce what in humanist terms is considered monstrous, through its continued experimentation with cloning, xenotransplantation, and transgenics. Therefore, making a human organ as an

artistic object appears rather benign in the face of monsters that are produced every day by biomedicine. We should remember, however, that to use the body as a template for the production of a new body that mirrors the original body is exactly what happens in human cloning. Stelarc has used his body before as a template to replicate the body and to metaphorically "shed his skin." In his 1982 *Event for Clone Suspension* at the Maki Gallery in Tokyo, his body was wrapped in wire mesh, and plaster was applied to it. When the cast was disengaged from his body, Stelarc said that "the sensation was of shedding skin."[36] Like a partial chrysalis, the plaster mold remained hanging in the gallery space for one week after the performance. It metaphorically represents the discarded obsolete body form—the cloned hollow body and the coded body evident by the presence of residual skin cells. This early trope of shedding the skin to evolve into another form is evident in Stelarc's most recent project, *Exoskeleton,* in which insect, animal, and primate gait are deployed in a robot to point to the evolution of the human species.

In looking at Stelarc's use of a bioengineered *partial life,* we become alerted to the facts that human bodily material is appropriated every day, trademarked and copyrighted by biomedical corporations for their own economic purposes, and that humanity is redefined every day through the activities of biomedicine and surgical practice. Stelarc maintains that for him the issue is how can the body be reconceptualized and remade and whether it is adequate or inadequate in new technological environments. He said early in his career, "The artist can become an evolutionary guide, extrapolating new trajectories; a genetic sculptor, restructuring and hypersensitizing the human body; an architect of internal body spaces; a primal surgeon."[37]

Although the *Extra Ear 1/4 Scale* represents a dismembered dislocated bodily part, it contains potential beyond the scope of the predetermined morphology of the human ear. Vincent Van Gogh's severed ear lobe was cast aside as surplus, but his ear functioned perfectly well without it. The extra ear as partial life suggests an excess often played out by the body's own production of aberrant forms. As such, the *Extra Ear 1/4 Scale* alludes to the monstrous, the implausible, and the unthinkable. Indeed, the allusion to the monstrous destabilizes the difference between what is human and what is considered not human. It points to lives differently configured and imagined—lives that are enhanced and extended by prosthetics. The *Extra Ear,* then, is an organ without a body—a desiring machine, a

partial object that may be connected to other partial objects in a sensory feedback loop between the body of technology and the body of desire.

Notes

1. The ears had large Buddha lobes, which represent wisdom and compassion.

2. Alexandra Munro, *Scream against the Sky: Japanese Art after 1945* (New York: Abrams, in association with the Yokohama Museum of Art, Japan Foundation, Guggenheim Museum, and San Francisco Museum of Modern Art, 1994), 198.

3. Munro, *Scream against the Sky,* 198.

4. The drawing also depicts a detached third arm adjacent to the right arm.

5. James D. Paffrath and Stelarc, eds., *Obsolete Body/Suspensions/Stelarc* (Davis, CA: JP, 1984), 76.

6. Paffrath and Stelarc, *Obsolete Body,* 134.

7. E-mail from Stelarc to the author, 22 August 2003.

8. Conversation between Stelarc and the author, Melbourne, 14 August 2003.

9. Amanda Fernbach, *Fantasies of Fetishism: From Decadence to the Post-Human* (Edinburgh: Edinburgh University Press, 2002).

10. Stelarc, "Stelarc: Interview by Yiannis Melanitis," *a-r-c: Journal of Art Research and Critical Curating* (November 1999), http://a-r-c.gold.ac.uk/reftexts/inter_melanitis.html (accessed August 2003).

11. http://www.stelarc.va.com.au/movatar/index.html (accessed August 2003).

12. Elaine L. Graham, *Representations of the Post/Human: Monsters, Aliens and Others in Popular Culture* (Manchester, UK: Manchester University Press, 2002), 22.

13. Joanna Zylinska, "'The Future Is Monstrous': Prosthetics as Ethics," in Joanna Zylinska, ed., *The Cyborg Experiments: The Extensions of the Body in the Media Age* (New York: Continuum, 2002), 217.

14. Zylinska, "'The Future Is Monstrous,'" 229.

15. Stelarc, Joanna Zylinska, and Gary Hall, "Probings: An Interview with Stelarc," in Zylinska, *The Cyborg Experiments,* 122.

16. E-mail from Stelarc to the author, 22 August 2003.

17. Stelarc, "Fractal Flesh," *internet.au,* Australia, 1995, 34.

18. Stelarc, Joanna Zylinska, and Gary Hall, "Probings: An Interview with Stelarc," 115.

19. Shelley Rowland and Jared Scarlett, "The World's Most Litigated Mouse," *NZ Bio Science* 13 (February 2003), http://www.bsw.co.nz/articles/xfactor13.html (accessed August 2003).

20. "Mouse Grows Human Ear!," *Weekly Web News* (October 1995), http://www.ils.unc.edu/blaze/mousedemo.html (accessed August 2003).

21. Daniel Palmer, "Piccinini & Hennessey: Sincerely Artificial," http://www.realtimearts.net/rt43/palmer.html (accessed August 2003).

22. Oron Catts, Ionat Zurr, and Guy Ben-Ary, "Extra Ear 1/4 Scale," http://www.tca.uwa.edu.au/extra/extra_ear.html (accessed August 2003).

23. *Stelarc: Zombie and Cyborg Bodies, Exoskeleton, Extra Ear, and Avatar,* Melanitis Yiannis, curator (London: Ciel, 1999), n.p.

24. Catts, Zurr, and Ben-Ary, "Extra Ear 1/4 Scale."

25. Conversation with Stelarc at Druids, Melbourne, 7 August 2003.

26. E-mail from Stelarc to the author, 22 August 2003.

27. Gilles Deleuze and Félix Guattari, *A Thousand Plateaus: Capitalism and Schizophrenia,* trans. Brian Massumi (Minneapolis: University of Minnesota Press, 1987), 161.

28. Z. F. Cui, H. Ye, A. B. Zaratsky, J. Triffitt, and T. Q. Liu, "Bioreactor for Tissue Culture," Research Summary, Department of Engineering Science, University of Oxford, 5 January 2002, http://www.eng.ox.ac.uk/World/Research/Summary/B-Biotissue.html#P-Cui.Z.F.12 (accessed August 2003).

29. This information about stem cells is taken from National Institutes of Health, "Stem Cell Basics," http://stemcells.nih.gov/infoCenter/stemCellBasics.asp#1 (accessed August 2003).

30. E-mail from Oron Catts to the author, 19 August 2003.

31. E-mail from Stelarc to the author, 29 August 2003.

32. Conversation with Stelarc, 7 August 2003.

33. The procedure shown in the film is known as preimplantation diagnosis (PID). It involves the removal of one or more cells from embryos generated by in vitro fertilization (IVF) and analysis of the DNA from the cells. David S. King, "Preimplantation Genetic Diagnosis and the 'New' Eugenics," *Journal of Medical Ethics* 25, no. 2 (April 1999): 176–182.

34. E-mail extract from Oron Catts to the author, 19 August 2003.

35. Brian Massumi, *Parables for the Virtual: Movement, Affect, Sensation* (Durham, NC: Duke University Press, 2002), 132.

36. Paffrath and Stelarc, *Obsolete Body,* in Paffrath and Stelarc, 111.

37. Stelarc, "Strategies and Trajectories," in Paffrath and Stelarc, *Obsolete Body,* 76.

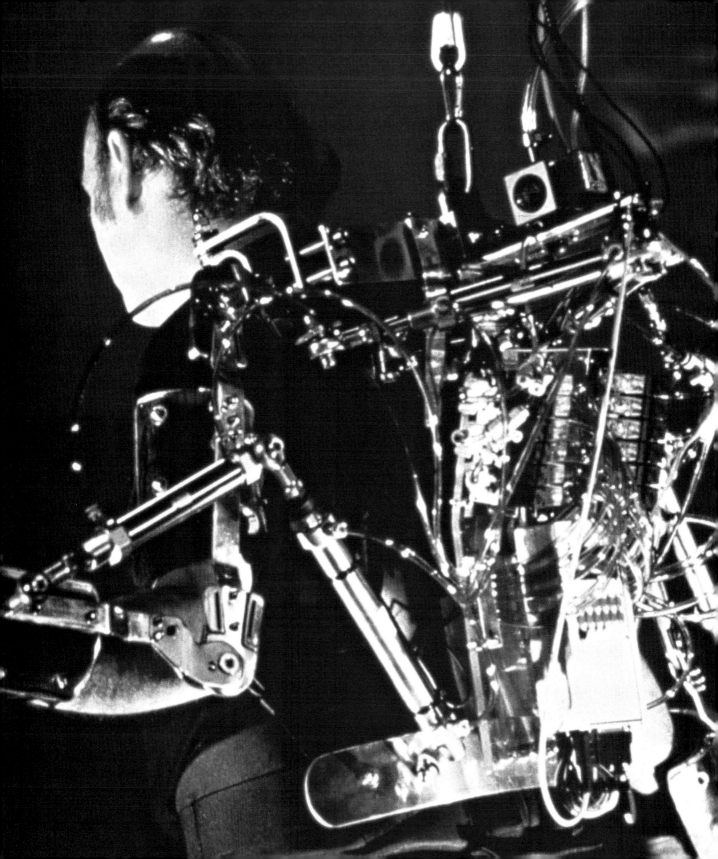

ANIMATING BODIES, MOBILIZING TECHNOLOGIES: STELARC IN CONVERSATION

Stelarc and
Marquard Smith

Performance, the Body, and Intimacy

MARQUARD SMITH (MS): What is Stelarc?

STELARC (S): Oh, the name comes from combining the first few letters of each of my original names. My parents are Greek Cypriots. The name was changed from Stelios Arcadiou to Stelarc over thirty years ago. It's what's on my passport, credit card, and driver's license. So the name means nothing more than that [a desire at the time to shorten the name]. . . .

MS: Do you see yourself as a performance artist? A body artist? A telematic artist? A site-specific artist? A sculptor? A collaborative designer? A robotics engineer?

S: I'm a performance artist, I guess. I had to do something after discovering I was such a bad painter in art school [laughs]. I was always interested in the body as a structure rather than a site for the psyche or for social inscription—not as an object of desire but rather an object one might want to redesign, the body as a biological apparatus that fundamentally determines our perception of the world. This physiology and anatomy generate our kinesthetic position and orientation in the world. I guess I was always envious of dancers and gymnasts—the body as both a medium of experience and expression. The 2D arts deal in metaphors and symbols of the body. In performance art, you have to take the physical consequences for your ideas. To make three films of the inside of my body, to suspend the body with steel hooks, to extend the body with a third hand:

——215

it was not enough to imagine and speculate. Rather, the approach was to actualize the idea, to experience it directly, and then try to articulate what happened. The resulting ideas are authenticated only by the actions. Most of my projects and performances required medical and technical advice and assistance. For example the *Stomach Sculpture* was constructed collaboratively with a jeweler and a microsurgery instrument maker. *Exoskeleton* was realized with f18, a group of artists/engineers from Hamburg. And the *Prosthetic Head* was only possible with two programmers and a 3D modeler from San Francisco. Growing the quarter-scale replica of my ear (to advance the *Extra Ear* project) would not have been possible without the assistance of the TC&A [Tissue Culture and Art] group from Perth [artists who use living tissue in their art] and a German lab. Each project goes beyond my expertise. Another way to characterize what I do and how I do it is to say that I've made a career out of being a failure. None of the projects and performances can be said to have been successfully realized—at least the way I'd imagined them at first [laughs]. . . .

MS: To put the somewhat timeworn metaphysical question to bed once and for all, at least as far as Stelarc is concerned, how do you see the connection, if indeed there is one for you, between the mind and the body, cognition and materiality?

S: Well, when I talk about the body, I mean this cerebral, phenomenological, aware, and operational entity immersed in the world. Not only should we not split mind and body; we should not split the agent from its environment. (Having said that, I have spoken of "splitting the body" itself to simultaneously experience automated, involuntary, and improvised motions.) The body has to function effectively in a complex technological terrain of fast, powerful, and precise machines. Our instruments generate an intensity of information that assaults the body and extends it beyond our human scale. To be an intelligent agent, one needs to be both embodied and embedded. To be a person, one needs to stand in relation to other bodies. What's important is not what is within you or me but rather what happens between us—in the medium of language we communicate with, in the social institutions we are functioning in, in the culture within which we've been conditioned, at this point in time in human history and so on, depending on your frame of reference. When this body speaks as an *I,* it does so realizing that in the context of "I go to London" or "I make art," the letter *I*

designates only "this body goes to London," "this body makes art." It's a huge metaphysical leap to imagine that *I* refers to an inner essence, self, or soul. The English language perpetuates outmoded Platonic, Cartesian, and Freudian constructs of a body. . . .

MS: Your performances enact physiological and cognitive experiments. They are not psychological or somatic exercises. You are not interested in the human body's materiality. Why? If the question is misguided, how is this question missing the point?

S: Seeing the body as an evolutionary architecture for operation and awareness in the world means not seeing the body simply as a site for the psyche or for social inscription but rather as a structure—one connected to other structures. I guess it's questioning simplistic notions of identity and agency and how a body is positioned in a complex and interacting system enmeshed in a high-tech terrain. For the last two thousand years of Western history, we've poked and prodded the psyche. We can now internally probe and electronically slice the body. Using stem cell technology, we can extract cells from the body, multiply

Street Suspension, Mo David Gallery, 604 East 11th Street, New York, 21 July 1984. Photo by Nina Kuo.

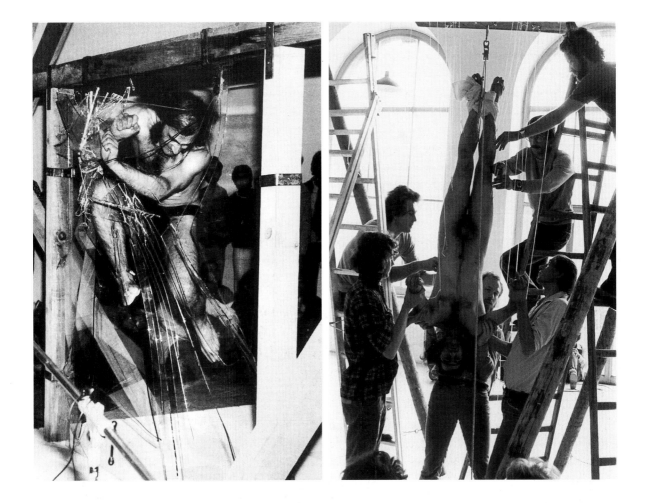

them, and then inject them back into an injured area. In the next fifty to one hundred years, we will be able to grow any organ in our body in its full complexity—no need for cloning body bags for harvesting organs. We have developed invasive electronic and genetic techniques to monitor, map, modify and possibly regenerate the body physically. That's what has become meaningful—significant as well as seductive.

MS: In her contribution to this publication, Amelia Jones has said that your "performative works enact a networking that is simultaneously technologized and embodied, simultaneously conceptual and corporeal." She works to integrate *your* body back into *the* body that you occupy and utilize as art, and she does this in a number of ways, one of which is to foreground the presence of pain and uncomfortableness in the performances themselves, by no means masochistic. Would you tell us more about this pain, this uncomfortableness?

S: What is there to say about pain—or for that matter about pleasure? OK, I will admit to an intensity of experience. Sadomasochist description frames the experience in a psychosocial way. Perhaps we can talk about an action being physically

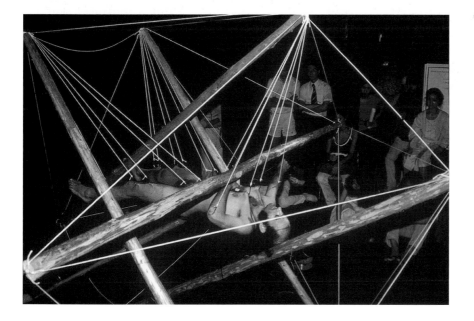

Event for Amplified Tension, Tenjo Sajiki, Tokyo, 6 August 1979. Photo by Takayuki Ozawa.

facing page:
Event for Penetration/ Extrapolation, Museo Universitario, Mexico City, 14 August 1976. Photo by Xicohtencatl Pavia Castro.

Event for Stretched Skin No. 4, Art Academy, Munich, 8 August 1977. Photo by Harold Rumpf.

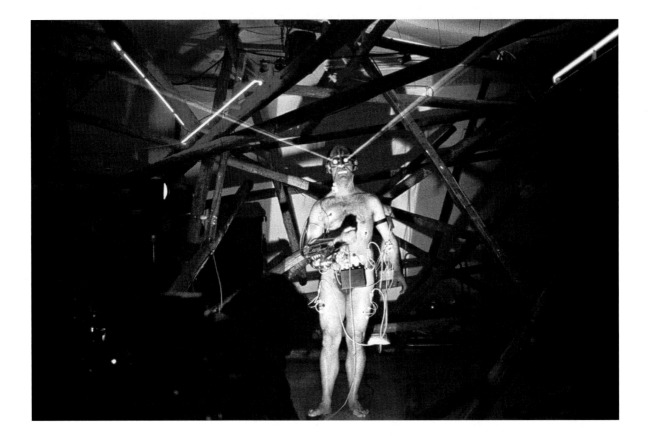

Event for Amplified Body, Laser Eyes, and Third Hand, Maka Gallery, Tokyo, 1985. Photo by Takatoshi Shinoda.

facing page:
Muscle Machine, Gallery 291, London, July 2003. Photos by Mark Bennett.

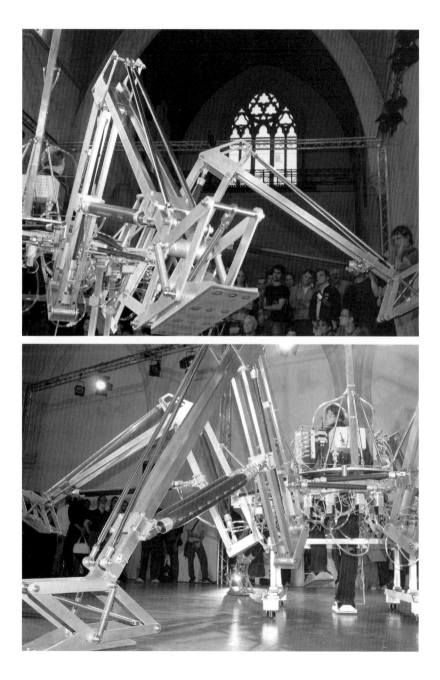

difficult? And what constitutes feeling uncomfortable? Perhaps I feel unwilling to report on subject experiences like this because I've read a little Wittgenstein [laughs]. These projects and performances have proved challenging to achieve, both physiologically and technically. Pain has never been the subject of a performance. Neither have complex technological systems. I guess to do these performances they had to be done with a certain indifference—an indifference that allows you to remain open to possibilities rather than doing something with expectation, which brings closure and collapse of an experience. Intense experiences do make it difficult to draw convenient boundaries between mind and body. When you're in pain, you are one throbbing body. When you are inserted and interactive with a complex technological array, the issue of whether the body or the machine is in control is erased. It becomes meaningless to ask that kind of question. There is no need for a sense of agency when you are performing automatically and effectively as a component of an extended operational system. One can argue that effective operation is done without awareness. Or we can define awareness as that which happens when we malfunction [laughs]. . . .

MS: You have said that you are not interested in emotion but rather in e-motion.

S: The e-motion reference originally came from Edward Scheer and was expressing what happens with the *Movatar* system. In motion capture, I have sensors on this body that allows the mapping of these movements onto a computer model. My movements animate the avatar. But imagine if the opposite was possible—that an avatar imbued with an artificial intelligence was able to access a human body and perform with it/through it in the real world. The body itself becomes a prosthesis for the behavior of an artificial entity. And if electrodes were on facial muscles as well as limbs, the avatar would not only move in the world with its surrogate body but also might express its emotions through the facial muscle movements of the surrogate body. So emotion is not evaluated or defined as an inner quality but rather as an eternal expression—tensing, a gesture, a choreography of certain kinds of facial and limb motions.

MS: Following on from that, Timothy Murray has remarked that you have a "deep technical and performative engagement with the morphing of touch." Is there a way in which the tactility of your work, its haptic qualities, have any kind of emotional quality?

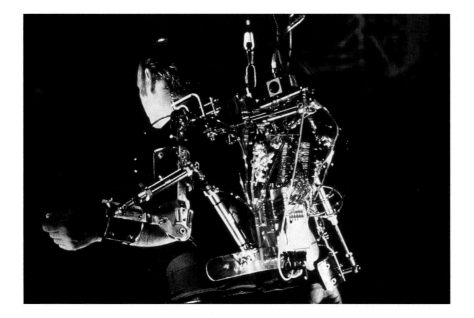

Movatar, Cybercultures,
Sydney, 2000. Photo by
Heidrun Löhr.

following pages:
The Third Hand, Yokohama,
Tokyo, Nagoya, 1980. Photos
by Simon Hunter.

s: I don't think it's interesting to emphasize emotion. All of these perfor-
mances are done with acute indifference, not with expectation or immersed in
emotional expression. If the body moves and that conjures up associations that are
indicative of what we want to identify as emotional states, OK. The tactile, the
haptic, the visceral: yes, that might generate responses from people, from feeling
queasy to vicarious pain or pleasure. Does the artist play on seduction, on emo-
tionally snaring, on the expectation of immersing an audience in psychosocial
narratives? No, not this artist. . . .

MS: In Brian Massumi's essay for this publication, he speaks of the ener-
getic potential for the body to think itself. Your work offers a paradigm for ac-
tion without intention and involuntary impulse without emotion or expectation,
without memory. Would you say more about this prospect?

s: I think it's the philosopher John Searle who points out that in a high-
tech terrain, the space between intention and action collapses. There is no time
for the meditative moment. We have to function faster. It's a more stimulus-
response situation. Now, I think he had a negative spin on this. But what's
interesting is how this collapse into literally a singularity of experience can be

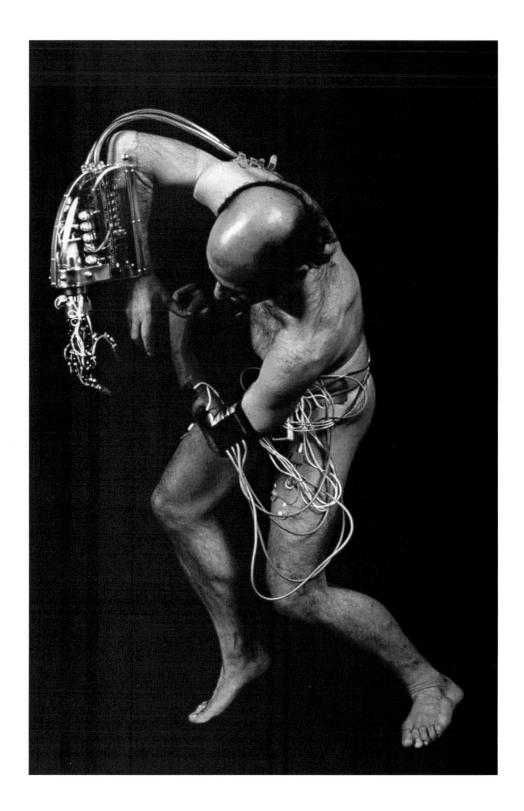

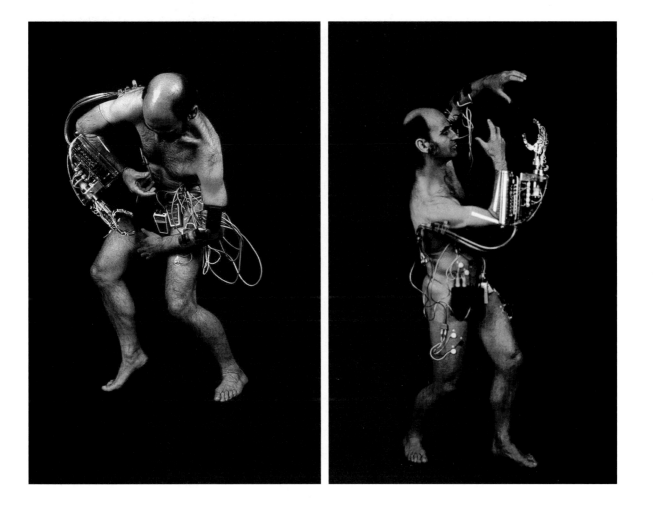

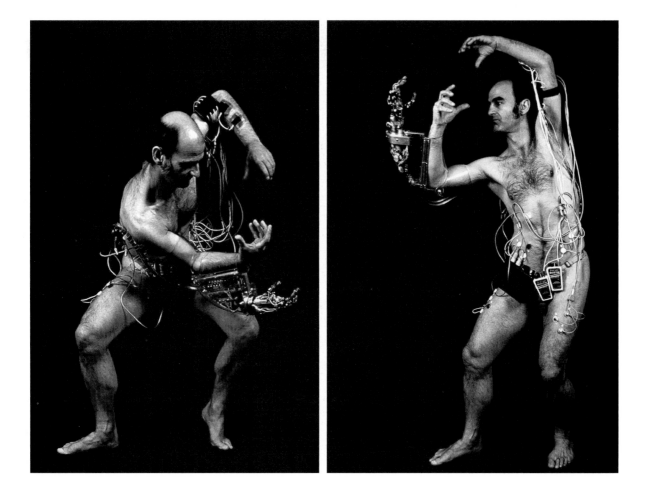

The Third Hand, Yokohama,
Tokyo, Nagoya, 1980. Photos
by Simon Hunter.

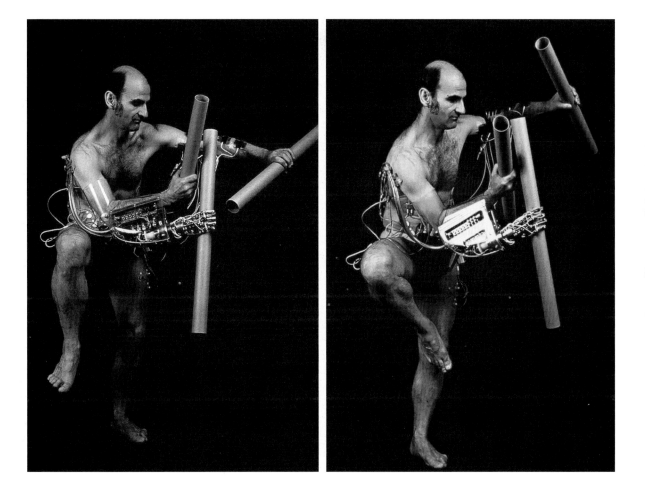

The Third Hand, Yokohama,
Tokyo, Nagoya, 1980. Photos
by Simon Hunter.

managed. How we can function faster and more effectively? Or put differently, how can we explore the alternate, the intimate, and the involuntary—the alien and the remote? There is a curiosity to intensely experience what is not ordinarily accessible. Is it meaningful to talk about an action without intention? Yes, in the sense that it might be your body performing with someone else's programming. Without emotion or memory? Yes, in the sense of performing with acute indifference immersed in ambiguity. And yes, in the sense that the remote choreography is plotted and prompted by another person in another place. This body becomes a host for remote and multiple agents. (Words like *agent, person,* and *body* are being deliberately interchanged.) It's as much a language problem as anything else. This body responds anxiously and unknowingly for it is not in proximity. Its presence is not affirmed by another. Rather, the absence of the other is unsettling. The intimacy is in the anxiety, not in the affirmation or presence and proximity. . . .

Interactivity, Technology, and Prosthesis

MS: It is obvious that for you the body is an aesthetic object and an aesthetic object that is available for redesign with all the engineering possibilities that this entails. You have said that the body is not "an adequate biological form" to cope with the sheer volume and complexity of information it has had to accumulate and will go on to accumulate. The body, you believe, is in fact "intimidated by the precision, speed, and power of technology." Would you say more about this?

S: And to add that technology accelerates the body to attain planetary escape velocity. The body finds itself in alien environments that it can't survive in without life-support systems. So it's the intensity and accumulation of information, the intimidation of precise, powerful, and speedy machines and extreme off-the-world environments that confront the body with its obsolescence. Its softness and wetness is difficult to sustain off the Earth. It's susceptible to microorganisms like bacteria and viruses. Its survival parameters are thus very slim, and its longevity is limited. So the body with this form and with these functions is not adequate, and we should consider its redesigning, its reengineering. Do we accept the biological status quo of the body, or do we consider alternate enhancements? Heidegger authenticates life with death. But birth and death might be the outmoded means for shuffling genetic material and for population control. This

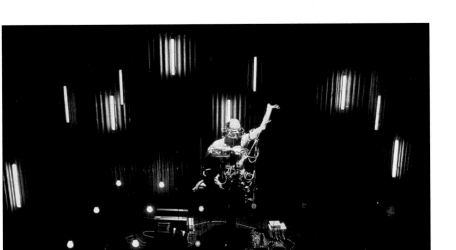

Remote: Event for Amplified Body/Involuntary Arm, La Mama, Melbourne, 22–24 February 1990. Photo by Anthony Figallo.

is not about utopian blueprints for perfect bodies but rather speculations on operational systems with alternate functions and forms. Perhaps ergonomically designing technology for the body is not enough. We have to design bodies to match our machines. When I first looked at alternate anatomies for the body, I speculated about engineering a synthetic skin. It would be quite plausible to make a membrane permeable to oxygen so you could breathe through your skin. And if the skin also possessed some sophisticated photosynthetic capabilities, then it could produce nutrients for the body. So simply through a change of skin, we could radically hollow out the human body. You wouldn't need lungs to breathe, a gastrointestinal tract to digest food. You wouldn't need a circulatory system to convey nutrients and oxygen throughout the body. And a hollow body would be a better host for all the technological components you could pack into it! Whereas in our past evolutionary development, a change of locomotion could be argued as the significant event (resulting in two limbs becoming manipulators), our future development would be prompted by a change that was only skin deep. This hollow body would be literally a body without organs—a body that need

not be organ-ized. Even if we kept our organs, they should be of a more modular design to facilitate the replacement of malfunctioning parts. . . .

MS: This is an expenditure question: Over the last thirty years, your body has had physiological, prosthetic, networked, and robotic incarnations. In your opinion, has that body remained mostly the same, or have technological developments—the kind of ongoing interactivities that have taken place—forced you to alter your understanding of that body? Which is to say, have technologies provoked the body's expiration?

S: This body speaks and acts a little differently than before. In this way, it indicates that its projects and performances have had some discernible behavioral effect. To assert anything more would not be meaningful. . . .

MS: Taking on the extent to which your work has helped shape many discourses around cyberculture and the posthuman, what impact have these conversations had on you, on your thought, and on your artwork?

S: It's difficult to establish specific connections to conversations or to discourses! Art doesn't simply illustrate an idea. An idea is not a blueprint for an art installation. Intuitive and aesthetic explorations are the result of a complex interplay of bodies with artifacts enmeshed in social structures and cultural conditionings. From a personal perspective, these ideas can be authenticated only by my actions. The process is that you have an idea, you then experience it in these performances, and that allows you to then articulate the implications. Yes, I've read widely but not methodically—from evolutionary theory to cognitive sciences. I am fascinated by the writings of philosophers like Schopenhauer, Spinoza, Nietzsche, Hume, Heidegger, Wittgenstein, and Derrida, to name a few. I'm not an academic or a theorist. I'm intrigued, more than anything, to attempt to analyze how ideas evolve. I'm fascinated by the history of ideas and bodies of knowledge. McLuhan (technology as the external organs of the body), Baudrillard (simulations), and Virilio (with every new technology there's a new kind of accident) are ideas that were exciting to uncover. . . .

MS: The *Prosthetic Head* is your latest project. This sounds somewhat different again from the earlier robotic pieces. What is the direction of this work?

S: The *Virtual Arm* project, actuated by a pair of data gloves, and the *Virtual Body* motion-capture performances are precedents. I've been intrigued not only with human-machine interactions but also with virtual-actual interfaces. The

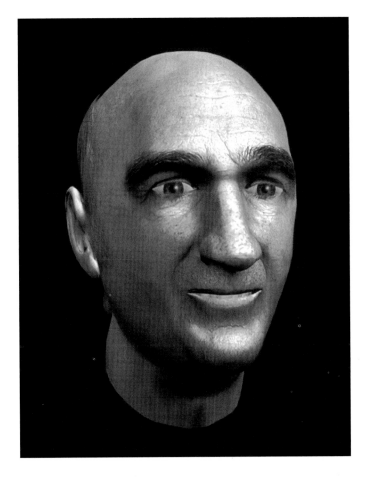

Prosthetic Head, San Francisco, January 2003. 3D model by Barrett Fox.

Prosthetic Head is a conversational system—a 3D computer-generated head that somewhat resembles the artist and responds to the person who interrogates it. You might say it's only as intelligent as the person who speaks to it [laughs]. It's not supposed to illustrate some kind of disembodied intelligence. Rather, it exposes the problems associated with notions of awareness, intelligence, agency, and embodiment. Of course, the *Prosthetic Head* is massively embodied with all the technology that is required to present and operate it effectively. With the assistance of three programmers in San Francisco (Karen Marcello, Sam Trychin, and Barrett

Fox), we stitched together software that included a text-to-speech engine, the source code for facial animation, and a customized Alice chatbot. Over the next few years, the *Head* will become more informed and less predictable in its responses. In fact, the artist will not be able to take full responsibility for what his head says [laughs]. And imagine if this *Head* has a biorhythm mapped to its expressions. So it might be grumpy answering questions in the morning, happy to talk to you midday, but getting tired in the late afternoon. And we are thinking to give the *Head* information of the user through a vision system. So the *Head* might comment on the color of your sweater or query why you are looking so glum. It would be a more seductive interface with that kind of knowledge. The *Head* is not illustrating a Cartesian split between mind and body, but rather it exposes the problematics of this kind of discourse. In fact, what's important now is not the problem of split mind and brain but rather of splitting the body itself and of the body-species split that will result in new post-evolutionary phylums.

MS: In their essay in this publication, Authur and Marilouise Kroker say that you are "the artist par excellence of prosthetic culture." It's certainly the case that no other artist has carried out such a sustained engagement with the interface between the body as a biological entity and its integration of/with prosthetic technology—a technology that is invasive, incorporative, and always already intrinsic to the machinery of the body. Why this desire to invade the body with technology or, conversely, to attach the body to technology?

S: I guess that if the premise is that the body is an evolutionary architecture for operation and awareness in the world, altering the architecture means adjusting its awareness. And ever since we evolved as hominids with bipedal locomotion, two limbs became manipulators, we begin to construct artifacts, instruments, machines. McLuhan's notions that technology is the external organs of the body and that with electronic circuitry we "outer" our nervous system are astute realizations. The body has always been a kind of prosthetic body coupled to its technology. And technology has proliferated in the human horizon. But with its increasing microminiaturization and with more and more biocompatible materials, technology cannot only be attached to the body but can also be implanted. Technology doesn't contain the body so much as become a component of the body. It's not so much an agent desiring to be invaded by technology but rather a body that positions itself to be indifferent to invasive probes. But probes are coun-

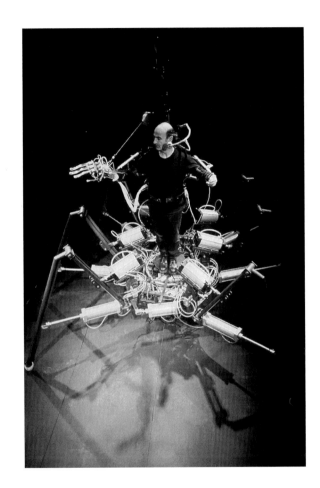

Exoskeleton, Cyborg Frictions, Dampfzentrale, Bern, 1999. Photo by Dominik Landwehr.

terpointed in other projects and with large machines that alter and extrude the body's functions. *Exoskeleton* is a six-legged, 600 kilogram walking machine that supports a body. It is controlled by arm gestures. An upper-body exoskeleton has magnetic sensors at each segment, allowing different arm gestures to select the modes of locomotion. The robot walks forward and backward with a kind of ripple gait, sideways left and right with a tripod gait. It also squats and stands up as well as turns on the spot. The body's bipedal gait is translated into an insectlike machine locomotion. With the *Muscle Machine,* the body is not positioned on the

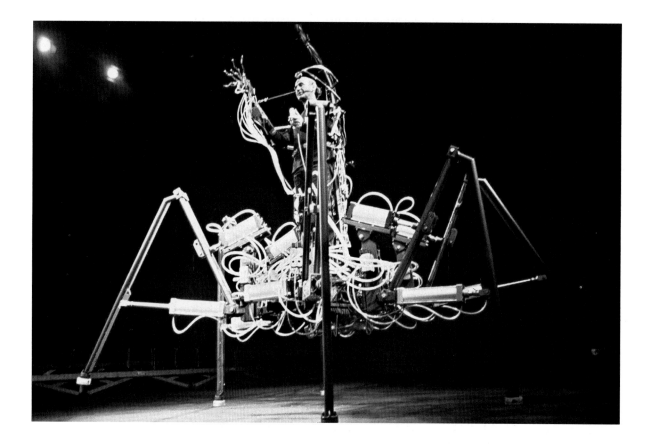

robot but stands on the ground within the machine, connected to the chassis with an inner exoskeleton with encoders on each joint. As the body lifts its legs, three alternate machine legs lift and swing forward. The machine walks in the direction the body faces, as it turns its torso. So it's a very direct and intuitive coupling of body and machine. What's interesting about the new robot is that it has pneumatic rubber muscles. Inflated with 1 bar of air pressure, the muscles act like springs to dampen the impact of the leg on the ground. At 5 to 10 bar of air pressure, the muscle expands in girth and contracts 20 percent of its length, producing a very strong pulling force and lifting the legs high. Visually, the machine legs look both limb-like and wing-like in their function. There is a fascination with both machine- and insect-like locomotion and alternate kinds of couplings of bodies and machines. The performances are walking performances—the choreography of a simple repertoire of leg movements. . . .

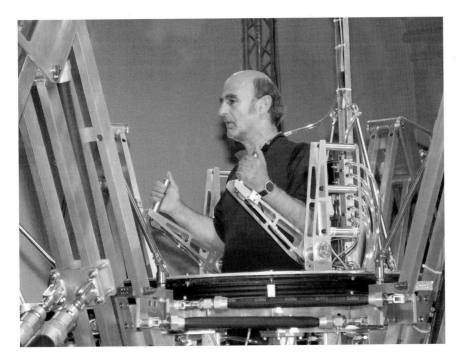

Muscle Machine, Gallery 291, London, 1 July 2003. Photo by Mark Bennett.

facing page:
Exoskeleton, Cyborg Frictions, Dampfzentrale, Bern, 1999. Photo by Dominik Landwehr.

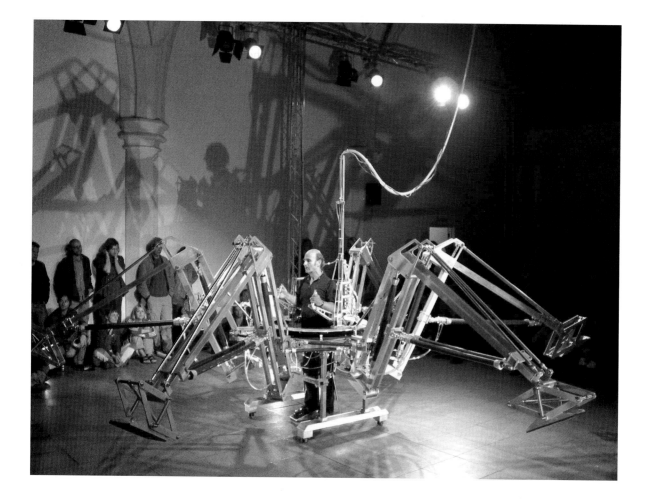

MS: Your work has always used sound. As the technology you employ is upgraded, how have the reasons why you use sound changed?

S: The *Third Hand* performances amplified body signals and sounds—brainwaves, heartbeat, blood flow, and muscle signals among others. Generally, you composed the sounds by controlling your body functions and thereby varying the signals—for example, relaxing, slowing your breathing, constricting the radial artery, and contracting the muscles. The *Third Hand* motor sounds were also amplified. I often used a digital delay with a hold function to sample and loop interesting motor sounds—sometimes synchronizing but often counterpointing the heartbeat. It was a combination of thumping, beeping, whirring, whooshing, clicks, and oscillating tones. But when the muscle-stimulation system began to be used to generate involuntary limb motion, the voltage being applied to my muscles (15 to 50 volts) was affecting the electrode pick-up of internal body signals (from microvolts to millivolts). So the decision was made to use devices like flexion, proximity, and pressure sensors as well as tilt sensors. There was a shift from amplifying internal body rhythms to registering involuntary limb motion. It was also a transition from analogue to midi-interface in the production of sound. In *Exoskeleton,* the six-legged walking robot, the compressed air, relay switch clicks, and mechanical sounds and impact of the machine were amplified. The function and movement of the machine are registered by the sounds, and with the large manipulator it was possible to generate repetitive sequences of finger and wrist movements and thereby produce rhythmic loops of sounds. You composed the sounds by choreographing the movements of the machine. With the new *Muscle Machine* (actuated by pneumatic rubber muscles), accelerometer sensors monitor the velocity of the leg motion and provide the signals to make sound. . . .

MS: Your fascination with the Internet, virtual reality, the globalization of information, and technologies of interaction seem to be somewhat at odds with the liveness of performance—the need to be there, on site, for an event, a conference, a presentation, a festival, and so on. Is there a contradiction for you here, or is this more to do with an emancipation or unfastening of the interactive spectator of your work?

S: No, there is no contradiction at all. And remember that many of the sensory deprivation and *Suspension* performances were done in private or remote spaces with no one there except the people directly assisting. An audience as a

Muscle Machine, Gallery 291, London, 1 July 2003. Photo by Mark Bennett.

witness to a live performance is not always possible and is not necessary to authenticate the action. Yes, the *Fractal Flesh* performance required people in other places to initiate a remote choreography of the body. Nothing would have happened without this interactivity. But this performance was really an exception. And to involve an audience directly was always a problem as the actions were either difficult physically or complex technically. Generally, the projects have been structured to be performed and experienced by the willing body, which is the artist. Sometimes people have seen that, sometimes not. There is a body, and there are its attachments. They function, coupled, to construct architectures of extended operations. The body inhabits a local space but can also project its presence elsewhere. The body speaks here but can be heard over there. Tasks are performed in proximity but can be mimicked by remote surrogate robots. Transduced, physical actions extend into virtual task environments. This body functions effectively. We constantly and seamlessly slide between the physical and the virtual, the proximal and the remote. That's what technology coupled to the body constructs. It's a terrain of operation that is bounded neither purely by body physiology nor by body scales. . . .

MS: I have a question about intimacy. You have said, variously, that you are interested in both "intimacy through interface" and "intimacy without proximity." Examples of the former would be, say, your *Extra Ear* project, implanted with a sound chip to emit sound, whose ultimate aim, as you have said, would be for it to whisper sweet nothings to the other ear, or your *Stomach Sculpture,* in which a self-illuminating and sound-emitting sculpture is inserted down your esophagus. An example of the latter would be, for instance, the cybersexual implications of *Stimbod.* How do you see such intimacy?

S: Well, in the *Stimbod* system, the body you are accessing is being prompted by you. Or described in another way, your movements here are being performed and felt by another person over there. *Stimbod* was only a one-way touch-screen interface system. But if you both are wired with stimulation pads and had electrodes to pick up your own EMG muscle signals to transmit, then a half of my body here would be actuating a half of another body elsewhere and vice-versa. Caressing my body would be felt through the caress of another from a remote place, looping back as a secondary and augmenting sensation. The sensual and sexual loop would be extended, and the pleasure would be doubled

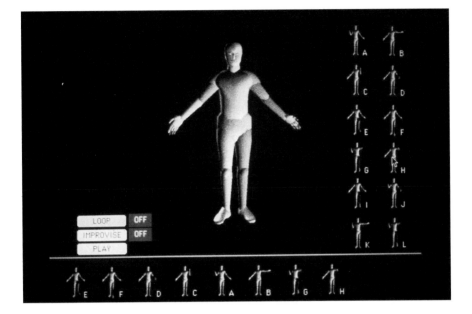

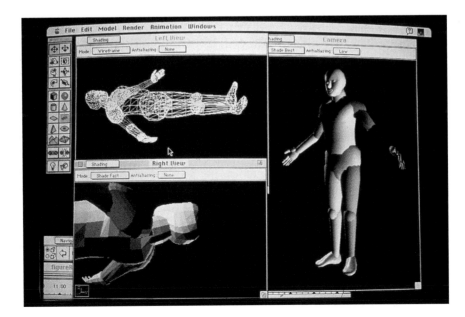

Stimbod software, Empire Ridge, Melbourne, 1995. Images by Troy Innocent.

by the remote body. Your caress would prompt the caress of another. You would sense the other as a phantom presence, as the aura of another (not phantom as in phantasm but as in phantom-limb experiences). It would not be so much as a collapse into the other but rather a host for its desires. Here and there, you and me would be meaningless distinctions. The space in which you operate and the body over there are meshed into an operational system in which bodies and spaces are indistinguishable—a space marked with a phantom presence. . . .

MS: Incidentally, on the matter of the *Extra Ear,* this yet to be completed soft prosthesis: Is it purely a conceptual gesture or something you're really hoping to achieve?

S: I'm still trying to realize the *Extra Ear* project. I never did see this project as merely a conceptual gesture. As with all of the previous projects and performances, what's interesting is the actualization and the action. Having said that, it's been difficult to convince a reconstructive surgeon to assist, not to mention getting any microsurgery done. This would have meant going far beyond cosmetic surgery. It's certainly a plausible project medically. All this is quite possible with the right sort of assistance. Ear reconstructions are done all the time for accident victims. OK, the medical community is ethical—but conservative. Well, we know they do experiments on people—on the aged, the injured, and the ill, but not on consenting artists [laughs]. I'm now trying to bypass the need for this kind of surgical assistance. The strategy will be to grow the underlying cartilage structure of the ear with my bone-marrow cells. Having done that, it could be inserted beneath the skin of the forearm. After a few months, when the cartilage has fully grown and the skin has stretched over it, the back of the ear can be cut and lifted, then buttressed by more cartilage and with a skin graft positioned over the wound. The ear lobe would have to be also constructed, but you'd have an ear on your arm. I'd always have something up my sleeve [laughs]. Actually, Oron Catts and Ionat Zurr from SymbioticA (and a German lab) have already collaborated with a quarter-scale replica of my ear, which was exhibited in Galeria Kapelica in Ljubljana, Slovenia, in May 2003. The lab was to have used animal cells but obtained donor human cells. So instead of being half-rat/half-Stelarc, the ear can now be more aptly described as half-German/half-Australian [laughs]. It was cultured in a microgravity bioreactor that kept the nutrients washing over the ear and allowed the cells to grow in a 3D structure. This was in an incubator kept at the

appropriate temperature, with CO_2 occasionally pumped into it to emulate body conditions. . . .

MS: In her contribution to this publication, Jane Goodall has suggested that in your work prostheses are augmentations (rather than simply replacements) for the possibilities of the species. You have said in the past "Information is the prosthesis that props up the obsolete body." This is a broader question than the previous one: what future do you see for the human?

S: The issue for the human is not in a future but in the problem of its present. In affirming its presence and constructing a present, it erases its past and escapes its future. This realm of erasure and escape is made possible only by its experience of extreme absence and its posture of acute indifference (and with the realization of its obsolescence). It generates a fractal, multiple and alternate proliferation of possibilities. Framing a future collapses the world. What it means to be human is not to merely perpetuate our form and functions but to be immersed in the alternate. We've defined actuality as that which happens when we collapse possibility. But becoming is not about closure or collapse. Oscillating in ambiguity and anxiety keeps the body on edge—neither as a body that was, nor as a body that will be. But rather as something Other. . . .

TIME LINE

Projects and Performances

1968–1970

Multimedia performances, Melbourne, Australia

1968–1972

Helmets: Put on and Walk, Sensory Compartments, Melbourne, Australia

1970–1994

Amplified body events (EEG, ECG, EMG, bloodflow, kinetic angle transducers, position sensors), Japan, United States, Australia

1972–1975

Sensory-deprivation events and body suspensions with harness, Japan, Australia

1973–1975

Filming the inside of the body—16 mm color films of stomach (14 mins.), colon (16 mins.), and lungs (15 mins.); full-body video x-ray scan (60 mins.), Tokyo, Japan

1976–1981

The *Third Hand* project (grasp, pinch, and wrist-rotation functions with tactile feedback system for a sense of touch), Yokohama, Nagoya, Tokyo, Japan

1976–1988

Body suspensions with insertions into the skin, Japan, Europe, United States, Australia

1981–1994

Third Hand events (laser eyes, muscle stimulators, and interactive video), Japan, Europe, United States, Australia

1991–1994

Events with industrial robot arms, Europe, Canada, Australia

1992–1993

Virtual Arm project (a universal manipulator with DataGlove Control—a gesture-recognition command language for extended capabilities), Melbourne, Australia

1993

Stomach Sculpture (a self-illuminating, sound-emitting, extending, and retracting
capsule structure actuated by a servomotor and logic circuit), with the
assistance of Jason Patterson, Rainer Linz, and Nathan Thompson,
Melbourne, Australia

1994

Muscle stimulation system (for programmed choreography of body motion), with
the assistance of Troy Innocent and Empire Ridge, Melbourne, Australia

1995

Touch-screen interface for remote access and actuation of the body, with the
assistance of Troy Innocent and Empire Ridge, Melbourne, Australia

1995–1998

Fractal Flesh, Ping Body, and *Parasite* Internet performances, with the assistance of the
Merlin Group, Sydney, Australia

1998

Exoskeleton, a six-legged, pneumatically powered, walking robot controlled by arm
gestures, construction by F18, Hamburg, Germany

2000

Extended Arm, with an eleven-degrees-of-freedom manipulator, with the assistance of
Jason Patterson, Melbourne, Australia

2000

Construction of the six-degrees-of-freedom motion prosthesis for *Movatar,* an inverse
motion-capture system, with the assistance of F18 in Hamburg, Germany

2001–2002

Hexapod robot prototype in collaboration with the Digital Research Lab, the
Nottingham Trent University, and the Evolutionary and Adaptive Systems
Group, COGS, Sussex University, United Kingdom

2002–2003

Prosthetic Head project, an embodied conversational agent that speaks to the person
that interrogates it, with the assistance of Karen Marcello, Sam Trychin, and
Barrett Fox in San Francisco

2003

Extra Ear 1/4 Scale project, a small replica of the artist's ear grown with human cells,
in collaboration with Oron Catts and Ionat Zurr of the Tissue Culture and
Art project, Perth, Australia

2003

Muscle Machine project, a six-legged walking machine with pneumatic rubber muscle
actuators, constructed by FACCT, the Nottingham Trent University, United
Kingdom

2004–2005

Partial Head project: growing quarter-scale replicas of the artist's mouth, nose, closed
eye, and ear with primate cells (a partial portrait, partially alive and partially
human), with Oron Catts and Ionat Zurr of the Tissue Culture and Art
Project, Perth, Australia

Artist-in-Residence

1990

Ballarat University College, Ballarat, Australia

1991–1992

RMIT Advanced Computer Graphics Centre, Melbourne, Australia

1993

Kansas City Art Institute, Kansas City, United States

2000

Carnegie Mellon University, Pittsburgh, United States

2001

Hamburg City, Hamburg, Germany

2001

Art and Technology, Ohio State University, Columbus, United States

2002

Faculty of Art and Design, Monash University, Caulfield, Australia

2003, 2004

Art and Technology, Ohio State University, Columbus, United States

Major Grants

1972, 1981

The Myer Foundation, Australia

1975, 1976, 1982, 1989, 1994, 1996

The Visual Arts/Craft Board, Australia Council

2001–2002

The Wellcome Trust, United Kingdom

2002–2003

Arts and Humanities Research Board, United Kingdom

2004

New Media Arts Fellowship, Australia Council

Acknowledgments

Assistance with performances in Japan:

Shigeo Anzai, Goji Hamada, Keisuke Oki, Takuro Osaka, Takao Saiki, Takatoshi Shinoda, Kazutaki Tazaki, and Nobuo Yamagishi.

Recent projects and performances:

The *Muscle Stimulation System* circuitry was designed by Bio-Electronics, Logitronics, and Rainer Linz in Melbourne, with the box fabricated by Jason Patterson. The graphical interface was done by Troy Innocent at Empire Ridge, with the assistance of Tim Ryan. *The Stomach Sculpture* was constructed by Jason Patterson in Melbourne. The *Fractal Flesh, Ping Body,* and *Parasite* software was developed by Gary Zebington, Dmitri Aronov, and the Merlin group in Sydney. *Exoskeleton* was completed by F18 as part of Stelarc's residency in Hamburg City, coordinated by Eva Diegritz from Kampnagel. Jason Patterson constructed the *Extended Arm* manipulator. F18 in Hamburg constructed the *Motion Prosthesis.* Rainer Linz, Damien Everett, and Gary Zebington developed *Movatar. Hexapod* was a collaboration between the Digital Research Unit, Nottingham Trent University and the Evolutionary and Adaptive Systems Group, COGS, at Sussex University. The project team included Barry Smith (project coordinator), Inman Harvey (robot designer), John Luxton (engineer), and Sophia Lycouris (choreographer). For the *Muscle Machine* Dr. Philip Breedon (FACCT, TNTU) was the development and project manager, and Stan Wijnans (DRU, TNTU) developed the sensor technology with V2 and did the sound design. This second stage of the project was funded by the AHRB, United Kingdom. The first performances in London were done at Gallery 291 on the 1 June 2003. *The Extra Ear 1/4 Scale* was a collaboration with TC&A (Oron Catts and Ionat Zurr of SymbioticA). *The Prosthetic Head* was done with the assistance of Karen Marcelo, Sam Trychin, and Barrett Fox from San Francisco. Rainer Linz produced the *Stelarc (Amplified Body)* and *Fractal Flesh* (Internet performances) audio CDs. The *Humanoid* audio CD was a collaboration with Chris Coe (Digital Primate) and Rainer Linz (Ontological Oscillators). Gary Zebington is the Webmaster for Stelarc's site.

Additional thanks:

Alex Adriaansens, Rachel Armstrong, Mark Bennett, Stuart Bunt, Alessio Cavallaro, Ashley Crawford, Eva Diegritz, Inman Harvey, Kathy Rae Huffman, Lloyd and Liz Jones, H.J. Koellreutter, Kirsten Krann, Dominik Landwehr, Jason Patterson, Bryan Rogers, Ken Scarlett, Nina Sellars, Barry Smith, and Wim Van Der Plas.

The institutions and galleries that have significantly supported Stelarc's projects and performances are: ACMI, Melbourne; Cybercultures, Sydney; ISEA, Groningen; Kapelica Gallery, Ljubljana; La Mama, Melbourne; Maki Gallery, Tokyo; Merlin, Sydney; V2 Organization, Rotterdam.

Stelarc's artwork is represented by the Sherman Galleries, Sydney.

ILLUSTRATION CREDITS

INDEX

Note: Page numbers appearing in *italics* indicate illustrations.

Electronic Culture: History, Theory, Practice

Timothy Druckrey, series editor

Ars Electronica: Facing the Future: A Survey of Two Decades
edited by Timothy Druckrey, 1999

net_condition: art and global media
edited by Peter Weibel and Timothy Druckrey, 2001

Dark Fiber: Tracking Critical Internet Culture
Geert Lovink, 2002

Future Cinema: The Cinematic Imaginary After Film
edited by Jeffrey Shaw and Peter Weibel, 2003

Stelarc: The Monograph
edited by Marquard Smith, 2005